WHAT IS A WESTERN?

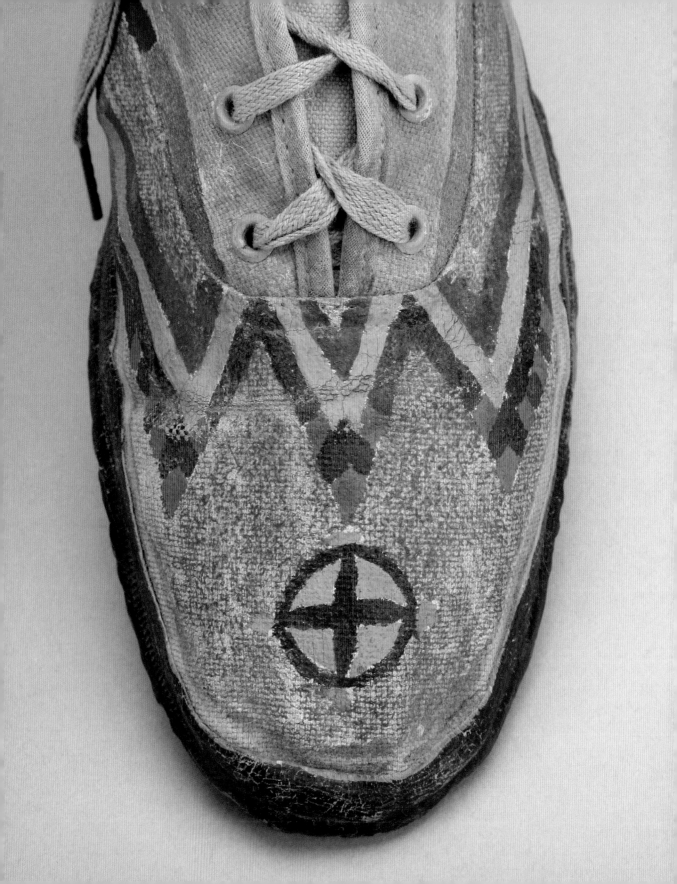

WHAT IS A WESTERN?
REGION, GENRE, IMAGINATION

Josh Garrett-Davis

FOREWORD BY *Patricia Nelson Limerick*

UNIVERSITY OF OKLAHOMA PRESS NORMAN

Also by Josh Garrett-Davis

Ghost Dances: Proving Up on the Great Plains (Boston, 2012)

This book is published with support of the Autry Museum of the American West. Located in Los Angeles, the Autry brings together the stories of all peoples of the American West, connecting the past with the present to inspire our shared future.

Frontispiece. Unidentified artist, canvas tennis shoes, date unknown. Mixed media, 4¾ × 10½ × 3½ in. Southwest Museum of the American Indian Collection, Autry Museum of the American West, 2077.G.2AB. See page 48.

LIBRARY OF CONGRESS CATALOGING-IN-PUBLICATION DATA

Names: Garrett-Davis, Josh, author. | Limerick, Patricia Nelson, 1951– writer of foreword.
Title: What is a Western? : region, genre, imagination / Josh Garrett-Davis ; foreword by Patricia
 Nelson Limerick.
Description: Norman : University of Oklahoma Press, [2019] | Includes index.
Identifiers: LCCN 2018060909 | ISBN 978-0-8061-6394-9 (paperback : alk. paper)
Subjects: LCSH: West (U.S.)—In literature. | American literature—History and criticism.
Classification: LCC PS169.W4 G37 2019 | DDC 810.9/35878—dc23
LC record available at https://lccn.loc.gov/2018060909

FOR LYGIA

CONTENTS

ILLUSTRATIONS

FOREWORD

Patricia Nelson Limerick

I begin by bringing together—for the first time ever—four illuminating events in western American intellectual history. Each event featured an enterprise aimed at conveying an understanding of western American history and contemporary life to a wider public.

In 1869 Samuel Bowles published his book *Our New West: Records of Travel between the Mississippi River and the Pacific Ocean* (with a subtitle that then went on for lines and lines).

In 1939 John Ford released his movie *Stagecoach*.

In 1988 the Autry Museum of the American West opened.

In 2019 Josh Garrett-Davis is publishing his book *What Is a Western? Region, Genre, Imagination*.

Why bring these seemingly disparate events together? First, because having the chance to read *What Is a Western?* awakened in me a lasting enthusiasm for the intellectual sport of juxtaposition. And, second, because each of these enterprises captures the way the American West scrambles, jumbles, and rattles conventional categories of individual and group identity. Thus, this juxtaposition provides an optimal framework for telling readers of this book what is in store for them: they are headed off on a wild ride in wild company. To make the most of this experience, readers should do nothing to render the journey smooth, safe, or predictable. In other words, they should resist the impulse to locate a seatbelt or to hold onto anything—other than the author and each other.

In 1869 Samuel Bowles set a wonderful precedent in noting the revelations produced by a disorderly overnight trip in a Western stagecoach: "Everybody's back hair comes down," Bowles wrote, "and what is nature and what is art in costume and character is revealed."[1]

In 1939 John Ford placed a bunch of difficult and peculiar people in the confined space of a stagecoach. The people who got into this tiny traveling vehicle did not like one another. But then they got bounced around in the stagecoach and in their relationships with each other. Out of all this jiggling on rough roads, reconciliations and alliances emerged and persisted.

In 1988, just as the principles guiding the study of western American history underwent a widely publicized disruption, the Autry Museum of the American West opened. By their

very nature, the practices of museums often track and reflect the changing attitudes held by that enigmatic sector of society known as "the American public." Given the strong feelings aroused by nearly any reference to "the American West," the Autry Museum was nearly guaranteed to serve such a function, coming into being as an institution where many different visions and interpretations of the western past would have to share a limited space. Since its founding, the Autry has dealt with this "convergence" (apparently the museum's favored term) with an unexpected serenity and an equally surprising capacity for change.

In 2013 Josh Garrett-Davis made his first visit to the Autry Museum where he was "struck by the *juxtapositions* among the galleries"—the emphasis is mine, but it might as well have been his. In 2016 the Autry brought Garrett-Davis into this thought-provoking workplace. Serving as a curator, Garrett-Davis has spent his working days (and, one would imagine, sometimes his dreaming nights) contemplating a wildly improbable assemblage of paintings, texts, photographs, oral history interviews, films, songs, material objects, quotations, scholars, and celebrities. Notable for his capacity to keep his footing in terrain that might trip up a less agile thinker, Garrett-Davis has seized every opportunity to cultivate the two-step maneuver that invigorates this essay. Step one: juxtapose several of the items and entities assembled in the Autry Museum, while also including a few phenomena observed and acquired in the author's adventures outside the boundaries of the museum. And then, promptly on to step two: capture in words the connections and associations thus brought into view.

Aiding in the cause of luring these connections and associations out where we can contemplate them, this book features a question as its title: "What Is a Western?" The author's initial answer to the question—"I don't know"—may momentarily confound readers who were expecting a more authoritative authorial presence. But relief and reassurance move in instantly to de-confound. Garrett-Davis's readers soon figure out that he has favored them with a promotion in status: rather than serving as passive recipients of a learned and finalized treatise on the definition of "Western," they will take the role of the author's comrades in curiosity.

And curiosity is off and running, maintaining a very brisk pace through twenty-one essays with only the rarest moment of rest.

And now, in the following over-packed paragraph, the readers' guide to what lies ahead, I will present an inventory of the reasons why readers have made a wise choice by agreeing to accompany Garrett-Davis on a journey of juxtaposition, exploring the Western genre, as well as a number of the regional genres inspired by events and activities in the West that do not necessarily place cowboys and their accoutrements at center stage.

Garrett-Davis's gift for selecting the most compelling (and often the most under-noticed) examples is evident on every page. You may sense that, in any given passage, five or six other examples were elbowing to get into the picture. But you will know that the author has fended off their insistence on their own importance and told those wannabe case studies that this is not their moment to shine. As a reliable method of mobilizing curiosity, Garrett-Davis draws your attention to material objects associated with the West, and he persuades those objects, if not to speak for themselves, at least to trust him to speak for them. (To note one example, the motorcycles carrying the brand name "Indian" prove to be particularly willing to defer to this curator-ventriloquist to convey their message.) Although certified by degrees from prestigious universities, Garrett-Davis never demands readers' deference to those degrees. On the contrary, he explicitly declares the intention to avoid academic mannerism. More to the point, he embraces every opportunity to serve as translator and interpreter in conveying insights that originate in the academic world to a wider audience. He never misses a chance to unleash the redemptive power of humor, even when a subject might seem too encapsulated in solemnity to allow such redemption. In the right places, Garrett-Davis efficiently sketches out the context in time for people, events, books, paintings, trends, and themes. Readers will have many occasions to say, "Now I get it! That's why *that* happened *then*." These declarations will respond, in particular, to his tracking of the transitions among generations as the dynamic behind the reconfiguring of perceptions of the Western. In a similar way, *What Is a Western?* draws much of its force from Garrett-Davis's skills in the excavation of the forgotten, digging back into time, uncovering human works that held and then lost recognition, and restoring them to the reach of our appreciation. And, in a feature that offers great promise in the early twenty-first century, Garrett-Davis offers an alternative to the practices of fact-checking and debunking that have, counter-intuitively, *deepened*—and seldom dispelled—the resistance of devotees to giving up the vision that moviemakers persuaded them to see as the real West. Rather than deploy fact-checking to discount the beliefs and convictions of such devotees, Garrett-Davis displays an adeptness in dealing with belief and in recognizing the split ownership of property between those who claim to own the Western genre and those who claim to own the story of the West as a record of fact and evidence. Finally, when it comes to drawing on the insights of a wide range of academic disciplines, from film studies to literary criticism, from art history to cultural studies of borderlands, Garrett-Davis performs a reenactment of the wonderful operations of the Denver International Airport luggage system in the mid-1990s (this, for those who were not around to observe the mechanical system, was a spectacularly failed effort to construct an underground network of belts to deliver bags

from the planes to the main terminal; bags only rarely got to their destination, but they were tossed in the air in unintended direction with great vigor—not a good treatment for suitcases but a very appropriate treatment for disciplinary territorial claims).

Josh Garrett-Davis enlists readers as his comrades in curiosity, providing an example that may inspire emulation even in those rare souls who, before taking up this book, thought they had figured everything out. And why is the mobilization of curiosity at such a premium with the topic of this book? For all of the sense of adventure and fresh starts associated with the American West, the region—and its affiliated genre, the Western—has proven to be a psychological ecosystem where conventional wisdom has been inordinately successful in getting itself rooted and spreading like rural cheatgrass or urban crabgrass. Initially defined by John Kenneth Galbraith (who, it must be acknowledged, did not maintain a complete immunity from the seductions of this mode of thought), conventional wisdom displays the identifying qualities of convenience, familiarity, predictability, and acceptability. Most of all, as Galbraith noted, conventional wisdom "makes vigorous advocacy of originality a substitute for originality itself."[2]

Spend too much time with individuals or groups who hold a whole-hearted belief in any of the widely popularized representations of the American West, and Galbraith's warning about the conventional wisdom gains in relevance: "[T]here are also grave drawbacks and even dangers in a system of thought which by its very nature and design avoids accommodation to circumstances until change is dramatically forced upon it."[3] But quoting Galbraith's warning makes it clear why Garrett-Davis's approach to conventional thinking carries great value and also relief and even delight. He does not attempt anything close to "dramatically forc[ing] change" upon outmoded ways of thinking about the West and its representations. On the contrary, he invites the conventional wisdom to participate in an open-ended consideration of his core question, "What is a Western?"

As Garrett-Davis declares in the introduction, "This book generally delights in the subjects it covers." The essays do not labor along. They "go off track; they even play." When he notes in "An Old Song" the hope for an alliance between the traditional Western genre and "regional work" (forms of expression that arise from particular places and communities within the American West), his phrasing is persuasive, charming, and fun. The Autry should invite these two forms of creativity and imagination, he says, "onto the same dance floor."

The fun shifts into high gear when the juxtaposition reaches the frontiers of improbability. To use a couple of striking examples, Garrett-Davis is surely the only person on the planet who has ever thought to juxtapose actor Pee-wee Herman to environmental guru

Edward Abbey, as contrasting case studies in Western masculinity. In the same spirit (well, almost the same!), Garrett-Davis conjoins, in another essay, aging heavy metal musicians and wild horses on public lands, with both cohorts seen as vestiges of a world that refuses to freeze time on their behalf. To put this in a nutshell, wild horses, like cowboys and heavy metal veterans, "look ahead to no safe retirement pasture."

Even if you start this book satisfied with your knowledge of western American history or the genre of the Western, you are likely to experience moments when you look back at what you *thought* you knew and realize that you only knew it in part. You may also have moments when Garrett-Davis makes a statement that reminds you of some western American pattern or quality that you had guessed at or suspected but dismissed as too implausible—a dismissal you are now invited to reconsider. Very much in line with the aspirations and hopes of many historians of the American West writing today, these essays serve as exercises to enhance the range of the minds and souls of the sector of humanity known as "the general public."

In the early years of the twenty-first century, the word "healing" works overtime, sometimes charting a path toward action but just as often serving as a pious ideal floating several feet above practicality. Characteristically, Josh Garrett-Davis, in choosing his analogy for dealing with our complicated heritage, breaks from the formulaic. Borrowing a phrase from the borderlands band Calexico, he calls attention to the aspiration for "sewing the dream better suited for both soul and soil." Each of the juxtapositions, connections, and associations in this book constitutes a stitch in that cause.

ACKNOWLEDGMENTS

This book is partly produced by the Autry Museum of the American West in conversation with its mission and collections. At the Autry we acknowledge the Tongva-Gabrielino peoples as the traditional caretakers of the land on which the museum stands.

This book is part of the conceptual work of renovating the core exhibition within the Ted and Marian Craver Imagination Gallery, a work in progress scheduled to open in 2021. This in-progress exhibition project, prospectively titled *Imagined Wests*, is being funded by the National Endowment for the Humanities, Public Humanities Projects Grant. (The specific publication of this book is not part of the grant funding.)

Many people have supported the inquiries published in this book over the many years I have been exploring these topics. Seth Archer, Ben Fitzsimmons, and Kevin Riordan read the whole manuscript, as did two anonymous readers for the University of Oklahoma Press. David Wrobel offered key suggestions on the book proposal and sample chapters. I am so grateful for their time and advice amid busy lives. On individual essays, many others have offered insight or assistance. For some, it may be so long ago they do not even remember, but I thank them. Nell Boeschenstein, Carolyn Brucken, Sergio Carmona, Chris Clarke, Everett Drayton, Mike Goetzman, Margo Handwerker, Michael K. Johnson, Marina Libel, Emily Sieu Liebowitz, Betsy Marston, Michelle Nijhuis, Marni Sandweiss, Richard Saxton, Amy Scott, and Sean Wilentz offered comments or support for pieces included here. I hope I have not forgotten anyone. For research, the Los Angeles Public Library has been an essential resource for a writer without university library privileges.

So many people at the Autry Museum have helped out with pieces of this, particularly with the images. I am grateful to my many friends and colleagues at the museum. Marilyn Van Winkle, Carmel France, Conor McCleary, Liza Posas, Sara Ybarra, Sarah Signorovitch, and Nick Kramer facilitated viewings and photography of collection objects, amid so many other projects at the museum. Brenda Litzinger, Carolyn Brucken, Amy Scott, and LaLeña Lewark offered advice and support at various points in the process. This book's title is adopted from the film series "What Is a Western?" begun by Jeffrey Richardson and Lisa

Woon, and the phrase seems to have been around the museum for some time. I have enjoyed the flexibility this question has offered.

Many thanks to all the artists and rights-holders who allowed their images to grace these pages.

At the University of Oklahoma Press, I thank acquisitions editor Kathleen A. Kelly for her interest in the project, for finding stellar peer reviewers, and for steering the manuscript through to publication. Emily Jerman Schuster facilitated the editing process, and freelancer Chris Dodge copyedited and refined the text substantially. Museum work has made me appreciate how much an intellectual experience depends on nonverbal framing; Julie Rushing's beautiful design fundamentally shapes this book.

Chapter 7, "The Wonders of Leslie Marmon Silko," originally appeared in slightly different form in the *Iowa Review* online, September 6, 2011. Many thanks to Emily Sieu Liebowitz and Jenna Hammerich for placing it there.

Chapter 8, "Horse Power," first appeared in slightly different form in Amy Scott, ed., *Art of the West: Selections from the Autry Museum* (University of Oklahoma Press, 2018). Thanks to Amy Scott, Kathleen A. Kelly, and Brenda Litzinger for that opportunity.

Chapter 9, "Standing Rock at the Museum," appeared on KCET *Earth Focus* on May 16, 2017. Thanks to Chris Clarke for editing and to (among others) Cannupa Hanska Luger, Zoë Urness, and Jamie Gordon for their help and thoughts for the Autry exhibit *Standing Rock: Art and Solidarity* in 2016–17.

Chapter 15, "A California Commonist," appeared in slightly different form in the *Los Angeles Review of Books* (*LARB*), February 22, 2016. Thanks to Mike Goetzman and the *LARB*.

Chapter 16, "California über Alles: On Joan Didion," appeared in a different form in the *Faster Times* online newspaper, which no longer exists in the form it had in 2010, when the essay was published. Thanks to Nell Boeschenstein for editing the original review essay.

Chapter 18, "A Homestead for Contemporary Art" appeared in shorter form in Margo Handwerker and Richard Saxton, eds., *A Decade of Country Hits: Art on the Rural Frontier* (Last Chance Press and Jap Sam Books, 2014). I'm grateful to Margo and Richard for this opportunity, my first foray into M12, and to Anthony Cross for the cover photo.

Chapter 21, "American Remains," appeared in *An Equine Anthology* (Last Chance Press, 2015), along with a companion song, "Blood Horse." Thanks to Nell Boeschenstein for her suggestions and edits on this piece, and to M12 and the Santa Fe Art Institute for making that project possible.

Finally, I must thank my family. My parents placed me in the West and introduced me to Indian Country, the borderlands, the country, and the cities. My dad, Jay Davis, still sends me western snapshots and newspaper clippings and spurs my explorations, virtual and road-based. My mom, Kathy Garrett, brought me to the excitement of the urban West, with its many cultures and subcultures. She and the Libel family have also helped make space for writing at key points in the creation of this book. Marina Libel has read over and talked over many of these topics as I explored them over our nearly two decades of adventures together. And the book is for Lygia, who lent me her Dr. Seuss book, helped introduce *Rango* and *The Wizard of Oz* screenings at the Autry, and is one of our hopes for the future of the West.

WHAT IS A WESTERN?

INTRODUCTION

The title of this book is a question. Not a rhetorical question but an open-ended one that will not be answered by the last page. What is a Western? I don't know, despite having spent a significant part of the past two decades thinking and writing about the American West and art (broadly construed) about the West. The Western is a genre of stories, books, art, movies, TV shows, music, fashion, and other material culture, often about the cowboy and his adventures in a rugged and mythic West. But "western" can describe any art made in or about North America west of, say, the Mississippi River. This could include Kansas City jazz, Haida house posts, Mormon hymns, Chicano/a Aztlán murals, San Francisco hippie comic books, or Los Angeles noir movies—none of which you might initially use the word "western" to describe or classify but all of which are legitimately western. One thread of this book is the strange relationship of this broadly western regional art to genre Westerns. It seems that frequently western regional art evokes the genre Western, which itself depends on (and is inspired by) the reality of the West, such that the two cannot be cleanly distinguished.[1]

Another way of framing the title: I work as a curator at the Autry Museum of the American West, which seeks to be an institution of regional cultural history. The museum was founded by two cowboy stars (Gene Autry and Monte Hale) and their wives (Jackie Autry and Joanne Hale) in the city that made the Western king of the big screen and small screen alike for a time in the twentieth century. The Autry Museum is built around the Western—the genre is something like a Stetson-topped sun, around which a complicated array of other subject matter swirls. I came to the museum as essentially a regionalist and had already begun writing much of the regional western material in this book. Now I help curate the long-running film series "What Is a Western?"—and much of this book's writing on the genre began in relation to this series. Intended by its original curators to span genre and regional movies (including California beach movies and sunshine noir), the series has largely stuck to so-called classic cowboy films, roughly from *Stagecoach* (1939) to *Unforgiven* (1992). Perhaps responding to the titular question, audience members sometimes police our choices. A few grumble or send email messages to comment. One wrote, for instance, that

The Treasure of the Sierra Madre (1948) is not a Western, because Humphrey Bogart's character was not heroic enough (and he wore a fedora to boot).

In a sense, the dilemma and the opportunity of the series echo those of the museum and this book. Not everything here engages explicitly with the Western genre, but, discussed in the context of what many presume to be a cowboy museum, it cannot help but be associated with the genre. Sometimes distortion results from viewing western regional culture and Westerns together, but sometimes the Stetson sun casts revelatory light. As a popular culture curator at the Autry Museum, I fear I will never be able to catch up on decades' worth of Western minutiae: the supporting actors, the movie ranches, the toys, the TV shows. The question "What is a Western?" can thus also signify my wonder within such a vast and complicated solar system. "What is a Western? What is a Western?" seems to echo mockingly off the terra-cotta tiles of the museum's main plaza.

Western Afterglow and Penumbra

A third way of thinking about the title question adds "now" to the end: "What is a Western *now?*" Often declared dead, the genre lives on in many revivals and playful adaptations that may look quite unlike the Westerns of old. The West and its many subregions live on as well, even as populations shift and mix, even as the very concept of region itself is suspected to be irrelevant.[2] There is no denying that region and genre—at least as framed in terms of the West or Western—are more peripheral than they were a generation ago, much less two. How do we present (for instance, at the museum) this array of popular culture to audiences increasingly unfamiliar with the status the West and Western once had? This question may have been cause for anxiety at one time but now seems to be another opportunity. We live in the afterglow of the Western's once-blazing sun, and this moment casts anything we call "western" in a queer light, calling high noon into question too. Now even the most classic Western seems more international, sexually ambiguous, and stylized than it once may have appeared.[3] Listen, for example, to the opening ballad from the film *High Noon* (1952), composed by the Russian Jewish immigrant Dimitri Tiomkin, with lyrics written by Ned Washington and sung by country star Tex Ritter (who'd gotten his break in New York City in the somewhat queer folk play *Green Grow the Lilacs*—see chapter 13). The song initiates the romantic thread of the film's plot—"Do not forsake me, oh, my darling"—to a creepy underwater rhythm track that sounds like something by the industrial-rock band Nine Inch Nails. This mysterious percussion clashes beautifully with the sentimental tune. Today's perspective, even on decades-old cultural artifacts, squints slantwise in the afterglow.[4]

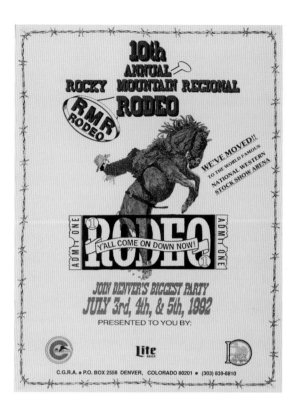

FIGURE 0.1. Poster, Rocky Mountain Regional Rodeo, Colorado Gay Rodeo Association, 1992. Paper, 26¼ × 16¼ in. International Gay Rodeo Association Institutional Archives, 1982–2009, Autry Museum of the American West, MSA.26.3.1.

Indeed, the most straightforward approach to the Western—examination of straight, white, American male identity at mid-century—is scarce in my analysis. There is a roughly John Wayne–shaped hole in this book. So many thinkers have limned that iconic silhouette, and done it well, that this screen-time-deficient critic could not add much insight.[5] (I grew up in the 1980s and 1990s in the rare US home without a television and had relatively little exposure to even Western reruns. However, this was in small-town South Dakota, so I had some significant exposure to real cowboys, real Indians, and real pretty landscapes.) To risk extending the solar analogy too far, I am interested in the penumbra around the John Wayne silhouette. Cultural artifacts in the penumbra or even seemingly far outside it take on new tones in conversation with the terms "western" and "Western." Take a poster advertising a gay rodeo, for example (see fig. 0.1). Gay rodeo arose near Reno, Nevada, in 1976. The Rocky Mountain Regional Rodeo, the second gay rodeo, began in 1983 east of Denver. Gay rodeo remains a vibrant institution in the American West and beyond. The Autry Museum received the donation of the International Gay Rodeo Association institutional archives in 2009.

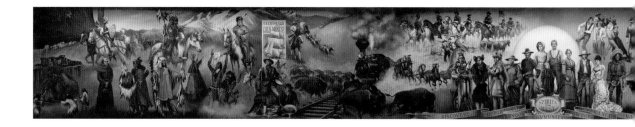

Pre-reflections

All this framing may seem a bit stilted, but this book generally delights in the subjects it covers. The essays wander on and off track; they even play. (Academic readers may find the book "under-theorized." Sorry.) Brace yourself for the occasional flash flood of references, not all glossed. The chapters were conceived and in some cases first presented or published for a variety of purposes, so style and tone vary. Yet they all circle connected themes, and any jagged joinery, I would argue, reflects the reality of the West (the western) and the Western. Read the chapters in any order. Enjoy the images from the Autry collection and elsewhere. These are intended as a virtual exhibition that illustrates and sometimes loosely accompanies the writing. This stuff—the objects, the movies, the stories—forms a key part of national identity (and identity beyond borders) and holds serious consequences. But it is also pop culture. Although it is sometimes fun to pelt pop culture with scholarly theories, that is not my aim here.[6] One of the things I love about the West, as a place and as an idea, is that it has—pardon the language—shit on its boots and gold in its teeth.

I first visited the Autry Museum in 2013, its twenty-fifth anniversary year, during a research trip to the Braun Research Library, then located at the Autry's Southwest Museum of the American Indian site (and now combined with the historic Autry Museum library in a shared research center). Visiting the main Autry Museum in Griffith Park, I remember being struck by the juxtapositions and contrasts among the galleries: an exhibition about Jewish history in Los Angeles, one about Native American beadwork, the reverent Colt revolver gallery, and small display cases on ethnic communities in the West circa 1890 all orbiting around the panoramic 1980s Walt Disney Imagineering mural, *Spirits of the West*, depicting western regional and Western genre history and created by Guy Deel, an illustrator and Disney "imagineer."[7] The mural (see fig. 0.2) was like the privatized update of a Works Progress Administration epic, remade in the Ronald Reagan era. Meanwhile, the museum's core art exhibition, *Art of the West*, had been re-envisioned the year I visited to juxtapose eighteenth-century Spanish Catholic art, sublime Euro-American landscapes, Diné (Navajo) textiles, an Indian motorcycle, Taos

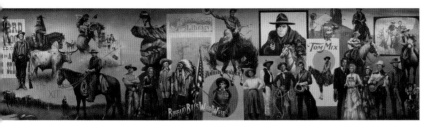

modernism, and contemporary Los Angeles art with an intercultural optimism that matched Barack Obama's years in the presidency. The seams that showed between *Art of the West*'s new vision for the Autry and the museum's many other exhibits might have foretold the ensuing era of American disharmony.[8] In a West with headlines dominated by the rebel ranchers at war with the Fish and Wildlife Service and Bureau of Land Management, Indigenous water advocates set upon by dogs while protesting an oil pipeline's route, ugly fights over a "beautiful" border wall, infernal forest fires, legalized marijuana, mass shootings by terrorists and madmen, and downsized national monuments, a seamless synthesis looks unlikely.

Cultural critic and adopted westerner Lucy Lippard has written about the contrast between vernacular collections like antique shops or curiosity museums and more institutional museums, saying that the latter have "become so clinically professional that life's inadvertent surprises are neglected and concealed within them. Even when a museum's staff thinks it is making the collections 'more accessible,' with computerized games and pull-out drawers, everything is still too well lit, too visibly insistent. The allure of mystery is absent."[9] I came to work at the Autry in 2016, and now I experience daily the pressures toward professionalism and didacticism—largely powered by funding needs and established fields of museum professionals. Yet the Autry occupies a middle ground between the "visibly insistent" institution and the kitschy, populist collections Lippard celebrates. A wall of police badges from the 1970s and 1980s assembled by the gun-leather maker John Bianchi evokes Bianchi's now-closed Frontier Museum where they once hung; pedestals full of silent movie paraphernalia suggest an old star's extra bedroom filled with glory-days treasures; the Deel mural might have commemorated a small town's centennial celebration if it weren't for its masterly use of vanishing points. The uneven seams between these features and the newer displays may reflect the region better than any single exhibition.

With cultural politics already on the table, here's a subject I'll raise briefly at the start in a western "tell it like it is" spirit: with some interesting exceptions, white men have dominated mass media for as long as mass media have existed. I am a white man; this book is a mass

medium. Problems of representation persist here. So much of what has been handed down to me as "Western" popular culture is a great hall of whiteness with a Native American nook. Even many of my unorthodox choices to examine here (for example, Pee-wee Herman, Flora Robertson, and Slayer) are tiles in that great hall. If I have failed to re-conceive "the West," the problem runs deeper than any personal fault. The very designation of a place as West or western implies an Anglo-centered, eastern perspective. And even the bringing of many traditions and societies together into a single story—the Autry's favored word for this is "convergence"—reflects a certain white privilege. Who, after all, usually gains access to the tower from which to survey the intercultural landscape? Of course, the actual West was completely or largely nonwhite for thousands of years and will likely be majority nonwhite in the near future, so that over the *longue durée* the twentieth century looks like an anomalous, pale-faced wave. But that century, spilling over a little at both ends, is the century of the Western.[10]

Is it possible to reframe things within the designation of the West? I attempt here to shift the frame—using the concept of borderlands is one promising alternative (see part 3 of this book)—but I have no illusions about dislodging a vast cultural structure with a slim book. Recent cinema suggests a similar endurance of long-established frameworks. Quentin Tarantino's Western films bring people of color into the equation with eloquent speaking and shooting roles but not without injury or offense. The brilliant art-house western filmmaker Kelly Reichardt has created some complex and humanized roles for Native characters, but overall her West is a mostly white place. The smash-hit video game Red Dead Redemption features a realistically multiethnic 1910s Southwest but one always seen over the shoulder of John Marston, the Anglo hero. *Hostiles*, a 2017 Western film, studiously attempted cultural sensitivity in depicting a detente between two old warriors, Cheyenne and American, at the end of the Indian wars. It included an African American soldier among its supporting cast. Yet it failed to fundamentally decenter the white captain's point of view or present the Cheyenne experience except behind a kind of glass frontier. This book, *What Is a Western?*, makes similar, incomplete moves in the "right direction," as we tend to say.

On Labor in the Imagined West

About a year into working at the Autry, I became fascinated by a small detail in the panoramic mural. Until that point I had viewed the mural as so scripted and obvious in its choice of characters and scenes—some actual, named individuals and some vague archetypes (the strapping blond gold panner and the *señora hermosa*)—that there was nothing to discover in it. No unpredictable artist's touch, no "inadvertent surprise" in Lippard's terms, just a pastiche

of the most canonical western figures joined together in Disney Imagineering's scene-painting style.[11] But on the right side of the panorama, which almost exclusively features the cowboy heroes of the Western genre from Buffalo Bill to Clint Eastwood, stand two faceless cowboys, straining at their labor (see fig. 0.3). They are in Monument Valley, but their labor is not wrangling or riding or gunslinging. One holds a scrim in front of the film set's artificial lights, and the other hoists the boom pole for the microphone. Their postures indicate how heavy both apparatuses are, and there is an almost Iwo Jima–like heroism to them. "All this fantasy," they seem to say through clenched jaws, "is damned hard work."

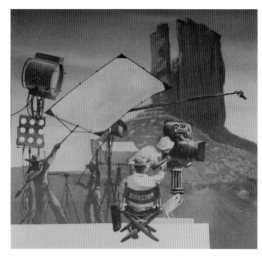

FIGURE 0.3. Guy Deel, *Spirits of the West*, 1988 (detail). Walt Disney Imagineering. Heritage Court, Autry Museum of the American West.

These anonymous, below-the-line workers flank John Ford in his director's chair, probably unnoticed by most viewers looking across the mural (it took me a year of glancing at it a few times per week). But I am grateful they are there. Think of all the hard work they stand for in actually building the invented West: the trail blazers and maintenance crews and firefighters cultivating postcard views in the national park system; the road crews paving the highways that lead to those parks; the Native artists weaving and sculpting and painting the little masterpieces that become souvenirs on so many shelves and end tables and walls (and in museums) around the world; the adobe masons restoring California's missions in the hot sun; the mariachi band busking table to table at the restaurant; the elves in Santa's shop and the factory workers assembling Hopalong Cassidy–branded merchandise; the leatherworkers adorning gun belts and the silversmiths hammering parade saddles and the engravers detailing replica revolvers; the embroiderers spider-webbing roses and horseshoes into snap-button shirts; the studio orchestras rehearsing the formula segues from sinister tom-tom rhythms to heroic fanfares; the parents reading genre stories and playing along with their children's games; the typesetters and editors proofing pulp magazines and comic books; the collectors and archivists preserving certain relics instead of others; the grips and gaffers and boom operators sweating in Monument Valley; and the mural painters hired by an upstart museum. You'd think that few of these workers would actually wear cowboy hats, but sometimes it is hot out there on the set.

A historian colleague described this oft-forgotten labor as a reason there might be a better term than "imagined West" for the fictional, cultural, invented, fantasy, manufactured

West. When I recounted this in passing to an Autry colleague, he pointed out that "Imagi-neering" is a better term. Disney knows its business.[12]

Daddy, Who's Gene Autry?

In 1978 Johnny Cash released a song titled "Who's Gene Autry?" In it Cash's young son asks the title question, then the Father in Black slips into a nostalgic reverie of going to the cinema to see Autry, a veritable superhero whose "pistol never ran out of bullets" and whose "bullets never drew any blood." Cash chuckles as he reflects on this, both recognizing the unreality of 1930s and '40s B-Westerns and appreciating the true heroism Autry represented: "In the eyes of a poor little country boy / He made the world look better to me."[13] Already in 1978—before I was born—a country singer had to conjure the Western's heyday for a child. Imagine me trying to explain this to my own daughter, born thirty-six years later! Her grandparents have vague memories of Gene Autry. Her great-grandparents, who grew up everywhere from Autry's own Oklahoma to Poland and Brazil, may have been fans but are either ghost riders or nearly there now. "Great-grandma, who's Gene Autry?" This is a question unlikely to be asked. For children, commonly we use analogy: Westerns were the *Star Wars*, the superhero stories, the *Fast and Furious*, or, for the youngest, the *PJ Masks* of the first two-thirds of the twentieth century. Or we could take the opposite tack: Westerns were the *Beowulf*, the *Arabian Nights*, the *Odyssey* of the modern world—timeless epics. All valid comparisons. But, of course, they miss some aspects of the specific genius of the Western.

A few factors made the twentieth-century Western unique as a popular culture phe-nomenon, perhaps never to be repeated. The Western is not rooted in any single work. As in other modern genres (such as fantasy and science fiction) many artists built and adapted the Western over time, to an extent that in the 1950s it dominated American and even global popular culture. Subsequent artists have dismantled and rebuilt the old mine; some still find gold in it, even as its market share has shrunk. Unlike any other genre, Westerns were tied to the identity of an ascendant superpower, a political and cultural empire such as the world had never seen. Mass culture exploded, and Hollywood churned out movies, including lots of Westerns, and shipped pallets of them everywhere. America loomed—heroically or ominously—and the cowboy was its avatar. The genre's "decline" beginning in the 1970s coincided with a more ambivalent and shifting US role in the world.[14]

It would be difficult to prove exact correlation, but the period of the Western's cultural hegemony, from, say, the 1910s through the early 1970s, coincided with the United States making substantial but compromised gains in realizing its democratic promise. Beginning

in 1909, a group of constitutional amendments allowed a federal income tax, provided for the direct election of senators, and granted suffrage to women. Charts of income inequality show a decline (with the exception of the 1920s boom) across this period. American Indians gained full US citizenship in 1924 and gradually rebuilt their tribal self-determination over the next several decades. Beginning with a period of racial terrorism and Jim Crow, African Americans made incomplete progress toward attaining full citizenship and civil rights via direct action, judicial rulings, and congressional bills. As an exception to a "progressive" history of this period, immigration in a nation of immigrants was sharply and racially restricted between 1924 and 1965, with many Mexican Americans (many of them US citizens) ethnically cleansed from the Southwest in the 1930s and Japanese Americans (also including many citizens) placed in wartime concentration camps the following decade. Women and LGBTQ citizens also endured persistent and even increasing containment in kitchens and closets. It is impossible to do justice to decades of complicated history in a short gloss, but I suggest that the dominant Western genre rode in time with a period of nationally circling the wagons against perceived outsiders while also negotiating the testy democracy within.[15]

By the time young John Carter Cash asked, "Daddy, who's Gene Autry?" in 1978, amid parallel changes in the nation at large, the Western became nearly "just a genre." American world dominance took some hits, most visibly in the debacle of the Vietnam War. (In John Wayne's 1968 film *The Green Berets*, the American base is nicknamed Dodge City, and the film's makers hoped for a Western-style triumph.) In the early 1970s, economic inequality began to rebuild toward today's Gilded Age levels. Churches, labor unions, and other solid institutions faltered within the circled wagons. Dreams of racial harmony stalled, but the nation's demographics began to shift in the wake of opened immigration. Women's liberation and gay liberation opened Americans to greater questioning of patriarchal heroes. A powerful conservative politics arose, implicitly (and sometimes explicitly) defending white supremacy and patriarchal mores. Overall amnesia and a sense of societal breakup took hold. In 1974 film critic Pauline Kael declared the Western dead.[16] Perhaps this was true for a *New Yorker* critic, but it was not so for the burgeoning right wing. In 1980 and 2000, the United States elected cowboy presidents who repurposed Western tropes. Historian Richard Aquila judges that "the mythic West was alive and well in the mid-eighties" and even had "relevance in a new century" after the year 2000.[17] Undeniably, however, artists' output of Westerns in film, literature, and other media had slowed to a trickle compared with earlier decades. British scholar Neil Campbell recently characterized the most artistically rich Western cinema as "post-Westerns," "ghost Westerns," and "dead Westerns."[18] For a generation at

least, the genre has lagged behind science fiction and fantasy. Artistically and commercially successful work continues to appear, but it does not command a central role. *Star Wars* and caped superheroes have seemed to dominate the universe of the post-Western era.

But historical context is not everything in explaining who Gene Autry was or who any of the other stars depicted on right side of the mural were. There is a "spirit," to quote the mural's title, in the Western genre that other genres lack. Its landscape is just outlandish enough but not otherworldly. The cowboy is a superhero, but imitating his feats does not require a lifetime of discipline, and wearing a hat and boots doesn't quite require fantastical cosplay. A president, for instance, can wear a Stetson without seeming as childish or bizarre as one would wearing a Batman costume. (That day may come.) The Western's supernatural elements are generally subtle. Its violence is blunt and laser-free. The figure of "the Indian" as a faceless threat or noble foil for the corruptions of conquest and "civilization" has inspired various audiences around the world in different times. In essence, Westerns form a fantasy genre that seems nearly historical (only a couple of generations past in the mid-twentieth century) compared to medieval knights or samurai. This nearness yet distance seems to me a fundamental appeal of the genre around the world. Hat and holster, and—voilà.

We ought not expect or desire a return to dominance for the Western. Yet throughout this book I periodically note a longing (in others and in myself) for the heroism and straightforwardness that Westerns and romantic tales set in the western region provided. Are we better off without these myths? Depending on how America's place in the world evolves, parts of the genre and the western region as metaphor will doubtless be scrambled with new tropes to speak to generations to come. The idea of a historical and present-day West as a borderland—or a two-or-more-sided frontier—where old-timers and newcomers coexist, collaborate, fight, and innovate holds ample ground for new stories and images. I am most inspired here by Chicana writer Gloria Anzaldúa's framing of this *frontera* as "wherever two or more cultures edge each other, . . . not a comfortable territory to live in" but one where "dormant areas of consciousness are being activated" (see chapter 11); by Native American writer Louis Owens's reconceiving of frontier as "the zone of trickster, a shimmering, always changing zone of multifaceted contact"; and by Neil Campbell's framing of the West and "westness" as a "traveling concept" that gets rebuilt in new contexts around the world.[19] There can be cowboys and Indians in such imagined Wests but also many others. The West may be a brutal place sometimes, as the Americas are and as the world is. But the West as both a real region and a fantasyland is also a wondrous place that can continue to confound and inspire us.

part one

COWBOYS AND ALIENS

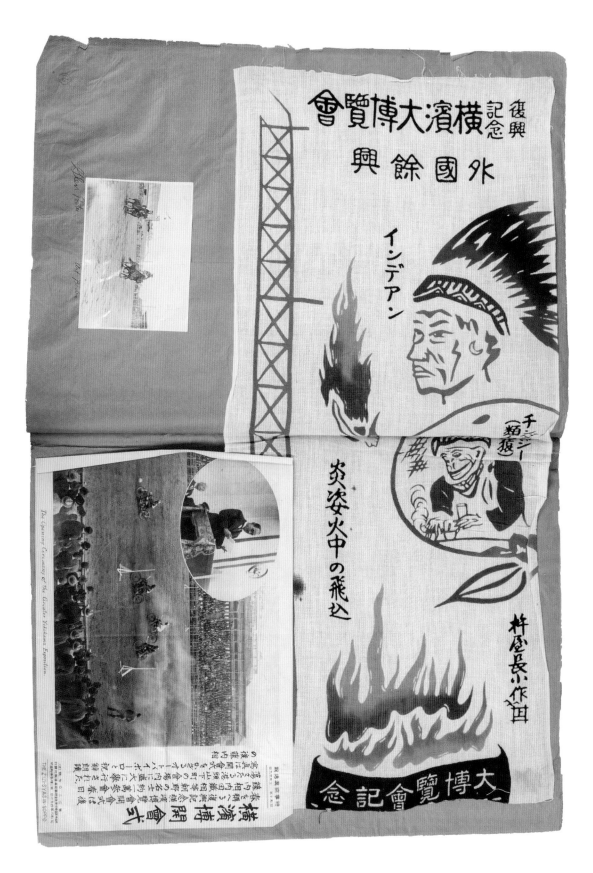

1. THE CLOSING OF THE FAR EASTERN FRONTIER

When I was twenty-four I traveled to Japan to visit a good friend who was teaching at an American school in Tokyo. I was then temping in the human resources office at New York's Metropolitan Museum of Art for twelve dollars an hour and could barely afford to fly to an expensive country and sightsee there. But I found a $550 plane ticket, crashed on my friend's floor, bought a Japan Rail pass, and pieced together two weeks as a tourist. Mostly I followed the usual tourist rail lines to some monasteries in Kyoto, the atomic bomb memorial in Hiroshima, and New Year festivities in Tokyo. But I insisted to Kevin, my citizen-of-the-world teacher friend, that we visit a small town called Imaichi (now part of Nikkō), sister city to Rapid City, South Dakota. Rapid City is not exactly my hometown, but it's the closest metropolis to Hot Springs and Pierre, the towns where I grew up. Imaichi was home to a one-third-scale model of South Dakota's own Mount Rushmore and a theme park called Western Mura, or Western Village.

Partly I wanted to go so my dad wouldn't hassle me when I got home for skipping over a gem of Dakotiana across the dateline. Partly I went for the comedy, to chuckle at the karaoke version of the Western, which already felt like a quaint, false-front genre in its country of origin. I was a fan of the Japanese heavy metal band Loudness for their awkward name alone; I proudly wore their T-shirt from 1985, emblazoned "Thunder in the East, Tour in the West." I figured the cowboy myth would be warped in translation to similar effect. I don't believe I had ever seen a classic Western film at that time (unless we count *An American Tail: Feivel Goes West* or *Dances with Wolves*), but I had read several Louis L'Amour novels and otherwise absorbed the tropes well enough through American theme parks, tourist traps, and presidents.

Western Village turned out to be humbler than I expected, once Kevin and I received our Confederate-money tickets and entered a gate in a stockade fence. A line of false-front storefronts (e.g., General Store and Arizona House Saloon) held jerky mannequins speaking Japanese (one was a grimacing John Wayne). We watched one of the

FIGURE 1.1. *Tenugui* (kitchen towel) from the Yokohama Grand Reconstruction Exposition, 1935. Fabric and dye, 29 × 3¼ in. Donated by Beau and Tinnel Hickory in the memory of Frank Dean. Autry Museum of the American West, 2007.97.2.4.

Rodeo star Frank Dean (who performed at the Yokohama expo) preserved this tenugui in a scrapbook. The text advertises "foreign entertainment," an Indian, and a "burning figure jumping into fire" (translation assistance by Yuki Ando).

hourly shoot-outs, which included one real *gaijin* (foreigner) actor in a Wyatt Earp getup. We crossed the Rio Grande and shrugged at some shrubs pruned to the shape of a mariachi band. We milled around the four-story fiberglass Rushmore, around which sat a dozen fiberglass collies, dalmatians, and German shepherds. While most of Western Village was built in the 1970s, the Rushmore replica had been constructed, at great expense, in the 1990s—in what now looks like a last-ditch attempt to keep the park going. It was during this time that Imaichi and Rapid City became sister cities.

A few years after I visited, this far eastern frontier closed. Its ruins have since appeared in lurid photo essays depicting a creepy carnival in decay. But that view belies the wholesome optimism that built it, the admiration for America not long after America had bombed Japan to the ground. Riding the train back to Tokyo, a fellow passenger bought Kevin and me beers just for being Americans. The Western was a cinematic projection of that postwar era buoyed by its country of origin, the United States. That nation, and that genre, glowed with such a mythic brilliance that it could entertain middle-class visitors, onetime enemies, sixteen time zones ahead of Hollywood, for decades. The myth never drew me in, but I do feel a pang at the passing of that age.

2. THE WEST'S WORLD

After World War II, Belgian Catholic missionaries working in Kinshasa, Congo, began to screen movies to help transform African men to accord with European ideals. Initially missionaries produced and screened documentaries to press their values on Kinois (Kinshasans), but they imported commercial films as well. Westerns, in theory, were a celebration of a parallel, so-called civilization process in an underdeveloped land. But by the 1950s, cinema had jumped the missionaries' corral, and open-air theaters sprang up, like Kinshasa's Astra that could hold fifteen hundred active, enthusiastic spectators. An account of a different, indoor theater in Kinshasa read: "At the first appearance of the cowboy, a deluge of applause and an explosion of deafening voices and whistles fill the room. The film dialogues are drowned out by the screams of vociferous spectators jumping to their feet, asking for more violent action. Some climb on top of their seats, clench their fists, and lash out at imaginary opponents."[1] Such a hard embrace of cowboy movies became, according to historian Ch. Didier Gondola, a strategy for reclaiming manhood for young men often displaced and struggling under colonialism. Many rebellious Kinois youth became "Bills," after William F. "Buffalo Bill" Cody, a loose subculture that entailed a culture of urban manhood as Congo moved toward independence in 1960. Bills did more than simply mimic the Western, Gondola writes. They "parlayed these movies' mystical paraphernalia into a hybrid culture, tropicalizing the Western in such a way that it became almost impossible to examine . . . juvenile gang movements in Kinshasa without reference to the Western."[2]

Sergio Leone may have saved the Western for film critics by stretching it into spaghetti. But an exceptional haute cinema practitioner may not provide the best lens for seeing the genre's quirky and shifting landscape around the world. Better to leaf wonderingly through a deck of wild cards, from Karl May's strange German adventure novels of Old Shatterhand and his Apache blood brother Winnetou to the streaky Mount Rushmore surrounded by fiberglass dogs and Western Mura in Japan and the identities of the fighting Bills in Congo. Other scholars have traced the appropriation of Western tropes in 1970s Jamaican dub reggae and twenty-first-century Iranian literature.[3] Aboriginal Taiwanese artists living in an intentional community in the early 2000s included a tipi in their collective space and displayed

VÉLODROME DE LA SEINE
173, RUE DE COURCELLES
LEVALLOIS-PERRET
S.F. CODY
contre un tandem

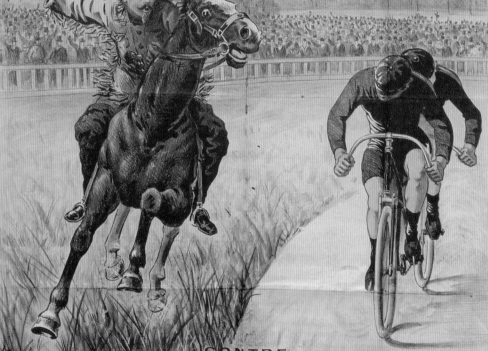

CONTRE
FOURNIER & GABY
EN BICYCLETTE TANDEM
GRAND MATCH DE 20.000 F.CS

ENTRE LE TANDEM & 6 CHEVAUX

SAMEDI. 11 NOV.BRE de 2H.½ à 4.H½ ET DIMANCHE 12. de MIDI ½ à 4.H½.

Imp. Parisienne Mon EMILE LÉVY, 132, Rue Montmartre Paris.

an affinity for cowboy hats and songs.[4] Somehow the genre grafted on to various times and places to produce diverse and tangy fruits. Local traditions and politics shaped the phenomenon of Billism in Kinshasa, the karate-inflected shoot-out in Imaichi, and the adventure tales of Karl May and Sergio Leone. The international Western in its many forms demonstrates not just the image-making power of the United States in the twentieth century but also something of the appeal of the Western itself, as discussed in the introduction.

From today's vantage, these wild cards may characterize the genre better than a dead man's hand like Buffalo Bill, John Ford, John Wayne, Frederic Remington, and Louis L'Amour. The *world's* West has received less attention.[5] Yet Gene Autry himself, who traveled the world as a global star when Leone was just a schoolboy in Rome, said, "It has always been my vision to build a museum which would exhibit and interpret the heritage of the West, and show how it has influenced America and the world."[6] It is an approach that makes more and more sense as time goes on.

Karl May, born in 1842 in a region that was not yet in Germany during a time when much of the West was not yet in the United States, was a petty criminal and fabulist whose education derived partly from a prison library. He published his foundational Western stories in the 1890s, before Owen Wister's *The Virginian* (1902) became the presumed first Western

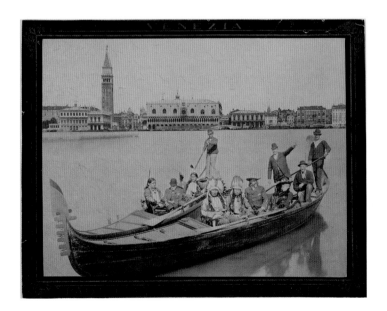

FIGURE 2.2. Paolo Salviati, group photo including William F. "Buffalo Bill" Cody and American Indians from his Wild West Show, Grand Canal, Venice, Italy, circa 1890. Paper, 12³⁄₁₆ × 15⁹⁄₁₆ in. Autry Museum of the American West, 87.182.45.

novel and *The Great Train Robbery* (1903) the first Western film. For German speakers and others around the world, few artists constructed a more influential picture of the West. Half a century after May's 1912 death, a series of West German movies based on his Westerns appeared. A number of these were dubbed into English versions that would achieve little success, just as May's novels translated into English have never found much of an audience on the continent where they take place. But in Germany and elsewhere the films were successful. Starring French actor Pierre Brice as the Apache hero Winnetou and American actor Lex Barker as his blood brother Old Shatterhand, the films were shot in Yugoslavia, in what is now Croatia, where local tourism departments use the film locations to attract visitors.

French scholar Pierre Bayard has written glowingly of May in his book *How to Talk about Places You've Never Been* (2016). Bayard wonders "whether this writer, who had never set foot in the American West, didn't manage in the end, through the work he effected on the imagination, to change the image the Europeans and the North Americans had of the Indians, thereby transforming the relationship between these peoples on a long-term basis."[7] This reading is wishful. Very little distinguishes Winnetou from James Fennimore Cooper's noble Mohican Chingachgook, or Old Shatterhand from Chingachgook's friend Natty Bumppo. Was the innovation of Old Shatterhand and Winnetou sealing their brotherhood a momentous, positive development in Native relations with non-Natives? Probably not.

Yet watching the 1960s films, at least, a distinct tone is evident. In *Winnetou 3. Teil* (1965), titled in English *The Desperado Trail* or *Winnetou: The Last Shot*, a group of corrupt land-grabbers make an alliance with one tribe called the Jicarillas, led by White Buffalo, in order to steal the land. Old Shatterhand and Winnetou, with Winnetou's tribe, called the Apaches (never mind that the Jicarilla Apaches are an actual Apache band), attempt to maintain peace and prevent the land grab. Winnetou's Apache village features Pueblo-style architecture, an adjacent group of Plains Indian–style tipis, and totem poles that appear to have been modeled after tiki bar decorations. Winnetou's saddle blanket resembles a faux Persian rug. In the English dubbing, the hero speaks of himself in the third person but omits many of the other hallmarks of "Tonto talk." The Croatian landscape of the film is sublime in its way, with craggy vertical rocks that serve the same visual function of conveying ruggedness and otherworldliness that Monument Valley gave John Ford's films. But the color palette—gray rocks with greenery around them, gray stone European buildings standing in for Spanish colonial outposts—adds a Grimms' fairy tale dimension to the story. When they are backed into a rocky redoubt at the climax, Old Shatterhand yells down a final entreaty: "We have retreated before you without fighting only because we do not want to fight. Because

we believe that all men should live together as brothers and try to understand each other without hurting and killing. We are strongly fortified here, and if you attack us a lot of blood will flow senselessly. White Buffalo, take off your blindfold and see why these renegades are grabbing all the land. They want wealth and power, and when they have it, they'll throw you out."[8] It is hard to imagine a Hollywood Western with a white protagonist so earnestly peddling the line "all men should live together as brothers." In that sense Bayard is correct to note that the Karl May stories predated sympathetic films such as *Little Big Man* (1970) and *Dances with Wolves.* On the other hand, sympathetic (if sometimes patronizing) portrayals of Native people in Westerns had appeared earlier in the United States, from silent films like *Ramona* (1928), directed by Chickasaw filmmaker Edwin Carewe, to Gene Autry films like *The Cowboy and the Indians* (1949) and *Apache Country* (1952) and John Ford's *Cheyenne Autumn* (1964). Probably nothing in this lineage owed anything to Karl May. The camps of German hobbyists who follow the "Red Road" and sleep in tipis to this day are among the real children of May.

Most impressive in the world of Old Shatterhand and Winnetou is the guileless pastiche of cultures, geographies, and historical moments. Like John Ford propping saguaros in Monument Valley or Nudie's Rodeo Tailors placing rhinestone Conestoga wagons on a gabardine suit, this disregard for specific place or time, while evoking a historical aura, seems close to the heart of the Western genre. It calls to mind the fantastical experience of the European immigrant Karl at the end of Franz Kafka's novel *Amerika*, written in the 1910s and published after Kafka's 1924 death. After his trials in New York City, Karl follows a bounteous opportunity out west by enlisting in the Nature Theatre of Oklahoma, a bureaucratic (even Kafkaesque) but splendid stage production that reads like a cross between a world's fair and a Wild West show like Oklahoma's own Miller Brothers 101 Ranch Wild West Show. As Karl watches from the train window rolling west, "Masses of blue-black rock rose in sheer wedges to the railway line. . . . Narrow, gloomy, jagged valleys opened out and one tried to follow with a pointing finger the direction in which they lost themselves; broad mountain streams appeared, rolling in great waves down on to the foothills and drawing with them a thousand foaming wavelets," and

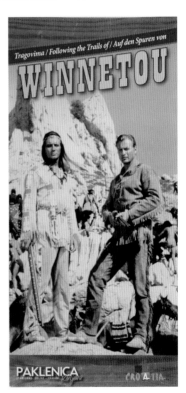

FIGURE 2.3. Folded brochure, *Following the Trails of Winnetou*, Rivijera Paklencia, Croatia, circa 2014. Paper, 8¼ × 4 in. Gift of Vlasta Radan. Courtesy of the Tourist Board of Starigrad. Autry Museum of the American West, 2014.36.1.

so on.[9] With this sublime and allegorical imagery, and with confidence in a bright American beginning, the novel ends, perhaps unfinished. Rather than combing through histories or landscapes to find an antecedent for such fictions, we might look to this as the true West.

Efforts by recent Hollywood art directors to be historically accurate or authentic seem anomalous from the Western's more typical form of outlandish fictions and spectacles.[10] As an alternative to such attempts at authenticity, some artists plug elements of the Western mystique into another part of the world altogether. An expert example is the 1985 Japanese gastro-cinema classic *Tampopo*. When the movie billed itself as a "ramen Western," its publicists may have simply delighted in riffing on the term "spaghetti Western" for a film based around a noodle shop. But by adopting bits of the vocabulary of Westerns—primarily the milk trucker, Goro, with his cowboy hat and cigarette and the cow horns atop his truck, but also broader elements of the plot and cinematography—the film highlights the dangers and passions of the Wild West in the everyday experience of creating and enjoying food.[11] The *noren* curtains across the doorway of a ramen shop acquire the drama of saloon doors, the uneasy separation of indoors and out. The ragtag members of the band of culinary advisors to the chef Tampopo become the Magnificent Seven, completing a Pacific circle from Kurosawa's *Seven Samurai* to Hollywood and back again. *Tampopo* pointed the way toward the inclusion of a little Western DNA—some myth, some grit—across the world, just like Gene Autry said.

3. A POSSE OF SOUL WESTERNS

It comes as a great shock, around the age of five, or six, or seven
to discover that Gary Cooper killing off the Indians when you were
rooting for Gary Cooper, that the Indians were you.

<div align="right">JAMES BALDWIN, 1965</div>

For many years, the Western Legacy Theater at the Autry Museum included a holographic video of actors dramatizing the story of the West in nine and a half minutes. Sometime, around 2000, this LaserDisc presentation was discontinued, and it has since largely been forgotten within the institution. But Everett Drayton, the museum's director of security and the only current employee who has worked there since the museum opened in 1988, has not forgotten it. Drayton knows by heart a short monologue by a woman homesteader:

> Sure, Jake and me got some land. Not five years ago they called it desert. Now they call it farmland. Ground so frozen hard, can't get a plow through it most of the year. Then comes summer, and we live half-buried in mud. Then locusts swept in here on a summer wind last year and ate everything but the mortgage. Seems they were fixing to eat us right out of our land. Well, here we are. Takes more than grasshoppers to move me and Jake off *this* land, *much* more.[1]

Few other staff, volunteers, or visitors have memorized museum-produced text, much less text that has disappeared into the archives for twenty years. But Drayton is African American, as is the anonymous pioneer woman. To be included finally in the West's heroic story of challenge and perseverance in a new land—particularly, perhaps, for a member of the baby boom generation—made an indelible impression. Drayton describes the holographic homesteader's fifty seconds in museum space as having been a much-needed counterpoint to the Manifest Destiny imagery of the John Gast painting *American Progress* (see fig. 6.2), where the destiny is all too white. For Drayton and others this elicited a sense that "we were part of this too."

No silver lining glimmers in African American history without its cloud.[2] The museum opened in 1988, just as high-profile revisions of the story of the American frontier began

to take hold. Patricia Nelson Limerick's *The Legacy of Conquest* appeared in 1987, and the revisionist art exhibition *The West as America* opened at the Smithsonian in 1991. Counter-histories had been growing in academia and in popular culture for a long time, but by the 1990s the revised story had become the main one, at least among scholars and younger audiences. The Autry appeared to split the difference, developing collections and a heroic tone associated with pre-revisionist history but including voices like that of the African American homesteader in the museum's video.[3] Now that a museum finally acknowledged black western histories, the complications of "conquest" would shadow the glory of emancipation in the region, an emancipation already diminished by discrimination. In black Western films, both of these themes limit the possibilities for liberation in the West.

In the epigraph to this chapter, James Baldwin describes his awakening to race in America as a black child. Baldwin was arguing for the proposition that "the American Dream is at the expense of the American Negro" before the Cambridge University debating society in 1965. In his shorthand, Gary Cooper, a movie cowboy, stood for the American Dream, for white America, and indeed for European-derived peoples and structures around the world subjugating the racial other, represented by the Indians. Baldwin's audience of young British men and women chuckled at the movie reference, but Baldwin then articulated the devastating meaning of these moving pictures and popular portrayals: "It comes as a great shock to discover that the country which is your birthplace and to which you owe your life and your identity has not in its whole system of reality evolved any place for you."[4]

An indictment of American racism, yes, but folded inside it lay an indictment of the Western. From around the time of this mid-sixties observation, some Westerns themselves began to contend with race and other social problems, and the revisionist trend in the genre anticipated the revisionism in scholarship. Cowboy heroes grew a dark side; Indians grew more sympathetic. A black sheriff even appeared in the successful satire *Blazing Saddles* (1974).[5] Still, there remained (and remain) profound distortions in the "system of reality" of Westerns reflecting an American society whose default heroes and communities are white, whose creation story is one of white conquest. In Raoul Peck's 2017 documentary *I Am Not Your Negro*, stitching together many of Baldwin's thoughts on race, civil rights, and cinema, Baldwin mentions John Wayne three times and Gary Cooper twice.[6] For Baldwin, movie cowboys broadcast white supremacy, whether Cooper's comparatively innocent variety or Wayne's aggressive style—"a black man who sees the world the way John Wayne, for example, sees it would not be an eccentric patriot, but a raving maniac."[7] Only when Cooper and Wayne were passing from the scene did large-budget African American stories come to film;

in this environment the relationship between black and Native characters became something to grapple with.

Despite an undeniable colonial and white-supremacist core to the genre, a line of African American Western movies pushed persistently toward historical and narrative redress. In the twenty-first-century Western afterglow, it appears that these cumulatively achieved a certain success, such that a high-budget remake of *The Magnificent Seven* (2016) would star Denzel Washington in place of Yul Brynner and that two of Quentin Tarantino's post-Westerns could star black cowboy heroes without needing to scaffold their stories—as many earlier films did—with an insistence that black cowboy heroes could exist. At the same time, many of the earlier black Westerns have been forgotten and must continually be rediscovered to remind us that Washington, Jamie Foxx, and Samuel L. Jackson are part of a lineage that began long before the revisionist era in film or history.

The Homesteader, released in 1919, was the first film by Oscar Micheaux, who had several years earlier left Chicago and homesteaded in South Dakota and then published a novel, *The Conquest* (1913), based on his experiences. For Micheaux, the West was a place to outrun both racism and the vices of city life. *The Homesteader* is a lost film, but Micheaux's later reworking of similar migration themes, in *The Symbol of the Unconquered* (1920) and the talkie *The Exile* (1931), survive.[8] *The Exile* is no doubt the only South Dakota homestead movie whose plot turns on the coronation of Haile Selassie (Ras Tafari) in Ethiopia. You'll have to watch it to see how. The hero, biblically named Jean Baptiste, moves back to the land from the hedonistic, tuxedoed club world of Great Migration–era Chicago. Settling in South Dakota, he suits up like a park ranger rather than a farmer or a cowboy. Eventually Baptiste finds the right bride to help make the homestead bloom, with some racial melodrama along the way.[9] Micheaux created a regionalist western story that, much like the Autry Museum's 1988 gallery film, claimed a small plot in the drama of remaking the West. As a virtuous standout from the gambling and showgirls, Baptiste is remembered back in Chicago as "the Exile," but Micheaux seemed to argue that exile was really transcendence.

Stirring up conflict and adventure, some other early black Westerns evoked, intentionally or not, some of the threats African Americans sought to escape in the West (and in other Westerns). In 1921, the Norman Film Company pulled cowboy heroes into the "race" market, hiring Bill Pickett, the 101 Ranch Wild West Show star, to anchor *The Bull-Dogger* (1922) and *The Crimson Skull* (1922). Richard E. Norman, a white filmmaker who hustled up low-budget productions for the underserved market of black audiences at segregated movie theaters, thought he could find success in black Westerns. He followed a trail blazed by Micheaux,

Noble and George Johnson's Lincoln Motion Picture Company, and others. Norman set *The Crimson Skull* in the "fast growing All-Colored City of Boley, Oklahoma," where a gang of hood-wearing rustlers terrorizes the community. An opening title read, "'The Skull' so called from his make-up, had with his band of 'Hooded Terrors' sown mortal fear into the hearts of the less intrepid of the countryside."[10] The specter of hooded terrorists, even if they were "All-Colored" beneath their hoods, could not help but reference the Ku Klux Klan, which had in 1915 been glamorized and revived by racist epic *The Birth of a Nation*. The Skull's warning evoked lynching and vigilantism's mockery of justice: "Sheriff! . . . if you cross my path again—you shall suffer the verdict of the 'Crimson Skull.'"[11] Race Westerns continued into the singing cowboy era of the 1930s, most prominently in several features starring Herb Jeffries. In *The Bronze Buckaroo* (1939), a haunting detail in an otherwise classic B-Western plot (crooked landowner tries to coerce little landowner to sign over a ranch holding a gold mine) is that the villain, Buck Thorn, brands his victim, Joe, with a hot iron and threatens Joe's sister Betty with the same torture. Though villain and victims are again all free African Americans in an ahistorical West, the echo of slavery and racial terrorism rang at least faintly even in films that sought to move beyond that history.

What happened when it was not Gary Cooper but the African American actor Woody Strode killing the Indians? Arriving a generation after Herb Jeffries, amid the rise of the civil rights movement, John Ford's *Sergeant Rutledge* (1960) bore a strange relation to James Baldwin's later observations about the white supremacist system of reality as it developed in Western celluloid. The film built a black-white solidarity against Apaches on "breakout" from the prison camp where the army was holding them. In a court-martial, Ninth Cavalry sergeant Braxton Rutledge, played by Strode, stands trial as an innocent black man charged with the rape and murder of a young white woman in Arizona Territory in the 1880s. The film's frankness in raising the issue of false rape accusations against black men is one of its virtues. Yet, while the courtroom drama exposes and provisionally defeats an anti-black American culture, the hero is not Rutledge but his white legal savior, his Atticus Finch. Rutledge, however, becomes an action hero in Monument Valley flashbacks. The film's ballad, "Captain Buffalo," invents a larger-than-life Buffalo Soldier, who Strode embodies, compared explicitly to John Henry and Paul Bunyan. The film combated the specter of the black rapist but used the specter of the Indian savage to do so. It barely whispered of black-red solidarity. A dying fellow Ninth Cavalry soldier at one point gasps to Rutledge, "We are fools to fight the white man's war," to which Rutledge the demigod replies: "It ain't the white man's war; we are fighting to make us proud." Ford could evidently not imagine a black hero or interracial progress without

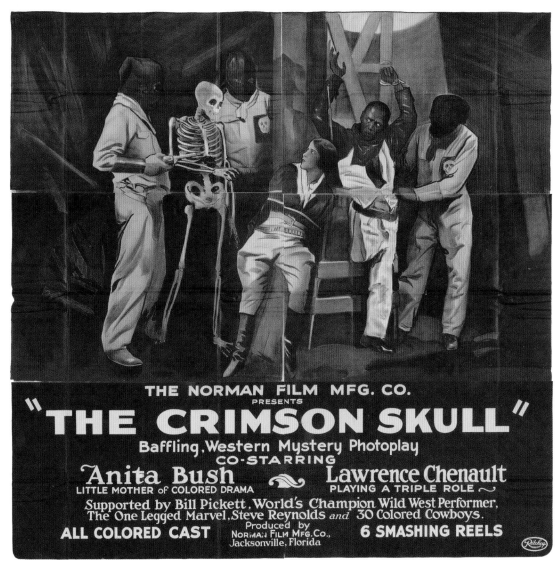

FIGURE 3.1. *The Crimson Skull*, six-sheet poster, 1922. Lithograph, 80 × 80 in. Autry Museum of the American West, 94.26.2.

a common enemy, and the enemy at hand was the faceless Indian. By pulling black folks to the Gary Cooper side (inverting James Baldwin's formulation that "the Indians were you"), *Sergeant Rutledge* might have given some African American viewers an Indian-fighter to cheer for. This was dubious progress. Whatever its virtues and flaws, the film did not perceptibly nudge John Ford's legacy, let alone an American system of reality.

It took ten more years and a black director, Sidney Poitier, to envision a different sort of solidarity. Poitier chose to frame his 1972 directorial debut, *Buck and the Preacher*, with onscreen historical text about the Exodusters, black migrants to the West after Reconstruction was betrayed in the South: "When the promise of land and freedom was not honored, many ex-slaves journeyed out of the land of bondage in search of new frontiers where they could be free at last." The character played by Poitier, Buck, is a wagon master helping a small black Louisiana community move west, negotiating with Indians and trying to evade whites hired by a planters' association back home. These villains threaten, rob, and even murder the Exodusters rather than allow them to topple a "whole way of life back there" (a whole system of reality) by yanking their labor out of its foundation. Night riders and terrorists historically did block the bulk of would-be emigrants for two more generations.[12] What is most satisfying in this film is that the dreamed-of solidarity between black and Native remains incomplete and compromised—the Indian chief does not forgive Buck his past as a Sergeant Rutledge (he is shown to be a former Buffalo Soldier), but realpolitik and business needs pull them together. Buck's claim that "his [the chief's] enemies are our enemies" may be true, but the film's tense black-Indian negotiation is a suggestive allegory. Solidarity within a history of colonialism and racism was and remains complicated. In an added complication, the titular Preacher, in an unrecognizably unhandsome character-acting performance by Harry Belafonte, only joins the wagon master's side after some suspense. And some white westerners in the film seemingly welcome their free-at-last black neighbors. The plot ties up cleanly, yet it leaves loose some of the tangled strands of freedom, opportunity, and colonialism in the actual and invented American West.

In a prelude to the 1993 movie *Posse*, Woody Strode appeared near the end of his life to deliver a monologue as a kind of Last Old Man Recalling the Frontier. The man begins with an old dude's comparison of a Colt .45 Peacemaker ("I haven't seen much peace it brought") with modern "pull the trigger and spray" guns. But he pivots to a critique of how history is told and retold: "One thing about time: no matter how much or how little passes, it changes things. People forget their past. They forget the truth." Strode's character shuffles some old photographs and continues, "But pictures don't lie. Forgotten gunslingers like Nat Love, Isom Dart,

Cherokee Bill. And troops too, like the Ninth and the Tenth. See, people forget that almost one out of every three cowboys was black. 'Cause when the slaves were freed, a lot of them headed out West, built their own towns. Shit. They didn't have much choice. In fact, over half the original settlers of Los Angeles were black. But for some reason, we never hear their stories."

Thanks to the entanglement of region and genre, a dearth of black histories of the West may be conflated with an absence of black Western movies. *Posse* knew this; it was *Posse*'s raison d'être, and it captured the spirit that Autry Museum staff sought in the museum's roughly

FIGURE 3.2. Prop advertisement from *Posse*, circa 1993. Paper, 15½ × 10¼ in. Gift of Catherine Hardwicke. Autry Museum of the American West, 93.24.22.

This artificially distressed prop "artifact" helped place African Americans in the historic as well as imagined West.

contemporaneous nine-minute holographic video. Strode's rumination flashes back to the tale of a made-up gunslinger by the name of Jessie Lee, played by the film's director, Mario Van Peebles.

Posse's plot is predictable enough. Suffice it to say that five pure-gold bullets find, one by one, the members of the lynch mob that killed Jessie's father and burned down the school in Freemanville. The film closes with the end of Woody Strode's story, revealed to be an interview that passes his knowledge along to two much younger black journalists. On-screen text reads, "Although ignored by Hollywood and most history books, the memory of the more than 8,000 Black cowboys that roamed the early West lives on." Hollywood and popular historians (see chapter 5), reflecting and reinforcing America's "whole system of reality," had ignored black experience, as James Baldwin had asserted in the sixties. *Posse*'s credits roll over film clips of black Western actor Herb Jeffries. This ending and the casting of Woody Strode, veteran not only of *Sergeant Rutledge* but also *The Man Who Shot Liberty Valance* (1962) and several other Westerns, lays claim to a tradition not only of nineteenth-century black westerners but also of twentieth-century black Westerns.

Film critic Vincent Canby concluded of *Buck and the Preacher*, "If they do nothing else, these new Soul Westerns may serve to desegregate our myths, which have always been out of the jurisdiction of the Supreme Court."[13] Soul Westerns were not really new, but they persistently performed slippery, unquantifiable work of forging new myths and systems of reality—beyond the laws, real estate covenants, and physical violence against black Americans. This black Western tradition, from Micheaux to Van Peebles and historic dramatizations at a museum, never grew to a legendary stature to rival John Wayne. (Wayne infamously said in 1971—a few years after James Baldwin made some of his cogent critiques of Westerns and the year before *Buck and the Preacher* made a damned fine effort at claiming a small bench in Wayne's big stagecoach—"I believe in white supremacy until the blacks are educated to a point of responsibility."[14]) In most black Westerns, the budgets were relatively low, the performances mixed, the tropes well worn. But the persistence of African American actors, writers, and directors mounting the horses that were supposed to belong to Cooper and Wayne, in an under-recognized tradition of bronze buckaroos, parallels the seemingly unsolvable but never hopeless history of race in America's system of reality.[15]

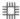

Postscript: How do we place the director Quentin Tarantino's work amid this history? A Gen-X John Ford, creator of epic genre spectacles, plumber of America's septic race relations, clever yarn spinner, Tarantino has made four Westerns by my liberal count: *Kill Bill* (in two

parts, 2003–4), *Django Unchained* (2012), *The Hateful Eight* (2015), and *Once upon a Time in Hollywood* (forthcoming). Much of the rest of his work is regionally western, set in Los Angeles. Tarantino's genre Westerns are crude, bloody, and brilliant. His two "race Westerns," *Django Unchained* and *The Hateful Eight*, may succeed where the rest of the tradition of black Westerns has not: film history will surely remember they existed. They are shocking and memorable, made by a white man with a cult of fans and critics, and provocative in their eager use of racial slurs and violence. *Django Unchained*'s revenge fantasy against slavery and white supremacy became a souped-up *Posse* that maybe only a white Hollywood darling could get made. *The Hateful Eight* deploys the allegorical premise of John Ford's *Stagecoach* (1939)—Union and Confederate veterans and other diverse Americans become confined together somewhere in the West to confront their differences—and pessimistically inverts Ford's hope that they can unite against the Apaches, instead showing a nation that will destroy itself, spraying quarts of fake blood to make Tarantino's point. A nation that largely forgot Oscar Micheaux, Bill Pickett, Herb Jeffries, Woody Strode, and Sidney Poitier's Buck virtually begged to be slapped across the face with Tarantino's nasty wit. Jamie Foxx, Kerry Washington, Samuel L. Jackson, and other African American actors have embodied the characters in Tarantino's Westerns with attitude and dignity.

Notably Tarantino has felt no need to add historical prologue or epilogue or an explicit protest against black invisibility in Westerns and western history. This no doubt reflects his own privilege to make his films independent of a need for historical redress. It also reflects the Western's atrophy from national metonym to antique genre. Tarantino's oeuvre is all about mashing-up and re-enlivening sclerotic formulas: *Kill Bill* is a Western cum martial arts flick; *Django Unchained* is a blaxploitation Western or "Southern"; *The Hateful Eight* is a Wyoming whodunit; *Once upon a Time in Hollywood* an urban spaghetti Western. One hopes that the absence of historical insistence—and the obvious fantasy—in Tarantino's films reflects a measure of success by earlier filmmakers and also historians in "desegregating our myths," whether or not viewers realize that Tarantino works in the tradition of less-well-remembered Westerns that preceded him.

4. ON *THE FRISCO KID*

One of my guiding lights in approaching the Western is a quote by Argentinean writer Jorge Luis Borges. In a 1966 interview, Borges said: "As to epic poetry or as to epic literature, rather . . . I think nowadays, while literary men seem to have neglected their epic duties, the epic has been saved for us, strangely enough, by the Westerns. . . . When I went to Paris, I felt I wanted to shock people, and when they asked me . . . , 'What kind of film do you like?' And I said, 'Candidly, what I most enjoy are the Westerns.' They were all Frenchmen; they fully agreed with me."[1] Borges spoke to a virtually universal appeal of the genre at that time—maybe especially for men but for many women too. The reason for that wide appeal may be, as he suggested, that these movies continued ancient literary traditions of heroes struggling and battling in a hostile or dangerous environment. This tradition of storytelling includes parts of the Hebrew Bible, Homer's *Odyssey*, the Old English epic *Beowulf*, novels like *Moby-Dick* and the *Lord of the Rings* trilogy, and similar traditions, ancient and new, from all over the world.

Not ancient but venerable enough is the tradition of the send-up epic, the buddy comedy. A hero and a sidekick embark on an adventure, and hijinks ensue. The friendship is tested, both seriously and ridiculously, and they emerge having learned lessons. Buddy comedies can be stupid but also profound—often at the same time. Probably the earliest and most famous example of this tradition is *The Ingenious Gentleman Don Quixote of La Mancha*, written in the early 1600s by Miguel de Cervantes Saavedra and perhaps the first modern novel. *Don Quixote* is among other things a satire of the romantic, epic literature of knights in shining armor: the hero loses sight of the distinction between romance and reality and sets out on a hilarious and delusional series of adventures, thinking he is a knight. He enlists a buddy, the farmer Sancho Panza, to be his sidekick and straight man and endeavors to revive chivalry in a fallen age. In many ways, that is what Borges said the Western did in the twentieth century—we might say quixotically. *The Frisco Kid* (1979), directed by Robert Aldrich and starring Gene Wilder and Harrison Ford, is an excellent example of this genre.

I recently watched, for the first time, the terrific film *Day of the Outlaw*, from 1959. It stars Robert Ryan as the hero Blaise Starrett, who must outwit and outlast a gang of bank

robbers who take over the town of Bitters, Wyoming. What is Starrett but a chivalrous knight on horseback, saving women and children from brutes led by Jack Bruhn (played by Burl Ives)? For all its power as a resurrection of the edge-of-your-seat epic, the film half-lost me in the end, when Blaise becomes superhuman and the story verges into true romanticism. It is in moments like this where even a brilliant and serious Western opens itself to parody as the literature of knights errant did four hundred years earlier. Don Quixote's adversaries famously include the windmills he tilts at with his lance, taking them for giants. Especially after World War II, the people who made Westerns began to take themselves more seriously, to elevate oaters to epics—making them ripe for send-up. Satire is often born from affection as much as criticism. Gary Cooper himself starred in a spoof, *Along Came Jones*, back in 1945, and in 1965 there was *Cat Ballou*. Maybe the most famous Western parody was the 1974 classic *Blazing Saddles*, featuring, among others, Gene Wilder.

The Frisco Kid, made five years later, satirizes and pays homage to the Western in some of the same ways as Mel Brooks's *Blazing Saddles*. It is full of blatant anachronisms and historical inaccuracies that reveal how even self-important Westerns have created a pastiche of history. It uses ethnic humor to shake up the way Westerns typically elevated white Anglo-Saxon Protestant heroes in what was always a multiethnic region. But it is not a Mel Brooks movie. What distinguishes Aldrich's *The Frisco Kid* from Brooks's twelve-jokes-a-minute, madcap style is the dramatic narrative of the buddy comedy—that is, the trope of Don Quixote and Sancho Panza, Gene Autry and Smiley Burnette, Butch Cassidy and the Sundance Kid, Thelma and Louise, *Dumb and Dumber*, and Victor Joseph and Thomas Builds-the-Fire (see chapter 5). Wilder stars as a guileless Polish rabbi, Avram Belinski, seeking to reach his newly assigned congregation in San Francisco in 1850. He befriends an outlaw, Tommy Lillard, played by Ford, as they traverse the continent. The film falls well short of being a masterpiece—for one thing, it drags on, scene after scene, in a picaresque that does not fill out its length the way *Don Quixote* does. But it's a warm portrayal of friendship, of America, and it's an opportunity to reflect on our history, both of the era in which it is set and the one in which it was made.[2]

Gene Wilder and Harrison Ford were both huge stars at the time *The Frisco Kid* came out. By the time he played Rabbi Belinski, Wilder had already starred as Willy Wonka—who shrinks the Western-wild, cap-gun-toting Arizona brat Mike Teavee to a few inches tall—as well as appearing in *Young Frankenstein* and *Blazing Saddles*. He had appeared in one comedy with Richard Pryor, but their classic buddy comedies were a still couple of years in the future. For his part, Ford had already appeared as Han Solo in a certain intergalactic Western two

years earlier, a film that demonstrated how the epic literary tradition that Borges discerned in Westerns would blast off for lands far, far away in the next few decades. If Borges were alive today, he'd probably be a great fan of *Star Wars* and superhero movies, like other global fans whose grandparents loved Westerns so much.

But what about 1850, when *The Frisco Kid* is set? Of course, the movie shreds history like a russet potato and fries it into latkes. It is little less brazen than *Blazing Saddles*, but it abounds in anachronism, beginning with the fact that Poland as a nation didn't exist in 1850, despite the opening scenes taking place there. There are 1880s-style frontier towns on the way to Gold Rush San Francisco, a silent Trappist monastery where there were none, and so on. Partly this is a result of sloppiness and the fact that the film used the default movie ranches, but mostly it seems intentional. Even though I'm a historian I was able to roll with it. The fantasy West didn't need to be historically authentic until very recently.

That said, the premise of a San Francisco synagogue is actually accurate. The Western States Jewish History Association—whose quarterly journal dates to about a decade before this film—reports that a congregation began to meet in Frisco in 1849 and that about three thousand Jews lived there by the 1850s. In fact, Jewish history in what we now call the US West goes back hundreds of years before the United States existed. Spanish Jews who had formally agreed to convert to Catholicism during the Inquisition moved to what is now New Mexico by around the time of Don Quixote. Certain Hispano Catholics lit candles on Friday nights and engraved Stars of David in their cemeteries. When much greater numbers of newcomers began to populate the West in the nineteenth century, a substantial number of Jews traveled among them.[3] By introducing a Jewish story into the fantasy West, this movie adds an element of historical accuracy that was missing in nearly all other Westerns. (The 1931 and 1960 versions of the film *Cimarron*, based on a novel by Edna Ferber, both include a Jewish peddler named Sol Levy.) Even beyond its specifically Jewish context, it hints broadly at a slightly more accurate multiethnic West—prefiguring, in farcical style, a historical borderland or "middle ground" of uneasy negotiation and alliances in places like the West.[4]

In the context of the 1970s, *The Frisco Kid* represents the beginning of the era of identity politics, and it demonstrates openness to joking around with ethnicity that was less careful than in times since. The film floats plenty of stereotypes, some quite unfortunate, but most of them are there to be burst. In playing with Jewish identity and cowboy identity, the film recalls a country-western masterpiece from 1974, by the singer Kinky Friedman, with his band the Texas Jewboys. In the song "They Ain't Makin' Jews Like Jesus Anymore," the

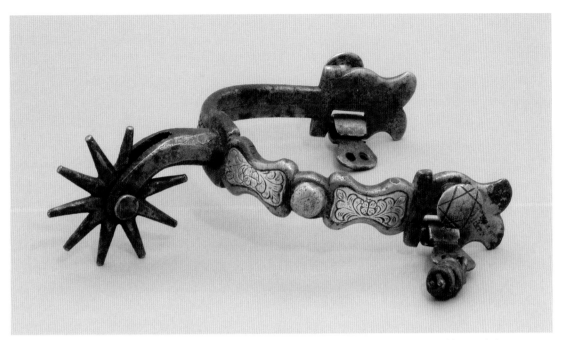

FIGURE 4.1. California-style dress spurs with full-drop shank and ten-point rowel, outer spur buttons engraved with the Star of David, made by H. Messing and Son, circa 1890. Iron, silver, nickel, 1⅞ × 4⅜ × 5¾ in. Autry Museum of the American West, 97.162.38.

protagonist beats up a "redneck nerd" in a Texas bar, singing, "We don't turn the other cheek the way we done before." For both Kinky and Rabbi Belinski, it remained a powerful gesture to claim the cowboy mantle in the face of ongoing anti-Semitism or narrow conceptions of Americanism. In the 1970s, they could cowboy and swagger with irony and evidently little fear.

5. HISTORY AS GENRE LITERATURE

Most people who have read a bit of western American history are familiar with Frederick Jackson Turner's frontier thesis of 1893: that "the advance of American settlement westward" into "free land" was the basis of the nation's exceptional, individualist, democratic, go-get-'em character.[1] With each leap to a new line of longitude, the multi-stage evolution of Anglo-Saxon culture from primitive to civilized continued, and the regular injection of frontier freedom into the greater body politic kept the nation fresh and industrious. Turner's famous essay is relatively short and sweeping, leaving the details of the process to future historians. Many have rejected or drastically altered the premise. But one who most avidly tended Turner's frontier furrows was his student Ray Allen Billington. In fact,

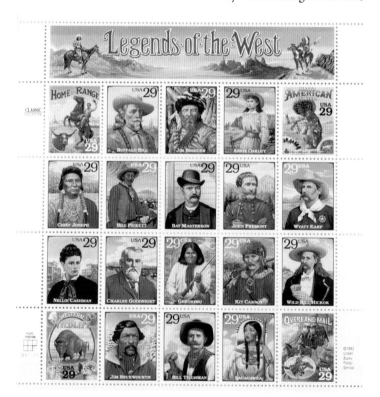

FIGURE 5.1. *Legends of the West: A Collection of U.S. Commemorative Stamps,* United States Postal Service, 1993. Postage stamps, 8¼ × 7¾ in). Gift of Mr. Peter and Mrs. Patricia Meursinge. Autry Museum of the American West; 95.60.1.

This stamp series largely followed the outlines of history established by the likes of Ray Allen Billington, with a 1990s-era attempt to include token gender and ethnic diversity.

Billington revitalized this stretch of terrain, which professional historians had buried in the 1930s and '40s. Billington championed what "new western historian" Patricia Nelson Limerick dubbed the "Restored Old Western History," in part by harnessing the power of Western genre literature.[2]

Billington's *The Far Western Frontier: 1830–1860* was published in 1956, more or less at the zenith of the Western genre. Its narrative history synthesized scholarship in regional historical journals and books plus published memoirs and letters of people involved in the Anglo-American exploration and conquest of the nineteenth-century Far West (the region of the present-day United States from the Great Plains to the West Coast). Billington acknowledged that Turner's claim that frontier development explained American history was too simple, saying that "a variety of factors" certainly shaped the nation. Yet he set out in his preface to prove the frontier thesis, adapted into a kind of environmental determinism. "Did trappers who sought wealth along the swift-flowing beaver streams of the Rockies respond differently to their wilderness world than the miners who panned the gold-bearing creeks of California's Mother Lode country?" he asked. "If the record shows that each band of frontiersmen responded in its own way to the strange new world of the Far West, a fragment of evidence has been produced in support of the 'frontier hypothesis.'"[3] Well, no. Turner hypothesized a uniform process of "rebirth" at the singular "meeting point between savagery and civilization," and Billington did too. Showing a different experience in each place, taking into account the differing origins of migrants and different reasons for migration—missionary, mercenary, or refugee—and perhaps even considering the points of view of people already living in those places would seem the obvious way to write such a book. But it would not necessarily vindicate Turner. Billington's far western frontier was uniformly "corrosive" to culture, from the wet Willamette Valley to Mormon Utah to gold-rush California, Colorado, and Nevada.[4] Every horror along the way, from genocidal forty-niner mobs to Donner anthropophagy, was attributed to the corrosive "environment," vaguely defined. And all of it set the stage, paved the way, prepared grounds for a new "civilization." Billington became more Turnerian than Turner, and, as Limerick later put it, showcased "considerable skill in contradicting himself with tranquility."[5]

The list of Billington's offenses against present-day scholarly sensibilities is a long one. Indians ("red men," as he usually called them) were scarce, rarely designated by tribe, and never by individual name. This book was exactly the type of history the anthropologist and ethnohistorian Anthony F. C. Wallace criticized in the early 1990s, in which "Native Americans appear only briefly as tiny blips on the screen of nineteenth-century history,

unfriendly but fortunately feeble opponents of . . . the inevitable march of the redeemer nation to the Pacific."[6] Often Indians struck like wolves or rattlesnakes out of nowhere in the natural environment, with no motivation other than blood thirst. Mexican Californios, another non-Anglo group, were "self-centered," wrote Billington, wore "barbaric costumes" that "rivaled the plumage of tropical birds," and lived for "the pursuit of bodily pleasures."[7] Similarly, in Texas, where "Spanish, and hence Mexican, civilization stemmed from that of ancient Rome" and thus fostered "blind obedience to state and church"—somehow the frontier didn't corrode that!—the hidebound Latin society was no match for Anglo individualism.[8] Slavery appeared hardly at all in Billington's account. Women were invisible, though in one particularly odious passage fur trappers were said to have "indulged in sexual orgies with passively indifferent Indian maidens."[9] Capitalism and eastern capital were deemphasized in favor of fleeting, romantic moments or characters like mountain men, gold panners, and Pony Express riders. He never followed the money.

Perhaps the book's most pervasive fault was its sense of inevitability. "If anything in history approached an irresistible force," Billington wrote, "it was the pioneer who had learned that fertile fields to the west awaited his plow." Or: "War with Mexico followed America's expansionist spree as inevitably as night follows day." Or a spoiler from the very first paragraph: "The outcome was never in doubt. The conflict ended with the triumphant American frontiersmen planting their flag—and their crops—on the blue Pacific's shores, the conquered continent behind them."[10] Billington exalted individual heroes and heroic feats, but it was unclear whether they really mattered. While close calls and cases of "might have been otherwise" abounded in a harsh landscape with rival cultures duking it out over scarce resources, the larger story for Billington was predestined.

With all these flaws, why not just let Billington's pages turn brittle? His book is virtually useless as a realistic view of history. One answer is that Billington provides insight into the Western's broad reach at mid-century. His *Far Western Frontier* and its pious devotion to the frontier was influential, and it was published at the time that Westerns were breeding like jackalopes—and overpopulating pulp racks and the silver and blue screens, just four years before John F. Kennedy labeled his progressive agenda the New Frontier. The long-evolving myths and symbols of the West were riding high.[11] In addition to being scholars, historians are writers, readers, and retailers of a sort, and it is worth considering the ways histories succeed by rhyming with or reinforcing fictions and other popular conversations of their eras. We may read with dismay the way a respected historian gave a kind of certificate of authenticity to what should have been indefensible ideas.

Yet it is refreshing to read a work of academic history that is as populist and engaging as Billington's. Like a good adventure novel, *The Far Western Frontier* pumps along forcefully. Here is a characteristic example: "John A. Sutter was a rotund little man who mixed bluff, deceit, and ability to a remarkable degree. When he fled his native Switzerland to escape a bankruptcy warrant in 1834, his pockets were empty but his head was jammed with grandiose plans. In New York, his glib tongue won him the friendship of numerous prominent persons who were too impressed with his tales of a noble background to inquire into his antecedents."[12] Overwritten, sure, but with a sense of humor. Despite the heavy-handed argument that reappears once per chapter or so, the book is not sluggish with analysis. Billington's journalistic chops come through—he uses journalism's brisk prose, if not its fact-checking—as does his openness to engaging the wider public with history. As the first president of the Western History Association, Billington welcomed amateur historians and buffs into the organization, and he was responsible for its publishing a popular magazine as well as a scholarly journal. He also served as president of the Organization of American Historians and the American Studies Association.[13] His outreach shines through his prose. Historians who wish to engage with popular audiences must use some of these techniques, even as they weigh the sacrifices they might make to popular prejudices and indeed to truth.

As Billington seemed to draw on the strengths of genre literature, contemporary genre writers plunged elbow deep into the gearbox of history. Henry Wilson Allen, one of the paragons of the Western novelist in the 1950s, '60s, and '70s under the names Will Henry and Clay Fisher, published several novels during Billington's time that drew on historical figures and events. *Who Rides with Wyatt* (1955) built on the Earp myth in Tombstone, Arizona; *Yellowstone Kelly* (1957) dramatized the life of the Montana frontiersman Luther "Yellowstone" Kelly; *From Where the Sun Now Stands* (1960) depicted Chief Joseph and the Nez Perce nation's struggle for independence in the 1870s; and many other novels followed suit.

A later Will Henry book, *I, Tom Horn* (1975), is exemplary of how such fiction engaged with historical practice. The novel purports to be a death-row memoir by the cowboy and hired gun Tom Horn as he awaits the gallows in Cheyenne, Wyoming, in 1903. A young friend of Horn's has ostensibly preserved Horn's vindicating account in a tin box in a remote cabin and then passed it on, just before dying in the 1970s, to a Wyoming boy who has become a Los Angeles lawyer. (Henry Wilson Allen wrote his novels in an old cabin behind his family's house in suburban Encino, California—see fig. 5.2.) The prologue to *I, Tom Horn* indicates, "It is not history, surely. It is only a fable, a Green River folklore stirred to that larger life named legend." Then it casts doubt on the doubt by mentioning the "stench of

FIGURE 5.2. Novelist Henry Wilson Allen in his writing cabin in Encino, California. Allen's family donated his typewriter, desk, coffee pot, and many other contents of his cabin to the Autry Museum in 2016. Image courtesy of the Allen family.

gun smoke" on the tin box.[14] In the novel, Horn's account ends with a dream of breaking out of jail the night before his execution, and then an epilogue questions whether Horn could actually have had the "grit" to pen his manuscript on the morning of his hanging. "Who is to say?" the omniscient narrator then asks. "Not the historians certainly. They only know what they read and they will never read this."[15] Allen immersed himself in history, and in *I, Tom Horn* he included a historical framing story and the faux academic apparatus of an "errata" section at the end. But he seemed to suggest that historians miss something while penned in their reality-based community, which by the 1970s was increasingly becoming a buzz kill for Old West enthusiasts. For the latter, Allen mastered Western wordsmithery, tying tight-yanked prose ropes with knotty verbs. Allen's Tom Horn writes of newspapermen with "double-hung tongues": "They will shrink a thing up to nothing when it's the truth, blow it up like a dead steer's belly when they've invented their own private history for the front page; the bastards."[16]

Ray Allen Billington retained some of this color and character in history books including

The Far Western Frontier. He also shrunk and blew up steer-belly details to support his style and ideology. As for the frontier thesis, it haunts any history of the West to this day. "Turner presides over western history like a Holy Ghost," historian Donald Worster has written.[17] Whether they adapt the thesis as an ecological-economic-cultural process or see it as a progression from inter-empire borderlands to nation-state "bordered lands," some historians continue to return to some version of a frontier progression to depict the nineteenth-century West, despite a quarter-century of anti-Turnerian "new western history."[18] The question remains whether the frontier theory endures because a grain of truth rests in it or because it gives intellectual legitimization to images of the western past first popularized by the likes of Buffalo Bill Cody, who was performing in Chicago at the same time Turner debuted his thesis. Theodore Roosevelt praised Turner in a personal letter for putting "into definite shape a good deal of thought that has been floating around rather loosely."[19] Floating around loosely, often, in fiction and popular entertainment. Turner's 1920 analysis—"The Indian was a common danger, demanding united action"—describes the essence of John Ford's *Stagecoach* (1939).[20] Billington saw Turner's bids and raised them, typing a macho caricature, a John Ford reading of the early-nineteenth-century West.

The storybook histories, which *feel* true to so many, have been difficult to root out. This has become clearer to me while working at a western history museum. Since the revisionist new western history rose to prominence in the 1980s, some observers, often political conservatives, have longed for older, heroic histories. Lynne Cheney, a literary scholar and the wife of politician Dick Cheney, wrote of the need for history filled with "the magic of myths, fables, and tales of heroes" that help us "feel part of a common undertaking"—"no matter how diverse our backgrounds."[21] Novelist Larry McMurtry, not so conservative, similarly invoked the parable of Don Quixote. In the end, without his chivalrous fancies to carry him, Alonso Quijano (Don Quixote) soon dies.[22] There is a real question whether less heroic histories can attract comparable enthusiasm from audiences without graduate degrees in history.[23] While I have joined in a seminar's ransacking of storybooks and certainly have misgivings about the myths, fables, and tales of heroes such as Billy the Kid and Wild Bill Hickock, I too regret the void their absence leaves for a widely shared culture. But I cannot buy into tumbleweed heroes or caped crusaders.

Can we imagine a legion of page-turners based on our own era's brilliant western histories? Think of Tiya Miles's *Ties That Bind*, recounting the complicated interlocking processes of colonialism and slavery in an Afro-Cherokee family; Richard White's *Railroaded*, explaining the crony capitalism and deal-making in the construction of the transcontinental railways;

Andrew Needham's *Power Lines*, linking the growth of Phoenix to energy extraction on the Navajo Nation.[24] All of these histories cross frontiers of East and West and race and ethnicity in ways that might appeal to audiences in our boundary-crossing times. But their reach is vastly more limited than Turner's or Billington's was. Some new western historians (e.g., Patricia Nelson Limerick and Elliott West) write lively prose that is accessible to non-specialists. But historians generally seem to write for each other, as Will Henry suggested. Many do maintain a focus on a cast of humble protagonists rather than attributing historical change to great men, great forces, or great ideas.[25] But few cross over to popular literature, much less best-seller status.

Billington's work still raises a number of questions for twenty-first-century historians. For example, could the past really have unfolded very differently than it did? Maybe some things, like greedy scrambles for natural resources, are almost inevitable. Are we too committed to our own universal frameworks? Do we impose new theoretical frames (such as "settler colonialism," the inverse of the "frontier") on the past as awkwardly as Billington imposed his theory of the environment "corroding" culture? Has American history really evolved, frontier-like, beyond boosterism and a Billingtonesque exclusion of groups like "red men"? Perhaps most crucially, is our writing too sober, too boring? Can we learn something from Billington and adopt the strengths of today's popular historical fiction and film to share new historical scholarship more widely? Fables and tales are now almost too easy to tear down, and I wonder if we can make a future for history that captures readers' imaginations the way genre literature can.

part two

NATIVE WESTS

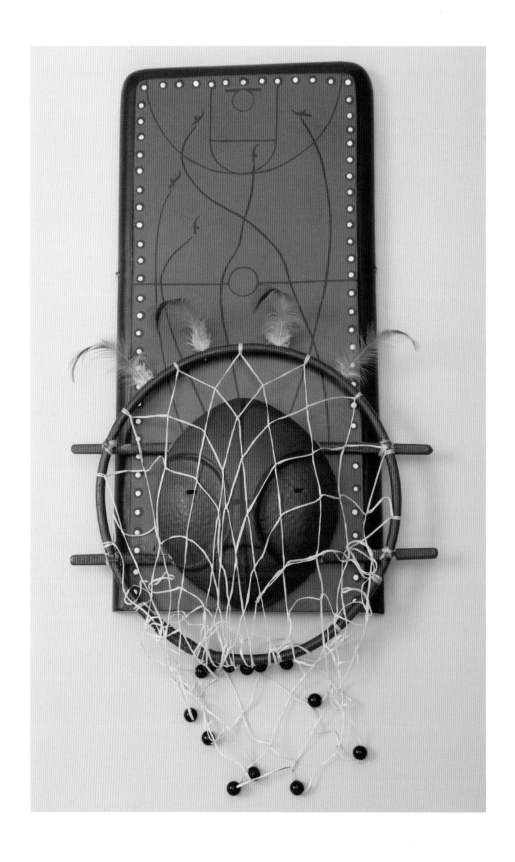

6. HISTORICAL ANGELS
On Smoke Signals *as a Western*

One of the most popular images from the nineteenth-century American West is John Gast's 1872 painting *American Progress*. It stars a kind of technological angel floating above the westward expansion of the United States, garlanding the landscape behind her with telegraph wires and leading the way for railroad tracks. Bison and Indians flee before her. Many Autry Museum visitors who have seen the painting reproduced in textbooks and history teachers' PowerPoints are shocked to see that the real thing measures less than 12 by 16 inches. Such an epic—shouldn't it be 12 by 16 feet? But in a mass media age, already well underway in 1872 thanks to printing technology and widely circulated magazines, an image didn't need to dominate a room to exert great cultural influence. Being reproducible as an engraving mattered more. Telling a culturally useful, memorable story that was easily "shared" (in today's phrasing) mattered most. Most nineteenth-century viewers encountered this image as an engraved, mass-produced image.

Scholars have dissected and deconstructed the image of "the Indian" in American mass culture. To say simply that Native people have been caricatured and fantastically invented, often irrespective of reality, is like pointing out, "Hey, look, there's the Grand Canyon." If you missed it, you weren't looking. There are strata to examine more closely—how did "the Indian" change in the ages of late-nineteenth-century imperialism, of mass immigration, the Cold War, and the sixties counterculture? Thinking of 1872, the recent completion of the first transcontinental rail line, the urge to unite North and South in a shared westward-moving imperial project, and bloody ongoing wars against Indians in the actual West—these particulars seem to inspire the tiny figures of stooping, cowering Indians in *American Progress*. The adaptation of Gast's painting that appears as an engraving in George Croffut's 1888 *New Overland Tourist and Pacific Coast Guide*, itself only a little smaller than the painting, makes the details of the

FIGURE 6.1. Jerry Laktonen (Alutiiq), *Dunqiiq*, 2011. Wood, paint, feathers, string, glass beads, 21 × 8 × 1 in. Gift of Monica Jane Wyatt. Autry Museum of the American West. 2013.37.1.

Laktonen points out that Alutiiq masks have long used hoops to symbolize "entering the spirit world" and that their three-section design is echoed in a basketball's lines. "As the old ones seemed to have pictures telling a story," he says, "it seemed a natural canvas to show a basketball play." His daughter, April Laktonen Counceller, PhD, an Alutiiq language specialist, helped develop the title *Dunqiiq*, meaning "dunk-it."

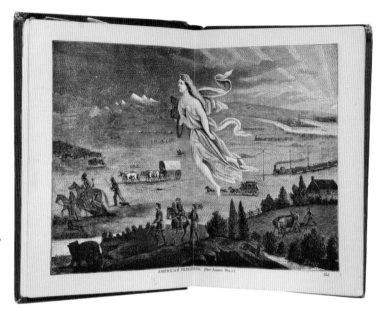

FIGURE 6.2. Frontispiece illustration engraved by Bross, New York, after John Gast's painting *American Progress*, in George A. Crofutt, *New Overland Tourist and Pacific Coast Guide* (Omaha: Overland, 1882). Print on paper, cloth binding, 8 × 5⅝ × 1⅛ in. Rosenstock Collection, Autry Library, Autry Museum of the American West, 90.253.126.

Indians irrelevant (see fig. 6.2). It is the Indians' small size and their trajectory toward the far edge of the continent that seem important.

Until very recently, the imagery that Native people themselves have produced has been less interesting to historians than how popular images of Indians have changed. Few Native artists, writers, or filmmakers gained the kind of distribution that spread *American Progress* or *Stagecoach*. But scholars have come to recognize sophisticated and compelling Native mass media in the Pequot minister William Apess's political and religious tracts, the *Cherokee Phoenix* newspaper of the 1830s, Edwin Carewe's silent films of the 1920s, and Native hip-hop, country, metal, or round-dance artists today.[1] Still, the number of people reached by American Indian artists and media producers over time is vastly asymmetrical to the massive number who have consumed non-Native caricatures of American Indians in literature, art, film, and other media.

After the silent film era of Native directors like Edwin Carewe (Chickasaw) and James Young Deer (Nanticoke) and actress Red Wing, born Lillian St. Cyr (Winnebago/Ho-Chunk), Native creators were never able to make a widely popular movie again before 1998, when a surprise hit film appeared: *Smoke Signals*. This was the first major movie directed by, produced by, written by, and starring North American Indigenous people. As central as Indians have been to American history, identity, and film—particularly in the

Western genre—it's astonishing that it took until the final moments of the twentieth century for a movie like this one to appear. The film was a kind of buzzer-beater in the basketball game of the cinematic century, as if one of those tiny Indians in the Gast painting had sunk an off-balance, half-court shot against the covered wagons, the railroads, and the angel of progress.

If you haven't seen *Smoke Signals*, the basketball analogy may seem strange. But one of the movie's great scenes involves a bruising two-on-two game in which a Coeur d'Alene Indian father and son scrimmage two Jesuit missionaries, with American colonialism weighing on every dribble. The sport is widely popular across Indian Country, as evident in Alutiiq artist Jerry Laktonen's sculpture *Dunqiiq* (see fig. 6.1), the title of which, he says, was an Alutiiq-language coinage based on the phrase "Dunk it."

The team that launched *Smoke Signals* was led by director Chris Eyre, a member of the Cheyenne and Arapaho Tribes in Oklahoma, who has now become an elder statesman of Native cinema. Screenwriter Sherman Alexie—Coeur d'Alene, like most of the characters in the movie, and among the most successful Native writers of the past thirty years—based the screenplay on *The Lone Ranger and Tonto Fistfight in Heaven*, his 1993 book of linked stories. (As of this writing, Alexie has dropped from public view after 2018 allegations that he abused his stature and sexually harassed several women. It remains to be seen how this downfall will change his artistic legacy.)

In 1998, Alexie described the movie as "a very basic story, a road trip/buddy movie about a lost father." He observed that both the buddy movie and lost-father story can be found "in everything from the *Bible* to *The Iliad* and *The Odyssey*. What is revolutionary or groundbreaking about the film is that the characters in it are Indians, and they're fully realized human beings."[2] The buddies slot into the typical categories of the tough guy and the oddball, the jock and the nerd. Victor Joseph is a closed-off basketball stud on the Coeur d'Alene Indian Reservation in Idaho, played by Adam Beach (from the Salteaux First Nation in Manitoba), who has since gone on to become one of the most successful Native actors in Hollywood. Thomas Builds-the-Fire is a more unexpected and memorable character, a weakling oracle and storyteller whose talents lie somewhere between poetry and bullshit. Builds-the-Fire is played by Evan Adams (Coast Salish from the Tla'amin Nation in British Columbia), now a prominent physician in Indigenous public health in Canada in addition to his artistic pursuits. Some more seasoned Native actors fill out the cast: Gary Farmer (Cayuga), Irene Bedard (Inupiat/Cree/Yupik/Inuit), and Tantoo Cardinal (Métis). One has to wonder if the mostly Canadian First Nations heritage of the cast reflects a national

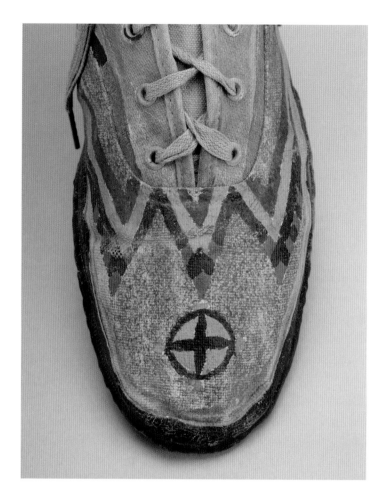

FIGURE 6.3. Unidentified artist, canvas tennis shoes, date unknown. Mixed media, 4¾ × 10½ × 3½ in. Southwest Museum of the American Indian Collection, Autry Museum of the American West, 2077.G.2AB.

Richard Davis Thunderbird (Northern Cheyenne, 1866–1946) was an actor and adviser on Hollywood films in the 1920s through the 1940s, and his home in Pasadena served as a hub for the Los Angeles Native community. His archives, donated to the Southwest Museum, included these sneakers painted to resemble beadwork.

difference in opportunities and training for Native actors and artists during the 1970s and '80s, but that is a subject for another time.

I would be remiss not to mention the Sundance Institute, which had begun supporting Native cinema several years before *Smoke Signals* came out. Films are expensive, and Indian Country suffers greatly for lack of outside investment in services much more basic than film-making. Even a low-budget independent movie like *Smoke Signals* would probably have been impossible to produce and distribute without some philanthropic support.

Is *Smoke Signals* a Western? In some senses, it is certainly not. To the extent that Westerns must take place in a mythic place called the West, which is by definition a lost world in the past, any story set in the twentieth century in the real world cannot be a true Western.

An Indian playing basketball tears down the facade of the orthodox Western, in which Indians are always on the verge of vanishing. And, after all, how could it be a Western, when not a single gun is fired in *Smoke Signals*? Stetsons, kerchiefs, and Colts were moldering in trunks.

Yet the film could not escape being a Western. It is a western film in a regional sense, but it tends to move into the orbit of the Western genre, as do so many works about the West and as do many other examples in this book. Also, Westerns were pretty much the only venue for American Indians onscreen for much of film history, and by this logic, if a film had Indians in it, it was a Western. (Further, the shadow of all Native characters—whether a Florida Seminole or a Seneca from New York—was a Plains Indian in buckskin, riding horseback.) Not only Native people face such stereotyping. The Western genre has exerted such a powerful cultural influence that much of the West's landscape alludes to it. *Smoke Signals* includes swooping aerial shots of rushing northwestern rivers and red-rock deserts, landscapes that, like Indian people, are stock characters in many movies. If a film then adds shots of men in jeans and plaid shirts trudging on a dirt trail, carrying canteens, as in *Smoke Signals*, the reference is doubled.

Then come the particulars of the *Smoke Signals* plot. The movie plumbs the struggles of a fatherless young man, Victor, who sometimes glares or throws punches to avoid his pain. He is joined by offbeat sidekick Thomas, as they travel from Coeur d'Alene, Idaho, to Phoenix, Arizona, to bring home Victor's father's ashes. The exploration of a man's unspoken pain amid the echoes of a tragic past is not a uniquely Western story line, but set in this landscape, with American Indian protagonists, the linkage is unavoidable.

The filmmakers knew this, and the film parries it expertly. The title of Alexie's *The Lone Ranger and Tonto Fistfight in Heaven* demonstrates how he has seemed to relish playing off the genre. The film twice includes television sets playing Westerns in the background: once the film *Santa Fe Trail* (1940) and another time a stock army cavalry shot—it's unclear from which movie.[3] *Santa Fe Trail* stars Errol Flynn, and includes Ronald Reagan as one of the most hated and mocked historical figures across Indian Country, Lt. Col. George A. Custer. (Another *Smoke Signals* scene shows Victor dribbling a basketball to a powwow drumbeat and singing about driving down the basketball court where Custer was guarding him.) The 1990 Hollywood film *Dances with Wolves* comes in for fond mockery. Thomas is a compulsive fan of that epic about noble Indians and their white savior, and he watches the film again and again. As for cinematic views of Indians less sympathetic than *Dances with Wolves*, *Smoke Signals* treats the late John Wayne sharply too. Wayne told *Playboy* magazine in 1971, "I don't feel we did wrong in taking this great country away from them, if that's what you're asking.

Our so-called stealing of this country from them was just a matter of survival. There were great numbers of people who needed new land, and the Indians were selfishly trying to keep it for themselves."[4] Rather than rebut John Wayne, Victor and Thomas ridicule him. They bewilder a long-distance bus full of non-Indians with a 49 song—an example of a century-old genre of intertribal Indian music—"John Wayne's Teeth," that questions whether the Duke's chompers are even real: "Are they plastic? / Are they steel?"

In refuting the "vanishing race" myth, the film opted for a similar subversion. Any story about modern, young Native people subverts that myth. This was one of the film's great gifts to American cinema. It also repeatedly used the kind of humor that scholar James C. Scott has called a "weapon of the weak" to poke holes in romantic or false stereotypes. As with the song about John Wayne, the film didn't argue—it needled. Where it strained a little, where the filmmakers perhaps tried too hard, was in adding surplus jokes of this type, knowing this would be the only movie about present-day Native American life that many viewers would ever see. For example, a joke about how Indians hate to sign contracts due to a history of broken treaties seems shoehorned in, as does a quip about needing a passport and vaccinations to leave the reservation. Yet one of my favorite lines critiques the dearth of modern Native stories. Thomas tells one of his questionable, prolix stories about Victor's father beating up a photojournalist during a 1970s Red Power–era protest, and ends: "At first they charged him with attempted murder, but then they plea-bargained that down to assault with a deadly weapon, and then they plea-bargained that down to being an Indian in the twentieth century. Then he got two years in Walla Walla."

Returning finally to where we began, with the technological angel above the western plain, I want to close with one of the most powerful images in *Smoke Signals*. It is possible, but a mistake, to let this pass by with a light chuckle. One of the gags about reservation culture is the movie's "rez car" that only functions in reverse, so its drivers just cruise around as if that were no impediment, completely accustomed to moving backward. Rez cars are an old trope in Indian humor, and there's an old 49 song from before World War II called "One-Eyed Ford." But a car that travels only in reverse—this was a new twist on an old joke.

Cruising in reverse is a striking image for me as a western historian, because I take it as a critique of my own discipline and subject. Many of us (both historians and normal folks) tend to think history moves in a straight line at a regular pace, like a transcontinental railroad or a frontier advancing steadily from East to West or an imagined progression from Indian Country to Old West to suburban Los Angeles. Gast's angel in *American Progress* is the apotheosis of this model of history. Academic histories have pushed toward more complexity,

but many people still think of western history in this way.[5] Some observers see a downfall, a destruction of paradise, in the same process—the angel as demon—but they accept the same epic story line. In either case, it is hard to draw a line from these frontier models to a present day in which the descendants of those tiny fleeing Indians are more politically powerful than they have been in over a century and in which people indigenous to the Americas make up the majority of the population in some parts of the West.[6]

But to remain at an angelic, historiographical level, there are other ways to conceive of our histories. The German philosopher, writer, and historian Walter Benjamin offered a modernist's critique of a linear "continuum of time" or "universal history" in his essay "Theses on the Philosophy of History." In one passage, Benjamin described what he called the "angel of history":

> [The angel's] face is turned toward the past. Where we perceive a chain of events, he sees one single catastrophe which keeps piling wreckage upon wreckage and hurls it in front of his feet. The angel would like to stay, awaken the dead, and make whole what has been smashed. But a storm is blowing from Paradise; it has got caught in his wings with such violence that the angel can no longer close them. This storm irresistibly propels him into the future to which his back is turned, while the pile of debris before him grows skyward. This storm is what we call progress.[7]

This is not simply the fall-from-grace, nostalgic inversion of John Gast's "progress." But it does recognize the blood that's missing from the ground of Gast's image and the dread we ought to feel, at least in moments, when we look back in time. For Benjamin, the work of history was salvaging moments or flashes from the past rather than reconstructing a "true," overarching epic. He based his angel on a haunting print by Paul Klee, *Angelus Novus* (1920), a small piece like Gast's. This angel shadows my own mind when I see *American Progress*.

In the context of *Smoke Signals* and Indigenous history, the house fire that begins the film could stand in for the historical devastation survived by Native peoples, and the rez car driving forward in reverse while facing a history of wreckage is a homegrown angel of history. It is closer to Benjamin's angel than Gast's, but it transcends Benjamin's despair. (Benjamin wrote his "Theses" as a Jew in France in 1940, not long before committing suicide, having failed to emigrate.) For centuries, Native American historians have used annual markers such as winter counts or calendar sticks to aid in record keeping alongside oral traditions, but many American Indians have also employed other ideas of history including more cyclical or spiraling time, beliefs about a time before recorded history, and a conception of place as

more important than time in thinking of the past.[8] Sherman Alexie has spoken of the *Smoke Signals* car as representing "a sense of time . . . in which the past, present, and future are all the same, that circular sense of time which plays itself out in the seamless transitions from past to present."[9] The young women, Velma and Lucy, who pilot their rusty angel do so with a worldly sense of humor, the mood of the film in general. Velma pronounces Thomas's plea-bargain story, sardonically, as "a fine example of the oral tradition." These women are not innocent of "wreckage upon wreckage," but they don't seem to posit any grand conclusion—either destruction or transcendence—to the story of Coeur d'Alene or the West more broadly. They keep rolling onward, backward.

7. THE WONDERS OF LESLIE MARMON SILKO

Somewhere outside Tucson, there's a woman living in a house with space blankets tacked inside the windows, half a dozen mastiffs, a pit bull, a pet rattlesnake, a small flock of macaws (including a twenty-two-year-old named Sandino, with one leg—owl attack), an African gray parrot singing along to *Sesame Street*, and tables full of quartz and turquoise collected from the arroyos nearby. The woman paints canvases to help communicate with "Star Beings." She is Leslie Marmon Silko, best known for her 1977 novel *Ceremony*.

Here's a passage from *The Turquoise Ledge*, Silko's 2010 memoir of her life in Arizona, her only book in the twenty-first century so far: "If gravity is distributed in this Universe unevenly, then there are places here on Earth where the gravity is weaker or stronger, where even light may speed up or slow down. At a certain walking speed, my eyes received light images from a parallel plane. Parallel planes or worlds may be visible briefly at certain points in this world from time to time. Thus the discrepancies between my recollections and notes immediately after a walk and what I actually find when I attempt to locate those places again."[1] The book is built on an unsettling amalgam of science, poetry, and Laguna Pueblo and intertribal mythology that at first may seem batty. ("Unsettling" has many senses in the context of settler colonialism and Indigenous knowledge.) But it is an important testimony, and through it readers experience time and logic at least partly outside the linear, empirical, and imperialist Euro-American worldview. In Silko's writing, her encounters with animals, vegetables, and minerals around her become windows into what she calls these "parallel planes" of existence.

The Turquoise Ledge—it largely records a settled writer's life. A forty-five-page section on rattlesnakes lists scores of interactions with her serpentine neighbors and notes her thoughts on them. Equally long sections cover turquoise and Star Beings, deities that return to Earth every seven hundred to eight hundred years, and whose contempt for humans (and the wrath they will unleash upon us) Silko heralds. (Silko adapts her telling of Star Beings from a number of stories about stars that come to earth in Indigenous traditions of the Americas and Australia. Perhaps, she suggests, "we are their descendants.")[2] An undertone of menace rumbles throughout the book from an anonymous developer's bulldozers that threaten a nearby arroyo.

The Turquoise Ledge is not a book that obviously builds toward some conclusion, and it mostly lacks the quality of modern legend that is so compelling in Silko's fiction. But it allows a reader to inhabit a mind that lives and breathes in space rather than time, in myth rather than report. Theoretical critiques of linear history and narrative are legion, but how does one begin to *live* any other way? The rez car of history, discussed in the preceding chapter, is a genial and accessible metaphor—a trickster's critique of the underlying presumption that Walter Benjamin described as "historical progress . . . through a homogenous, empty time." The disjointed form of Benjamin's "Theses on the Philosophy of History" reflects the fact that for those of us steeped in European ideas of progress and truth, it is only possible to momentarily turn our backs against the storm of progress that pulls us, like the "angel of history," forward.[3] But how does one *practice* nonlinear time or nonempirical ontology?

Since Silko's first novel, *Ceremony*, she has considered this question. *Ceremony* is one of the most powerful modern American Indian works of literature, and it is part of the multicultural American canon. It follows a half-Laguna man who returns from World War II and tries to recover from shell shock (what we now call post-traumatic stress disorder) through a spiritual journey. The protagonist visits a modern medicine man whose hogan is full of phone books and Woolworth shopping bags in addition to desert herbs and animal hides. He visits the sordid Indian bars and shantytowns of Gallup, New Mexico, pursues some half-wild cattle, and has a sexual encounter with a supernatural woman, and all of this is melded into a moving, nonlinear, southwestern legend. As the protagonist begins to shed the skin of his shell shock, he abandons Euro-American time: "The ride into the mountain had branched into all directions of time. He knew then why the oldtimers could only speak of yesterday and tomorrow in terms of the present moment . . . and this present sense of being was qualified with bare hints of yesterday or tomorrow, by saying, 'I go up to the mountain yesterday or I go up to the mountain tomorrow.'"[4] Silko is connected to a tradition of nonlinear storytelling as well as to the Euro-American literary tradition, and she inhabits a landscape, the desert Southwest, where parallel planes of time and energy are apparent in the stratified rocks (millions of years visible at once) and where some locals make claims about "energy vortices." Her ideas don't seem as arid or impractical as philosophical theory. Nor are they easily disregarded as New Age hokum.

Silko's writing has a dreamlike or druggy quality. Its internal logic promises a new world, yet it sounds a bit odd when explained the next morning. On page 98 of *The Turquoise Ledge*, where Silko sees, four days after her mother's death in 2001, two "rain cloud blue" rattlesnakes

just fifty feet apart on the trails near her house and explains how those snakes are her mother's "human form and energy changed and joined with the silver blue light of the morning." When I was reading this, a dragonfly alighted on the cover of the book. It was a gorgeous day, and I was lying on my right side in the grass with the book propped sideways on the ground. The dragonfly landed on the thin edge of the book's cover, a turquoise cardboard ledge. The dragonfly was red, all hues of red. The head was brown, with a slight rusty tinge in the eyes; it twitched around, sensing invisible signs. The thorax was maroon-brown and furry. The abdomen was burgundy underneath with a shell of nail-polish red on top. Normally I would have thoughtlessly brushed such a beast away, but I paused for a minute or two to watch it, noting the copper gleam to its legs and its steady patience.

What if one were to live so attentively all the time?

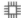

Silko was born in Albuquerque in 1948—"the year of the supernova in the Mixed Spiral galaxy" and "the Year of the Rat," she tells us in a typical cultural mash-up—and grew up at the edge of Laguna Pueblo.[5] She was formally educated in Albuquerque (including a degree from the University of New Mexico). Her family roots are Laguna, European, Mexican American, and an unknown Texas Indian tribe, but having grown up at the edge of the pueblo she identifies with Laguna storytelling traditions most strongly. "My sense of narrative structure, of how a story needs to be told," she writes, "all of this came to me from the stories Aunt Alice, Aunt Susie and Grandpa Hank told me."[6] She also grew up alongside an intertribal activist movement that arose on reservations and among the large numbers of American Indians displaced from reservations to cities in the 1940s and '50s, either after returning from World War II or through federal efforts to relocate Native people from reservations and politically terminate their tribes. In 1969, the same year Silko published her first story, the movement became militant when the first Red Power activists took over Alcatraz Island in the name of Indians of All Tribes.

Also that year, a classic "Indian manifesto" was published: *Custer Died for Your Sins*, by the activist and scholar Vine Deloria Jr. (Dakota). Silko's work evolved alongside Deloria's, and her writing reflects the influence of his philosophical and religious thought. She eventually wrote a short foreword to the thirtieth anniversary edition of his 1972 book *God Is Red* and a blurb for *Red Earth, White Lies*, his 1995 critique of the Euro-American "myth of scientific fact."[7] In her foreword to *God Is Red*, Silko writes that Deloria "expressed what a great many of us Indians felt and thought" and that his importance "will be appreciated by future generations when U.S. history ceases to be fabricated for the glory of the white man."[8]

Deloria helped define a Native identity and worldview in modern, radical terms, and his scholarly work illuminates the method in Silko's art.

Deloria, who died in 2005, was a stylish and sometimes funny writer, the polemicist to Silko's poet, and many of his arguments are strong and appealing. The principal difference between Native and European thought, he wrote in *God Is Red*, is that American Indians privilege place in their perception of the world whereas Europeans privilege linear time. With Yankton Sioux, French, and English ancestors, an Episcopal missionary father (in South Dakota), and training as a Christian theologian, Deloria was as much a critic of Euro-American culture as an explicator of Indigenous cultures. Without a respect for the gravity of place, Deloria argued, European thought extrapolates from "the manifestation of deity in a particular local situation" to a universal truth that must be crammed down the throats of every-one on earth. He also contrasted the Judeo-Christian "alienation of nature and the world from human beings as a result of Adam's immediate postcreation act"—original sin—with Indian beliefs in which, for example, animals and even inanimate objects are included in the invocation "all my relations."[9] Later, as Euro-America became more secularized, science assumed the role of unquestionable, universal truth that Christianity once held. With *Red Earth, White Lies*, Deloria took on this new threat to Indian cosmology. Looking at science from the perspective of people who have again and again been its objects of study—implicitly subhuman, better suited to the natural history museum than the art museum—Deloria was wary. Every benefit of Euro-American knowledge has come with a shadow of death, theft, and exploitation, so it's not surprising that the whole enterprise could look like a big smallpox blanket.

Silko's work also engages white knowledge and its dismissal of Indigenous knowledge. Priests and science teachers repudiate Native "superstitions," sometimes brutally, and then science, economics, and religion appear in all their destructiveness. Silko is a self-described "down-winder," and uranium mining and nuclear tests—the dubious fruits of science—are recurring themes in her fiction and nonfiction. The ravages of World War II are the basis of *Ceremony*, and her most ambitious book, the 750-page strange and visionary epic novel *Almanac of the Dead* (1991), imagines a sordid end to the white man's era through organ-harvesting corporations, drug and arms trades, and Indigenous uprisings in Latin America. Yet its truths remain place-bound: in the novel, Tucson is the center of the world.

In *Red Earth, White Lies*—perhaps the scholarly counterpart to *Almanac of the Dead*—Deloria took his critiques in a more constructive and difficult direction. Rather than dismiss science as outside the realm of theology, Deloria combined bits of scientific data with traditions from across Indian Country. He argues that theories about Paleo-Indians migrating to

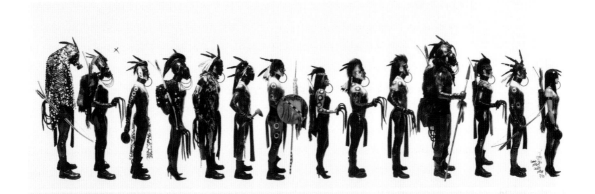

FIGURE 7.1. Virgil Ortiz (Cochiti Pueblo), *Venutian Soldiers, Lineup*, 2012. Dye coupler print (number 3 in an edition of 10), 10 × 30 in. Gift of Susan and Daniel Steinhauser. Autry Museum of the American West, 2017.1.1.

The series of which this work is a part, *Pueblo Revolt 1680/2180*, evokes a long time line, past and future, in Indigenous America and shares a futuristic, baroque spirit with Silko's *Almanac of the Dead*.

the Americas over the Bering Strait land bridge merely aim to portray Indians as "latecomers who had barely unpacked before Columbus came knocking on the door," in order to justify further land grabs.[10] Chains of logic lead from there to his own theories that giants in Indian legends are scientifically provable because of elevated carbon dioxide levels in ancient times. I sympathize with his suspicion of a scientific method that, while basically humble and self-questioning, has often been a rhetorical and literal weapon in service of genocide and land theft. And the deep ecological knowledge of place inherent in many Indigenous stories offers much to learn from in terms of land use.[11] Still, something in Deloria's later polemic seems to adopt the Euro-American universalizing tendency. Is quantifying the molecular components of air a "decolonial" way to prove a local story's veracity? Perhaps yes, perhaps no.

The *Turquoise Ledge* includes some similar amalgamations. Silko mentions offhandedly that in five hundred years everyone in the Americas will speak Nahuatl or another Uto-Aztecan language rather than English or Spanish, and later she asserts that the sun's expansion as a red giant has accelerated and that she can feel its subatomic particles pass through her, "leaving behind coded messages in my bloodstream."[12] Reading the book I got used to her letting fly with such jaw-dropping predictions and observations. But the tone is different than Deloria's in *Red Earth, White Lies*. In part the difference is Silko's literary voice, which is matter-of-fact but friendly; the writing is patient and poetic and generous, if sometimes, as in extended storytelling, a bit monotonous. Deloria's voice, on the other hand, seemed to turn from good-humored but biting erudition in the '60s and '70s to adamantine lecture in later work. The difference also comes from

the genres, fiction and literary memoir in Silko's case and scholarship or philosophy for Deloria. Silko's theories come from a visionary poet with a macaw named Sandino, rather than from an insistent professor. Silko and writers like N. Scott Momaday, Joy Harjo, and Simon Ortiz have been called leaders in a "Native American Renaissance" of the 1970s and '80s—and Deloria was such a stylist and thinker that he deserves to be in this cohort too. Silko's later works, particularly *Almanac of the Dead* and the prophetic parts of *The Turquoise Ledge*, and Deloria's late work offer a response or reaction to their earlier, more humanist and secular work. Each might be referred to as Native American baroque.

Silko's literary point of view is singular and compelling. In Deloria's earlier terms, her manifestation of deity is based squarely in a specific place, and her sense of time is effortlessly discontinuous. "I learned the world of the clock and calendar when I started school," Silko writes, "but I've never lost my sense of being alive without reference to clocks or calendars."[13] The concept of "Indian time," which Native folks talk about and non-Native folks sometimes use to criticize (or merely observe) a lack of hurry and punctuality in Indian Country, begins to look like resistance.

As a child watching her father, then the tribal treasurer, take Laguna elders to testify in federal court for the tribe's claims to millions of acres of land, Silko took the lesson that "if I could tell the story clearly enough then all that was taken, including the land, might be returned." Like the psychic in *Almanac of the Dead*, she would narrate justice into existence. Yet she doesn't push her truth as being exclusive. It is, like those elders' accounts, testimony. Other than Laguna storytelling tradition, the poetry of Emily Dickinson appears as Silko's major influence in *The Turquoise Ledge*. Three Dickinson poems appear in the text, chosen for their "mysterious glimpses of transcendence and eternity." It's easy to see how Dickinson flutters into Silko's place-bound, prophetic vision.[14]

In *God Is Red* Deloria recounted a parable related by the Dakota physician Charles Eastman in his 1911 book *The Soul of the Indian*. A missionary told a group of Indians the story of Genesis: the creation of the earth in six days and the fall of Adam and Eve. The "courteous savages listened attentively," Deloria wryly paraphrased it, and then one of them responded with his tribe's story of the origin of maize. The missionary, of course, demurred at Genesis being equated with "mere fable and falsehood." And the Indian scolded him: "It seems you have not been well grounded in the rules of civility. You saw that we, who practice these rules, believed your story; why, then, do you refuse to credit ours?"[15] One bit of wisdom I am still trying to learn—Native American history and literature is a pretty good place to do so—is to let incompatible truths circle around each other politely.

8. HORSE POWER

We can see ourselves in the chrome parts, the headlights and crash bar, and, of course, the mirror. But the whole bike—including the graceful tilde form of the fenders, the fringed leather saddle and saddlebags, and that Indian-head ornament leading the way—is forged from an alloy of American dreams into a shape both gorgeous and troubling.

In the Autry Museum's art galleries, a 1948 Indian Chief Roadmaster (see fig. 8.1) stars as a gasoline steed, close cousin to the horse. Two beaded Sioux "possible bags" from the 1920s—for horse travel—sit in a display case in front of the motorcycle, surrounded by a tooled Mexican-style saddle from 1855, small bronze horses, and many brushstroke ponies on the walls. The motorcycle-as-modern-horse symbology appears again and again in pop culture. Two examples are an early scene in *Easy Rider* (1969), in which Peter Fonda and Dennis Hopper change a tire while a noble rancher shoes a horse in

FIGURE 8.1. Indian Chief Roadmaster motorcycle, Indian Motorcycle Manufacturing Company, 1948. Leather, metal, 48½ × 36 × 100 in. Autry Museum of the American West, 97.70.1.

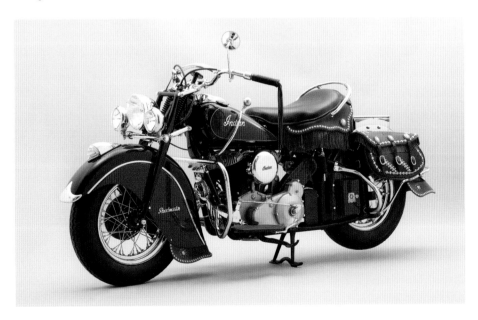

the foreground, and Jon Bon Jovi's 1986 arena-rock ballad "Wanted Dead or Alive," with its line "I'm a cowboy, on a steel horse I ride." Imagine the tasseled handlebars as reins, the exhaust sound as hoofbeats, and the brand as, well, a brand.

And what a brand: Indian. A name so blunt in its claim to both Indigenous American-ness and implicit westernness as to transcend (or at least precede) the many similar names by which automobile manufacturers have since hitched their horseless carriages to the mythic West. The Indian's peers and successors in western automobility include Ford Mustang (1962–), Jeep Wagoneer (1963–93), Ford Bronco (1966–96, 2017), Chevy Blazer (1969–99), Ford Maverick (1970–77), Ford Pinto (1971–80), GMC Sierra (1971–), Nissan Pathfinder (1985–), Dodge Durango (1997–), Nissan Frontier (1998–), Chevy Silverado (1999–), Hyundai Santa Fe (2001–), GMC Canyon (2004–), and Chevy Colorado (2004–). An equal number try to capture the West through Indigenous people, words, or place-names: Pontiac (after the eighteenth-century Odawa military leader, 1926–2010); Ford Thunderbird (after a multi-tribal spiritual symbol, 1955–97, 2002–5); Chevy Malibu (from a Chumash place-name, 1964–83, 1997–); Chevy Cheyenne (1971–75); Jeep Cherokee (1974–); Dodge Dakota (1987–2011, including a short-lived edition, the Dakota Warrior); Chevy Tahoe (from a Washoe place-name, 1992–); GMC Yukon (from the Dene name for the eponymous river, 1992–); Toyota Tacoma (from the Coast Salish name for Mount Rainier, 1995–); GMC Denali (from the Koyukon name for North America's highest mountain, 1999–); Pontiac Aztek (2001–5); Toyota Sequoia (from a tree that may be named for the Cherokee literary giant, 2001–); and Hyundai Tucson (from a Tohono O'odham place-name, 2005–).[1]

The West is inextricable from the romance of automobility. Reading these names more closely, multiple imagined Wests reveal themselves. Some, like Wagoneer, Silverado, and Maverick, evoke the Western genre. Others evoke the wilderness (Sierra and Canyon) or specific regional Wests (Santa Fe and Malibu). A recent Arctic turn in car naming (Yukon, Denali, and Toyota Tundra) may reflect a certain nostalgia for a frozen Far North as an annex of the West, a last frontier now charted, drilled, and thawing. A few model names—footnotes in automotive history, from the Kaiser Manhattan to the Subaru Tribeca—drew on iconic eastern, urban places, but never did car builders christen a model the Walden, the Charleston, or even the Wampanoag or the Chattanooga (to use some Native names). The open road is a western road.

And an Indian road. Why christen so many motor vehicles with Indigenous names? Philip J. Deloria has written incisively on the symbolic paradoxes of Indians and cars. In the early twentieth century, real Native people, like everybody else, immediately picked up on

the usefulness of a car—even if many were too poor to own automobiles at first. Those who could afford them followed "long-lived Indian traditions built around the utilization of the most useful technologies that non-Indians had to offer."[2] Cars were especially important tools for those confined on reservations. But non-Indians expected that automobiles were antithetical to Indian character, such that a photo of Geronimo in a Cadillac became a kind of joke, and that Native people who bought cars were squandering their money and lacking in thrift. On the other hand, the freedom that cars and motorcycles, and later sport-utility vehicles offered led them symbolically to the West and to western Indians.[3]

The Hendee Manufacturing Company of Springfield, Massachusetts, stenciled the word "Indian" on the sides of its skinny motorized bicycles from its founding in 1901, though the company did not adopt Indian as its official name until 1928. This early vintage probably accounts for the blunt moniker "Indian," which would morph into subtler appropriations like Denali a century later. A postwar innovation, the motorcycle's war-bonneted fender ornament—electrically illuminated on working bikes—is akin to a ship's figurehead. It recalls a Pontiac hood ornament from the same era as well as the silhouette on a few "Indian-head" coins from the early twentieth century (including the famous buffalo nickel designed by James Earle Fraser, sculptor of the *End of the Trail*). Silver and gold Indian-head motifs appear on sister artifacts throughout the Autry galleries, including an 1896 Tiffany punch bowl and Edward H. Bohlin's "Big Saddle" (see fig. 8.2). The saddle, said to be Bohlin's "personal masterpiece," includes several war-bonneted Indian heads, most prominently on the saddle horn and at the horse's breast, both roughly parallel to the ornament on the Indian motorcycle. Called by his biographer the "saddlemaker to the stars," Bohlin was born and raised in Sweden and immigrated to the United States in 1912, seeking opportunity but also having been enchanted after seeing a Wild West Show in Europe.[4]

For all the beauty in the lines of the generic Plains Indian head—always male, with Roman nose and eagle feathers—the form is troubling. No doubt those who placed an Indian image on a saddle, a coin, a motorcycle, or a football helmet felt an earnest respect for what they imagined an Indian to be. It is hard to imagine choosing a mascot or logo one finds hateful or valueless. But it is not really a human being there. It is more like ornaments depicting jaguars, bulldogs, eagles, and angels. A few other ethnic groups have the dubious honor of being

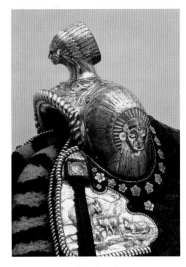

FIGURE 8.2. Saddle detail, 1947. Edward H. Bohlin and the Edward H. Bohlin Company. Gift of Jackie and Gene Autry. Autry Museum of the American West, 91.221.603.

sports team mascots (Vikings and Celtics, to name two), but American Indians are unique in being cast as hood ornaments. "Indians were removed, then reduced to a feathered image," writes novelist Tommy Orange (Cheyenne and Arapaho) in a prologue to his novel *There There* (2018). "Our heads are on flags, jerseys, and coins. Our heads were on the penny first, of course, the Indian cent, and then on the buffalo nickel, both before we could even vote as a people—which, like the truth of what happened in history all over the world, and like all that spilled blood from slaughter, are now out of circulation."[5]

The exact symbolism of the imagined Indian has changed over time and has yielded material for many cultural studies.[6] Sometimes non-Indians' sculpting of a mythic Indian looks to be the poignant result of wrestling with identity and with living on a continent on which they may never comfortably belong. Other times it becomes hackneyed clip art. Indian motorcycles display both tendencies. At one time the company referred to its assembly plants as "wigwams," and its divisions were labeled "tribes" or "reservations," with more ridicule than respect. A 1940 issue of the promotional publication *Indian News* announced, "With war hooping [*sic*]—'Ughs' and 'Huhs' and more 'Ughs'—Indians from the West Coast Reservations raced across the tarmac of Los Angeles Airport to greet Big Chief Dwight Moody, Vice President and General Manager of the Eastern tribes who raised his hand in greeting to bring them the exciting news of the new 1941—40th Anniversary Indian motorcycles." Moody, the copy reads, "alighted from a United Airlines Skybird," and a West Coast boss who greeted him was dubbed a "Heap big medicine man." Men identified as American Indian in accompanying photographs (High Sky, Willow Bird, and Big Heart) may or may not have been Native, and if they were, they may have been proud, annoyed, or amused to participate.[7] But whatever the minimal complexities, the Indian Motorcycle

FIGURE 8.3. Gerald Clarke Jr., *To the Discriminating Collector*, 2002. Steel, 5½ × 19½ × 62 in. Gift of Loren G. Lipson. Autry Museum of the American West, 2017.16.1.

Company playing Indian was, by the 1940s, far less elegant than the magnificent form of the bike.

Some Native American bikers ride Indians. Other Native people find the Indian motorcycle offensive or silly. Gerald Clarke Jr. (Cahuilla) has captured the violence and absurdity of Indian-as-brand in *To the Discriminating Collector* (see fig. 8.3). This sculpture evokes forced labor, racial discrimination, and the dehumanization of Native people inherent in collecting Indian imagery. A high-horsepower counterpoint, now in the Autry Museum's collection, is Lewis deSoto's conceptual sculpture, *Cahuilla* (2006, see fig. 8.4). Built on a 1985 Chevrolet truck, this piece plays with the tradition of naming cars for Indigenous people and places, emblazoning the grille and front quarter-panels with deSoto's ancestral tribal affiliation, Cahuilla. DeSoto notes pointedly that the paint colors of his modified Chevy are "saddle tan" and "Indian bronze," that the tires are Firestone Wilderness AT models, and that he has affixed an "Invader 454" decal to the tailgate. This reflects the ways carmakers have applied Indian and western makeup to their products at levels far beyond model names.

DeSoto's use of Indian and western automobile tropes is the chassis for a larger conceptual reversal. According the artist, *Cahuilla* was inspired by the advent of tribal gaming and the U.S. Supreme Court decision in *California v. Cabazon Band of Mission Indians* (1987), which held that the State of California could not prohibit casinos on sovereign tribal land. This led, for a few tribes (including some Cahuilla groups but not others), to wealth that led to increased political and economic power—including the ability to buy new pickup trucks. *Cahuilla* includes a splendid woven tonneau cover that combines longstanding Cahuilla basketry imagery such as rattlesnakes with the outline of a craps table. Blinkers and lights flash, evoking a casino. References to lucre abound, with the upholstery in hundred-dollar-bill webbing patterns, text fonts lifted from currency, and a dollar bill's Eye of Providence remade as a tipi (not a traditional Cahuilla dwelling but an archetypal Indian one). The piece achieves integration across the false divide of "traditional" and "modern," and it reckons with the ambivalence many Natives and non-Natives feel when confronted by rich Indians.[8]

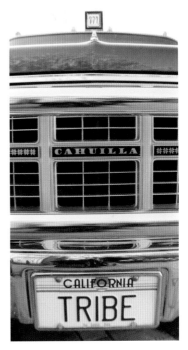

FIGURE 8.4. Lewis deSoto, *Cahuilla*, 2006. Pickup truck, mixed media, 121¼ × 97 × 77 in. Autry Museum of the American West; 2019.2.1.

Museum visitors in fifty or a hundred years may find the symbolic politics of Indian names, fringes, paints, and figureheads in the 1948 motorcycle and *Cahuilla*—and the latter's depiction of Native wealth—less striking than the remoteness of driving oneself, gasoline combustion, and cruising for style. Like the stagecoach, antique saddles, Clovis points, and flintlock rifles elsewhere in the Autry Museum collections, the motorcycle and the pickup truck may become true relics. Depending on the scope of devastation wrought by climate change, the beautiful relics of the industrial era may appear as small, ironic pieces of a tragedy as dramatic as the sagas of real Native American history.

9. STANDING ROCK AND THE MUSEUM

In the summer and fall of 2016, we at the Autry Museum were in the final months of preparing a large exhibition, *California Continued*, about California Native peoples and the environment. Meanwhile, in a different corner of the West, the camps of the Standing Rock water protectors—as those hoping to stop the Dakota Access Pipeline (DAPL) called themselves—began to receive widespread attention. As far as California is from the Standing Rock Indian Reservation (which straddles North Dakota and South Dakota), parallel issues have affected Native peoples in each place. Historical dispossession still impoverishes; sacred sites are destroyed; clean water is a precious and sometimes endangered resource; and tribes remain resilient and resistant in the face of these challenges.

Among the California Native experts who were teaching the mostly non-Native museum staff about traditional ecological knowledge and contemporary environmental challenges, several began traveling to Standing Rock in solidarity with the #NoDAPL movement. The Autry has increasingly sought to develop and maintain strong relationships with the Indigenous communities represented in its collections and to tell stories relevant to those communities. We constantly grapple with the colonial legacy of museums' acquisition and display of Indigenous cultures. It seemed in the case of Standing Rock that we had a responsibility to reflect on the events capturing such wide attention across Indian Country and beyond.

This sparked a proposal to mount a quick-turnaround (by museum standards) mini-exhibition, *Standing Rock: Art and Solidarity*, which would open in May 2017, a couple of months after the water protectors' camps were dismantled and the pipeline construction finished. What could a small museum display add to the already vibrant dialogue that these events inspired? As an institution of cultural history, the Autry was not necessarily the best venue to detail the probability of a pipeline leaking or the economics of oil. But we *were* poised to demonstrate the "shared cultural heritage of the Lakota nations and all people," as the American Alliance of Museums put it in a statement amid the controversy, and to stand against the destruction of sacred cultural sites.[1] We could also place what people were reading and seeing in the news media in the context of deeper histories already

on display elsewhere in the museum, where we hoped they would brush against the grain of both the ethnographic forms of display that historically characterized the Southwest Museum and the styles of display derived from the Western genre. And we could offer visitors the opportunity to stand in the presence of artworks and artifacts that conveyed the energy of the Standing Rock movement and the profound questions it raised.

Something historically significant occurred at Standing Rock. The artist Cannupa Hanska Luger (Mandan/Hidatsa/Arikara/Lakota), who is from Standing Rock and who contributed crucial objects and curatorial advice to the Autry display, put it this way: "What was happening at Standing Rock that was most amazing to me was the solidarity formed by different culture groups coming together to support one another and to look out for one another."[2] Indigenous people from across North America and around the world, joined by non-Native allies, traveled to Standing Rock or otherwise supported the water protectors. Intertribal solidarity is nothing new, but at this scale it may have been unprecedented. Zoë Urness (Tlingit/Cherokee), who loaned four powerful photographs to the Autry installation, also noted the spiritual significance of the movement: "Belief in the spiritual workings from ancient times is a weapon that doesn't need violence to win." The environmental movement, which has often ignored, romanticized, or disparaged Native perspectives, recognized Native leadership in a new way. And these alliances, while not without their difficulties, gained public and media attention for a Native American–led movement to a degree not seen since the 1970s Red Power era.[3]

Of course, part of that attention sprang from the violent responses of security and law enforcement to the water protectors' stand. While the violence was shocking to many non-Native observers, many Native people I have spoken with were outraged but not surprised. As most of us know in general terms, American history holds a long trail of violence against Native peoples as well as Native violence on invading settlers. Looking at those histories more closely, it is remarkable how often that violence flowed from natural resource extraction.

In his book *The Last Indian War*, about the Nez Perce struggle to retain their territory in the Northern Rockies, historian Elliott West observes: "With few exceptions, every major Indian conflict in the far West between 1846 and 1877 had its roots in some gold or silver strike."[4] West enumerates the violence that followed the California gold strike of 1848 (which led to out-and-out genocide), the Colorado strike of 1859 (which led to wars on the Cheyenne and Arapaho peoples, including the Sand Creek Massacre), the Arizona strike of 1863 (leading to wars on Apache groups), and the two strikes, in Montana and

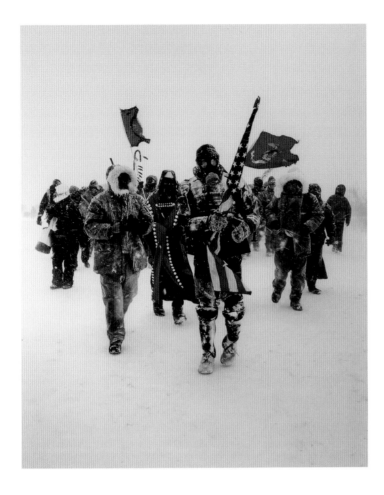

FIGURE 9.1. Zoë Urness (Tlingit/ Cherokee), *December 6, 2016: No Spiritual Surrender.* 40 × 32 in. Purchase made possible by Gary, Brenda, and Hayley Ruttenberg. Autry Museum of the American West, 2018.33.1.

In December 2016 thousands of US veterans traveled to the Standing Rock Indian Reservation in a blizzard to apologize to Native American peoples for their historic treatment by the US military.

South Dakota, that led to wars with Lakota peoples in 1868 and 1876 (including the Battle of Greasy Grass, better known to most non-Natives as Little Bighorn). Even Cherokee removal and the Trail of Tears were preceded by a gold rush in Georgia in 1829.

With this in mind, it was hard not to see the Bakken oil boom (roughly 2006–12) as a contemporary gold rush, with a familiar mix of economic opportunity and social-environmental upheaval, something characterized in the media as a Wild West atmosphere full of "man camps" and prostitution.[5] The Standing Rock movement too is part of a long line—a lineage of protectors or a lineage of obstructions to great fortunes, depending on one's perspective. The Autry tells some of these histories in other galleries, and we tried to place the Standing Rock events in context through a self-guided "Sovereignty and Struggle"

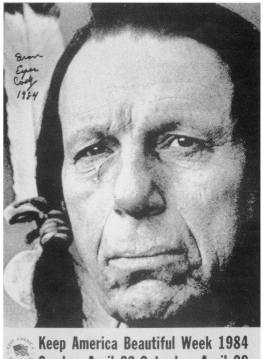

FIGURE 9.2. Iron Eyes Cody, 1984. Poster, 21⅛ × 13⅞ in. Braun Research Library Collection, Autry Museum of the American West, 14.C.1398.

tour we produced in association with *Standing Rock: Art and Solidarity*. Historical displays about the Little Bighorn and the occupation of Alcatraz in 1969 by the group Indians of All Tribes took on new life in conversation with current events, and we hoped that we helped visitors understand the painful echoes and the real threat that the pipeline represented for many of the Indigenous activists.

A small museum display runs the risk of oversimplifying complex issues. Many Native people favor energy extraction as a means of developing economic and political sovereignty. The Mandan-Hidatsa-Arikara Nation has taken part in the Bakken boom. Other Native nations from Oklahoma to Montana have profited from oil, gas, coal, and other fossil fuels over the past century. Often, unscrupulous and even murderous outsiders have sought to exploit Native nations' relatively weak political position to siphon off much of the wealth.[6] But the Autry is a place where the currents of "celluloid Indians," ethnographic displays, and

historical politics converge in strange ways. A long-running stereotype of Native peoples paints them as preternaturally ecological, most obviously exemplified by the "crying Indian" of the 1970s TV commercial, played by the Italian-American actor who rechristened himself Iron Eyes Cody. Cody married Bertha Parker (Seneca/Abenaki), the first Native woman archaeologist. Both were active in the Los Angeles Native community, and Cody's life in redface was a complex and not simply contemptible one. The two each contributed to the historic Southwest Museum and Autry collections, now united in the Autry after the museums'

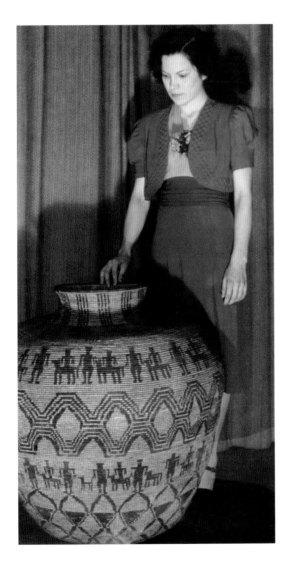

FIGURE 9.3. Mrs. W. W. Burleigh, *The Biggest Basket*, 1939. Photographic print, 10 × 8 in. Southwest Museum of the American Indian Collection, Autry Museum of the American West, P.9195, featuring basket 30.L.228.

The handwritten caption for this photo reads in part: "Mrs. Bertha Parker Cody standing beside a huge Apache storage basket, the largest in the Southwest Museum, which was collected by A. C. Vroman, about or before 1890, from the Apache Indians of Arizona."

merger in 2003 (see figs. 9.2 and 9.3).[7] If it ever seems we have strayed far from the Western in the museum (or if I have done so in this book), just turn the corner (or the page), and there is show business again. Of course, the museum business is arguably a part of show business.

With *Standing Rock: Art and Solidarity* we tried to avoid using the water protectors as ecological PSAs and instead presented their work and their words as representing a historical and cultural moment. But as Melanie Benson Taylor (Wampanoag) put it in an essay in 2017, "the line between comradeship and cooptation is frustratingly dim."[8] Demian DinéYazhi´ (Diné), another artist who contributed work to the Autry's exhibition, offered these thoughts on making sense of the movement growing out of Standing Rock: "Moving forward, we must collectively ask ourselves how this revolution will work, continually address our methods of resistance and decolonial praxis, and honor our relationship with the land as a sacred communion interwoven with our will to survive." The museum's job was not to promote or impede this "revolution," but we do need to engage in our own "decolonial praxis." I understand this phrase to mean a way of acting every day in our work and life that acknowledges the history of colonization on this continent and seeks to remediate (even in small ways) the damage that history has caused, for Native and non-Native people. Adding a "from the headlines" space to our galleries perhaps accomplished one small step in that ongoing praxis by presenting Indians not as people from long ago who vanished but as living, ongoing participants in a shared history, and by taking seriously a topic that many Indigenous people believe is important. Imagine Standing Rock on the far righthand side of the Autry's central mural, in which the only other Native presence is the Cherokee cowboy Will Rogers (invisible to most visitors as Indian) and the actor Jay Silverheels (Mohawk) as Tonto. The museum can deepen the facile descriptions of the Bakken oil boom and Standing Rock as "Wild West" phenomena and continue its broader exploration of the many intertwined stories of the American West past and present.

part three

BORDERLANDS TRILOGY

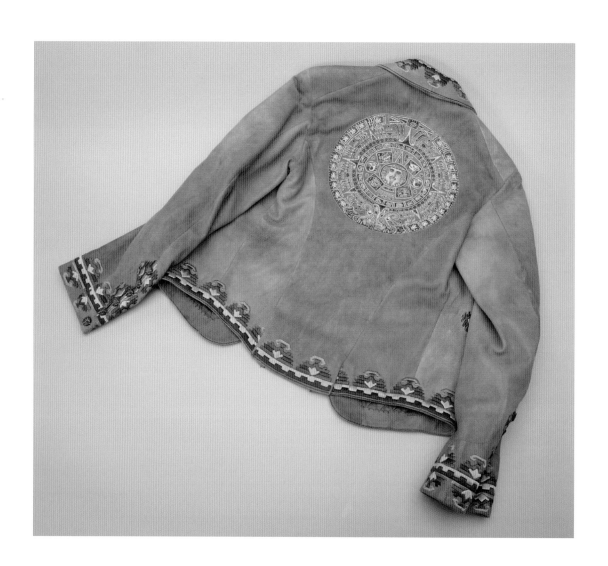

10. CALEXICO
Gateway to the Borderlands

In the summer of 2000, I was tasked with previewing dozens of compact discs for possible play on my college radio station. I heard most of what independent labels were releasing for hip young adult audiences: coastal and college-town rock, turn-of-the-millennium, Buddy Holly–glasses style. Amid all this, Calexico's third album, *Hot Rail*, arrived. The packaging featured stencil art by Victor Gastelum, a veteran punk rock artist, including the band's name in a tattoo-parlor Gothic font. Calexico hailed from Tucson, Arizona, and, while they had formed a few years earlier, they were a fresh blast of mesquite to me. *Hot Rail* began with a quasi-mariachi instrumental, "El Picador," and then moved on to a droll rock ballad titled "Ballad of Cable Hogue" after a Sam Peckinpah film and featuring the voice of Marianne Dissard, a French singer cast as a lover who betrays and kills the male narrator. Other tunes included spacey instrumentals that suggested a night drive through dark desert or a spaghetti Western soundscape. "Service and Repair," a country-rock tune featuring pedal steel guitar, evoked suburban sprawl in the Sunbelt. Brass riffs and accordion splashed throughout, adding a norteño feel to the album. I had never heard the term "borderlands," but I immediately sensed a synthesis here that was international yet profoundly American and regionally western.

I was a midwestern–Great Plains kid with some Pacific Northwest experience who had been to Arizona and Mexico a few times, and I had little idea how authentic this music was to the place where it was composed. I was alert to an *aesthetic* of authenticity, a sucker for anything from crackly boom-bap rap to ultra-honest folk and suspicious of twee pop and ironic rock. This band was both superbly original and evidently rooted in tradition. For the next several years, my formative early twenties, Calexico was my favorite band. My first book, written in the wake of this enthusiasm, attempted to produce a mytho-geographical vision of the Great Plains as Calexico did for the Southwest. I'm not sure this was successful, but I have kept trying to match Calexico's gestalt and will probably be trying for a long time.

FIGURE 10.1. Men's charro jacket with silk embroidery, circa 1906–10. Gift of Alfred F. Otañez. Autry Museum of the American West, 2009.5.1.

This jacket, featuring the Aztec calendar, offers a possible overlap between the imagined West of the cowboy and the imagined West of Aztlán.

FIGURE 10.2. Victor Gastelum, untitled (Virgin Cholita), 1992. Spray paint stencil on drawing paper, 18 × 24 in. Courtesy of Victor Gastelum.

This artwork, created before Calexico formed, emphasizes the presence of the Virgin of Guadalupe in twentieth-century Los Angeles.

For those raised on a west-facing frontier myth of Manifest Destiny—even a version that lamented what was lost in the US conquest of most of the continent—it is difficult to train ourselves to understand the region as an enduring borderland, especially a Latin American borderland. Intellectually we get it. But how do we recognize and inhabit a *frontera* sensibility if we haven't really lived it? One answer: by imagining it through scores of movies, records, or books. In an essay that assessed popular understandings of "the frontier" (a hard line between savagery and civilization) as of 1994, historian Patricia Nelson Limerick wisely referenced Gloria Anzaldúa's pivotal book, *Borderlands/La Frontera: The New Mestiza* (1987). Limerick concluded, "If the idea of *la frontera* had anywhere near the standing of the idea of the frontier, we would be well launched toward self-understanding." She continued, speculating, "Somewhere in the mid-2000s the term might make a crucial shift, toward the

reality of *la frontera* and away from the fantasy of the frontier."[1] If by 2050 such a shift occurs, it will be largely because the reality of today's borderlands makes the historical borderlands recognizable but also because artists render that reality, past and present, as powerfully and prolifically as their predecessors once produced frontier Westerns. Calexico has achieved one way of weaving together a borderland that *makes sense*. The band's Southwest includes cowboy Westerns but is also sonically part of Latin America. Threads of specific genres and traditions such as norteño, country, and rock are inextricable from Calexico's larger tapestry.

We must consider that Joey Burns and John Convertino—the two core members of Calexico—are Anglos and not originally from Arizona but from Los Angeles and New York State respectively. While they collaborate with Latino artists like Gastelum and the band Mariachi Luz de Luna, the curation seems directed by Burns and Convertino. It is possible, even likely, that Calexico's music appeals especially to listeners like me who appreciate the borderlands as outsiders to it. But that may be okay.

I am continually impressed by how many scholars have come to produce rigorous work on the West and on Native America beginning with the romantic seed of Western genre fandom or a childhood "playing Indian." In order for everyone to conceive of a South-west—or a West or an America—where not only Natives and Anglos but also Latino/as and migrants from across the Pacific and around the world belong, artistic versions of the region must reflect this.[2]

Calexico, as an indie or cult band, has had limited reach to increase broad public perception of *la frontera*, but the band's vision is worth celebrating. At the peak of my own enthusiasm, I wrote a profile of Calexico in the western biweekly *High Country News*. In it, I described their music as "a sort of grout that cements all the fractured tiles and asphalt and broken glass into a coherent mosaic."[3] Because music is so fluid, it seemed to me the perfect medium to unite seemingly disparate elements, creating a universe of its own. The scholar Josh Kun has called such musical universes "audiotopias."[4] Once Calexico had planted its audiotopia in my inner ear, a host of other creative works old and new seemed to fit into the band's world. The short essay "Kafka and His Precursors" by Jorge Luis Borges comes to mind: "The fact is that every writer *creates* his own precursors. His work modifies our conception of the past, as it will modify the future."[5] Unlike Borges, I am thinking of culture not as a coherent canon that "we" somehow hold in common but as a personal library each of us builds in approaching the world we all do ultimately share. In this personal sense, Calexico was my borderlands Franz Kafka, creating both precursors and later works in many media that nestled in their imagined geography—or at least in my version of it.

Some examples of Calexico's borderlands canon: Leslie Marmon Silko's epic novel *Almanac of the Dead* (1991); Terry Allen's concept country-western album *Juarez* (1975); twenty-first-century southwestern film and television like *The Three Burials of Melquiades Estrada* (2005) and *Breaking Bad* (2008–13); twentieth-century Westerns like *The Treasure of the Sierra Madre* (1948), *Giant* (1955), *El Topo* (1970), *Duck, You Sucker!* (1971), and *Walker* (1987); and Gastelum's arresting stencils (that seem like film stills or comic book panels). The short Western that is the music video for A Tribe Called Quest's "I Left My Wallet in El Segundo" (1990) unites a kitschy fantasy of an El Segundo—surely not the real city adjacent to the Los Angeles International Airport (or is it?)—that includes a four-foot-tall man in a sombrero and serape, a diner plate of enchiladas, and a landscape of Joshua trees. Even some Canadian-borderland Westerns make a certain transnational sense when figured as precursors of Calexico, such as Wallace Stegner's multi-genre book *Wolf Willow* (1962) and the television classic *Twin Peaks* (1990–91).

In most of these works, characters cross literal national borders, whether bringing Irish Republican revolutionary explosives expertise to Mexico like Seán H. Mallory in Sergio Leone's *Duck, You Sucker!* or traveling to One Eyed Jack's casino and brothel across the Canadian line in *Twin Peaks*. In *Giant*, the border to cross is the cultural or racial frontier between the Tejano workers and the Benedict family at the Reata Ranch. Anzaldúa presides over this cultural-artistic *frontera*, a kind of chairwoman of the border, and her discussion of the form of her own book *Borderlands/La Frontera* helps map this imagined landscape. She describes *Borderlands/La Frontera* as "a mosaic pattern (Aztec-like) emerging, a weaving pattern, thin here, thick there. . . . I see a hybridization of metaphor . . . full of variations and seeming contradictions."[6] Though I had not read Anzaldúa in 2004, I described Calexico's work likewise as a mosaic, and here I have mixed metaphors of hybrid forms (a weaving, a library, a universe). This mixture, Anzaldúa theorizes, is not sloppy writing but a structural truth of *la frontera*. Even the Autry Museum, with its layers of culture and history and its skipping back and forth from history to fantasy, coheres in my mind under a Calexican umbrella.

When I interviewed Joey Burns for the *High Country News* profile, he described the influence of many writers: Cormac McCarthy (particularly his border trilogy); Carlos Fuentes (especially *The Crystal Frontier* (1995)); Tucson's Charles Bowden and Lawrence Clark Powell; and Edward Abbey. In the first three lines of a song called "Sunken Waltz," Burns alludes to both Donald Worster's western environmental history *Rivers of Empire* (1992) and Mike Davis's analysis of Los Angeles history and landscape *City of Quartz*

FIGURE 10.3. Victor Gastelum, untitled (Impala), 2003. Spray paint stencil on bristol, 36 × 13 in. Courtesy of Victor Gastelum.

The stencil artworks of Victor Gastelum have accompanied Calexico's music for decades, emphasizing both a cinematic atmosphere and a borderland sensibility. This piece resembles his earlier cover art for the album *The Black Light* (1998).

(1990). In talking with me, he also mentioned the influence of Tucson Latino/a musicians and the influence of Europeans, including the Spanish-French pop star Manu Chao. No doubt the film composer Ennio Morricone too has influenced Calexico's sound (with the music in *Duck, You Sucker!* and many more spaghetti Westerns). But there is a difference between the band's artistic influences and my own array of what Borges called precursors, whom I see as fellow borderlanders. Each active listener can imagine that landscape and populate it, and over time—by 2050, we can hope—it may grow into as powerful or realized a world as the Western did. Assembling a mosaic, a library, a tapestry of the borderlands is not merely an exercise in tracing connections, rethinking artistic canons, or making pretty things. In many ways it matters deeply how the region's citizenry—and others from far afield—imagine it. A *fronterización* would aid in "self-understanding," as Limerick puts it, but perhaps also in more responsible actions within that borderland. In Calexico's lament about sprawl, "Service and Repair," the band concludes with a hope for "sewing the dream better suited for both soul and soil."

11. AZTLÁN COWBOYS

Prior to encountering and herself creating works of Chicano/a literature, poet and theorist Gloria Anzaldúa found that watching Mexican movies at the drive-in with her family imparted "a sense of homecoming as well as alienation." "*Vámonos a las vistas,*" her mother would say. A community formed in the shared glow of South Texas drive-in theaters in the 1940s and '50s, but South Texas was a world one would need to leave if one wanted to escape poverty and discrimination. Among the memorable films for Anzaldúa were the "singing-type 'westerns' of Jorge Negrete and Miguel Aceves Mejía."[1]

In these Golden Age Mexican Westerns, charro heroes like Negrete and Mejía wore big hats, drew revolvers, and saved damsels on dusty streets in the absence of law. This genre merits only a passing mention in Anzaldúa's *Borderlands/La Frontera*. But her inclusion of charro movies may suggest a saloon doorway from the imagined West of cowboy fiction to the imagined West of the borderlands, a portal from frontier to *frontera* and back. Crossing back and forth is, as Anzaldúa notes, neither comfortable nor restful. As Abraham Quintanilla (played by Edward James Olmos) puts it in the biopic *Selena* (1997), it's exhausting to "gotta know about John Wayne *and* Pedro Infante" (the Mexican star famous in part for his charro roles). The West of the imagination, as usually construed, contains precious little acknowledgment of the borderlands. Even in considerations of the West as a region or any of its subregions, any work that suggests a borderland has largely been labeled and constricted as "*ethnic* rather than *regional*," historian Richard Etulain asserts.[2] The Spirit of Imagination Gallery at the Autry Museum has, since the early 1990s, featured Latino/a characters such as the Cisco Kid. The museum's *Spirits of the West* mural includes a Spanish missionary of the eighteenth century, a stereotypical *señora* or *señorita* of the 1880s, and a California vaquero in its cast of western mytho-history. Displays in the museum's history galleries about Mexican-American communities, Californio leader Pío Pico, and the creation of a "Spanish fantasy past" have expanded the Latino/a footprint gradually and substantially over the years. And there have been temporary exhibitions: a history of Zorro stories, a survey of twentieth-century Mexican-American art, a show on muralist David Alfaro Siquieros, and one on influential Chicano newspaper *La Raza*. It remains unclear how far this inclusion has shifted the

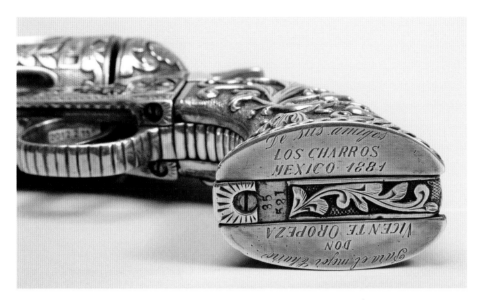

public's sense of the West. Yet, as borderlands scholars have noted, it is important not to disengage from the notions of the West and the frontier even as we critique or expand them. They hold too much power to merely reject or ignore them.[3]

As one digs, one finds that there are many imagined Wests. Alongside a cowboy or Wild West frontier is the imagined West of wilderness, a sublime, unpeopled landscape of giant sequoias and otherworldly canyons, views from a Sierra Club calendar. Indian Country is another imagined West, an archipelago of sovereign land as defined either by non-Native laws and stereotypes or by American Indian peoples themselves. The Sunbelt is a more recently invented landscape, a substantially western one filled with suburbs and golf courses on the "crabgrass frontier." There are other imagined Wests: the almost gothic Pacific Northwest, the western city of casinos or the Space Needle or Chinatown, and the feminized prairie homestead West.[4] But it is the borderlands/*frontera* West, especially as articulated by Anzaldúa, that seems resonant and flexible enough to rival and perhaps someday subsume the frontier West of myth and genre. For the moment, I suggest a hybrid place *between* the borderlands conception and that of the frontier.

Anzaldúa forged her queer, mestiza vision in mythic terms, engaging deeply with the Aztec earth goddess Coatlicue as a force to be reckoned with and reclaiming deep Chicano/a histories in the American Southwest. She framed the 1980s migration of Mexican workers across the international border as a "return odyssey" from the Aztec retreat from the northern reaches of Aztlán in the twelfth century.[5] Over the centuries returns had gradually occurred through the currents of European and then American imperialism; Mexican Indigenous and mestizo migrants came north beginning in the sixteenth century. Anzaldúa herself was a sixth-generation resident of the Rio Grande Valley of Texas. Her and earlier Chicano/a activists' casting of present-day migration in mytho-historic terms—pressing the conception of Aztlán, using an Aztec eagle on the United Farm Workers flag, and so on— had the storytelling power to dethrone the cowboy's white knighthood but not the political or media power to propagate these conceptions widely.

The place Anzaldúa framed as "the river where two worlds merge," the cowboy then-president of the United States, Ronald Reagan, called "a frontline, a war zone."[6] Reagan drew on the notion of a frontier as a border between civilization and savagery, and this conception continues in more recent efforts by President Donald Trump and other anti-immigration activists to erase any borderland ambiguity with an impregnable rampart to repel "bad hombres," as Trump put it in a line straight out of Western films. Executive pulpits and celluloid pulps broadcast that conception of the frontier far more widely than the independent publishers, neighborhood murals, or agitprop Chicano theater companies that have explored *la*

FIGURE 11.2. Still, *Cactus Crandall*, 1918. Gelatin silver print, 6⁹/₁₆ × 8½ in. In memory of Roy Stewart, Autry Museum of the American West, 89.103.472.7.

This film's hero, Bob Crandall (played by Roy Stewart, *left*), crosses the Rio Grande and attacks Mexican bandits led by a man named Mendoza. This and many films like it helped build the persistent idea of "bad hombres" and the right of Anglos to dominate them.

frontera. Yet even these small efforts threaten some Anglo observers. In a 2009 edition of *The West of the Imagination*, a book on West-themed art, father-and-son scholars William H. Goetzmann and William N. Goetzmann menacingly describe Latinos' embrace of Aztlán as "a form of racist totalitarianism" and explicitly Nazi-like.[7] This is an astonishing reaction in a book that generally celebrates (with a critical eye, to be sure) the art of Manifest Destiny and the ethnic cleansing of the West. Even a sliver of *frontera*, Goetzmann and Goetzmann seem to fear, might fatally infect the hale frontier.

Anzaldúa wrote that language itself was a medium that needed to be remade. One of her book's most powerful structural maneuvers was to embody *la frontera* in merging Spanish, English, Spanglish, and some Nahuatl throughout. "Until I am free to write bilingually and to switch codes without having always to translate, . . . and as long as I have to accommodate the English speakers rather than having them accommodate me, my tongue will be illegitimate."[8] My own experience accommodating her text as someone for whom Spanish is not a first language was to slow down, accept a certain level of incomprehension in italicized passages, and try to mentally inhabit that borderland where I am a stranger. This is demanding, akin to reading difficult poetry. Decades later, *Borderlands/La Frontera*, still provocative, was swept up in Arizona's 2010 ban on ethnic studies curriculums, and school districts like Tucson's chose Anzaldúa as an author to cut. The author had died in 2004, but her work still held a charge.

Can we code-switch between *frontera* and frontier? One place to look is in another framing of "borderlands," the one used more frequently in the academic discipline of history. Herbert Eugene Bolton had been an undergraduate student of Frederick Jackson Turner, the figurehead of frontier studies, so it was significant that he would champion an alternative framework placing the American West within a broader hemispheric study of borderlands. His own key work was *The Spanish Borderlands: A Chronicle of Old Florida and the Southwest* (1921), which recognized the southern tier of the United States as Spanish America's northern frontier rather than ignore this, as most Anglo historians had done. As a man of his era, Bolton unsurprisingly celebrated the virile feats of Spanish conquistadors and explorers over "savage tribes."[9] But, as Bolton's biographer Albert L. Hurtado points out, focusing only on this distortion in Bolton's view overlooks the way he fundamentally reoriented the overwhelming prejudice that supposed (as Bolton characterized it) that "Spanish institutions in the New World crumpled like a house of cards at the touch of the Anglo-Saxon."[10] Northern European and anti-Catholic chauvinism ran deep. From his vantage as a professor at the University of California, Berkeley, and his summertime adventures across the Southwest, Bolton reveled in the enduring borderlands.

FIGURE 11.3. Charles F. Lummis, [tile roof of the Mission of San Fernando Rey de España], date unknown. Photographic print, cyanotype process, 8 × 5 in. Braun Research Library Collection, Autry Museum of the American West, P.40128.

The restoration of California's Spanish missions became a way to preserve one version of a borderlands Southwest as championed by Herbert Eugene Bolton and Charles F. Lummis.

The "imprint of Spain's sway is still deep and clear," Bolton wrote. Both "old-time adobes" and the newest architecture in the Southwest carried mission or Spanish styles. And, beginning to see the world into which Gloria Anzaldúa would be born, Bolton noted that southwestern towns included "Spanish quarters, where the life of the old days still goes on and where the soft Castilian tongue is still spoken." Even in English, "hundreds of words of Spanish origin are in current use in speech and print everywhere along the border." This is the code-switching, the Spanglish, the bilingual voice that Anzaldúa would amplify as a native speaker three generations later. While Bolton surveyed all of this with a romantic, colonizing eye, he recognized that what would later be called Latino/a cultures were not fading away but "growing stronger."[11]

"From the Spaniard," Bolton continued, justifying his study, "the American cowboy inherited his trade, his horse, his outfit, his vocabulary, and his methods."[12] The buckaroo is just an anglicized "vaquero"; the lariat, *la reata*; the chaps, *chaparajos* to protect from chaparral. And, of course, there is "rodeo"—and even the word "hombre" in public discourse. All of these reveal *la frontera*'s persistence. But vaquero culture and charro westerns did not precede cowboy culture, they evolved alongside it. Cinema on both sides of *la frontera* included at least hints of shared cultures. A remarkable number of mid-twentieth-century Westerns include Spanish language without subtitles, from the fascinating Anthony Quinn film *The Ride Back* (1957), in which Quinn as a half-Mexican alleged criminal travels back north across the border with a lawman to face trial (and in which bad hombres and good hombres are not easily distinguished), to *The Treasure of the Sierra Madre* (1948) and even *High Noon* (1952).[13] A charro jacket in the Autry Museum collection (see fig. 10.1), worn in the 1910s and '20s, features an Aztec calendar and reflects that Aztlán was not an invention of the decolonizing Chicano movement in the 1960s but part of an older borderland synthesis. For me this single artifact evokes a hope that *frontera* and frontier might cohere; that Pedro Infante "vistas" might screen at the Autry alongside John Wayne flicks; and that the borderland of mixed populations and metaphors, while never harmonious or simple, will gain a cultural standing to match its on-the-ground reality.

12. A TRIPLE LANDSCAPE

In his 1996 book *Anything but Mexican: Chicanos in Contemporary Los Angeles*, historian Rodolfo F. Acuña found the Autry Museum to be prime evidence of why Los Angeles needed a Latino museum. (In 2011, LA Plaza de Cultura y Artes would open downtown.) The Autry in its initial 1988 form epitomized for Acuña "the Euroamerican cowboy's vision of the West," and by 1994 he had found "small improvements but no change in the museum's basic perspective." Exemplary and particularly objectionable was the *Spirits of the West* mural in the museum's main hall, in which most Indians are Plains warriors, the only African Americans are cowboys, the Spanish or Latino men are missionaries and conquistadors and vaqueros, and the lone Latina is a "buxom . . . dance-hall girl" (Acuña overheard a tour guide describe her to students as "one of the girls who kept the boys happy").[1]

Two decades later, in 2017 the Autry honored the poet Juan Felipe Herrera with its annual Spirit of the West Award. And so in some way this Chicano activist, powerful American voice in verse, and former US and California poet laureate was yoked to the museum's mural and its perspective. Herrera's life and work grow from parts of the American West, but that work does not identify itself as western. Instead its focus is California or a north–south axis of Chicano/a regionality or spiritual-cultural nationhood. Does it add anything to Herrera's work to be identified as "western" or for him to be honored as a carrier of the "spirit of the West"?

Herrera was born in the town of Fowler outside Fresno, California, in 1948, graduated from high school in San Diego, and attended UCLA as an Equal Opportunity Program student. Graduating in 1972, he was perfectly timed to participate in the Chicano movement. Among his key artistic influences were folk singer Woody Guthrie (see chapter 15); Luis Valdez, the creator of El Teatro Campesino, which brought farmworkers into folk and avant-garde theater productions, particularly in California; and Beat poets like Allen Ginsberg. All were westerners of a sort (Ginsberg, a non-westerner, spent key years in San Francisco), but none of them were depicted in the Autry's mural. Herrera would forge those influences into something open, something kind but also politically urgent, and in this way he calls to mind Walt Whitman. Though an easterner, Whitman wrote, revised, published, and republished his classic *Leaves of Grass* across a period of intense westward expansion, beginning in 1855.

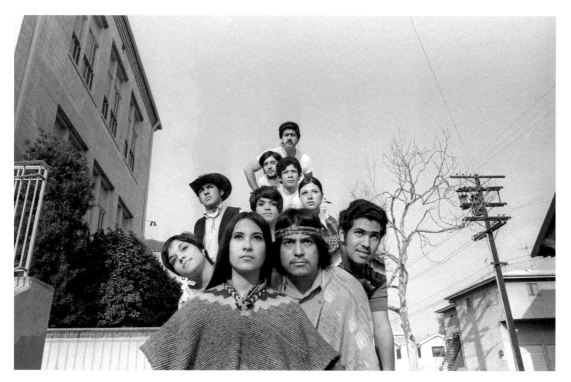

FIGURE 12.1. Guadalupe Saavedra and other members of Teatro Popular de la Vida y Muerte pose in front of the Euclid Heights Community Center in Boyle Heights, Los Angeles, circa 1970. Photograph by Manuel G. Barrera Jr. ©Manuel G. Barrera Jr. From the *La Raza* photograph collection. Courtesy of the photographer and the UCLA Chicano Studies Research Center.

This photograph was featured in the Autry Museum's exhibition *La Raza* (2017–19), about the photos produced through the Los Angeles newspaper *La Raza* between 1967 and 1977.

His all-embracing poetic vision was the kinder side of Manifest Destiny, welcoming the conquered lands into his freedom-loving bosom even as he acknowledged at times the coercion involved. One stanza of "Song of Myself" begins, "I saw the marriage of the trapper in the open air in the far-west. . . . the bride was a red girl," but the love scene is soon undercut: "One hand rested on his rifle. . . . the other hand held firmly the wrist of the red girl."[2] A similarly populist, voracious spirit (of the West?) appears in Guthrie, Ginsberg, and Valdez. Herrera evokes many characteristic regional elements, and his work also reflects deep engagement with Latin American Indigenous traditions and histories from his extensive sojourns south of the border.

"Rodney King, the Black Christ of Los Angeles & All Our White Sins" seems like a characteristic piece through which to explore Herrera's place in the West. Written in 1992 and published in 1994, the poem pans a kaleidoscopic lens across a western city in flames in the wake of four white policemen being found not guilty

of beating a black man despite the brutality having been captured on video. The Los Angeles uprising of 1992 and public awareness of racial discord in the West are said to have helped spur the "small improvements" Acuña noted at the Autry, changes that perhaps felt more momentous and progressive within the museum's walls than they looked to Acuña.[3] In Herrera's poem, Pampers and bread are looted ("the toasters / with extra-wide slots are ours too"), a war zone erupts (a motorcycle burns "into a chrome praying mantis"), and the black-white-Chicano-Korean metropolis overheats ("talkative gutters full of rainbow juice, / the kind that comes from radiators, skulls, / cracked batteries").[4] The poet's despair before this view, even as he seems to understand and love the city and its people, bleeds onto the page.

Near the end of the poem, Herrera writes, "I am carrying a triple landscape in my head. / . . . I can see everything—San Francisco, / Guadalajara, and the city which was an empire / once upon a time."[5] Seeing the United States, Mexico, and Aztec empire in simultaneous layers like film triple-exposed (I understand the third city he mentions as Tenochtitlan), Herrera achieves a panoramic borderlands, *la frontera* perspective. His ability to see *everything*, often assumed only by Anglo observers, reorients this California landscape. Tenochtitlan and Guadalajara form its primary historical and personal basis, and the likes of London or Chicago or Atlanta go unmentioned. With this perspective California is not "the West," really, but *el Norte*—upper or Alta California above Baja California (as it is also "the Center" for its Indigenous peoples). Double, triple, *n*-tuple landscapes such as the one envisioned in Herrera's poem, might be the sine qua non of the imagined West. Herrera uses the phrase "once upon a time" and the power of storytelling, calling to mind Sergio Leone's *Once upon a Time in the West* (1968).

Like Gloria Anzaldúa, Juan Felipe Herrera has long understood the need to reform language to reflect this layered landscape. In a book titled *Mayan Drifter: Chicano Poet in the Lowlands of America* (1997), Herrera concluded (writing of himself in the third person) that he had to "disrupt the terms, figures, and images of colonialism if he dared search for the way into America, a path leading back home." He had to resist or rework "the master's conquest language," and thus, while working primarily in English, "become a trickster, a language saboteur."[6] Perhaps Herrera's title, evoking Clint Eastwood's *High Plains Drifter* (1973), was such a trickster gesture. Trickster tales play key roles in many Indigenous cosmologies, and Michelle Raheja has argued that many American Indian film actors practiced trickster strategies to sabotage (in Herrera's term) the colonial stories onscreen.[7] Many writers sabotage their inherited languages, but in a borderland, where the language of conquest dominates, this choice often moves closer to the center of one's project.

The title "Spirit of the West" reflects a conquest language. And indeed Conquest is one of the seven articulated "spirits" on the Autry's mural. Accepting the Spirit of the West Award required Herrera to enter an edifice built in terms of the conquest language. Maybe the museum's basic perspective will endure such visits, as Rodolfo Acuña seemed to expect. But it is possible that Herrera's presence disrupted the terms and images of colonialism that will nevertheless continue to frame the Autry Museum for a long time. In Herrera's acts of creative sabotage, of tricksterism, there may be a path leading home, a way into America, with "America" signifying not just the United States but what borderlands historian Herbert Bolton called Greater America.

part four

THREE TAKES ON OKLAHOMA

W. ZAKRZEWSKI

PIERWSZY WESTERN
SCENICZNO-MUZYCZNY
BARWNY CINEMASCOPE

OKLAHOMA

REŻYSERIA:
FRED
ZINNEMANN

WYKONAWCY: GORDON MAC RAE, GLORIA GRAHAME
GENE NELSON, SHIRLEY JONES, ROD STEIGER I INNI
PRODUKCJA: MAGNA FILM, A. HORNBLOW, JR.

CWF

13. AN OLD SONG
On Oklahoma!

The musical *Oklahoma!* hails from the boom years of cowboy Westerns, and one suspects this timing spurred its making and success. The stage show debuted in 1943 and the film version in 1955. Studded with hats, boots, revolvers, and ponies (onstage, implied ponies), both iterations rate as midcentury western regional classics. Yet the musical is virtually absent from the Autry Museum's collections except for a movie poster that is part of a trove of Polish posters (see fig. 13.1). Curly McClain, the hero, does not appear in the museum's panoramic mural alongside his contemporaries Will Kane (Gary Cooper) and Nathan Cutting Brittles (John Wayne). This reflects a broader absence in the museum's cultural collections, related to what I have been calling regional westerns. Despite its cowboy trappings, *Oklahoma!* is more a regional than a genre work. The museum holds little related to Willa Cather, Laura Ingalls Wilder, Jack London, John Steinbeck, Georgia O'Keeffe, Thomas Hart Benton, Woody Guthrie, or other twentieth-century regionalists from various parts of the West. All of these canonical artists were Anglo westerners, celebrated in mainstream America at the time the museum was founded in the 1980s, and their absence reflects the museum's focus on the Western genre.

The museum's proximity to Hollywood, geographically and personally via Gene Autry, likely accounts for much of its cowboy-ness. One of my intentions with this book was to bring regional work onto the same dance floor with the Western genre. A reconsideration of *Oklahoma!* shows that the two have already danced together. It is a stranger and more complicated work than many of us may remember, a tangle of Western, folk regionalism, and cutting-edge art.

Two easterners, Richard Rodgers and Oscar Hammerstein II, have deservedly received critical acclaim for *Oklahoma!* But beyond their crucial contributions as composer and lyricist, the *Oklahoma!* stage show and film are most surprising *between* the oh-so-memorable songs. Particularly striking are a hard-whittled dialect in most of the spoken scenes and a long dream ballet that seems birthed from a 1940s psychoanalyst's couch.

FIGURE 13.1. Witold Janowski, Polish poster, *Oklahoma!*, 1964. Lithograph, 33⅜ × 22¾ in. Autry Museum of the American West, 96.48.6.

These elements derive largely from two western artists who contributed to the production. Lynn Riggs, a gay Cherokee regionalist, wrote *Green Grow the Lilacs*, the somewhat stilted play on which Rodgers and Hammerstein based *Oklahoma!* And Agnes de Mille, a Californian, choreographed the production, including the trippy dream ballet. Both Riggs and de Mille sought to create avant-garde work rooted in a real place and real histories they had known, and this added richness and queerness to what became a mainstream classic.

Green Grow the Lilacs debuted at the Theater Guild in New York in 1931. The play, like its musical adaptation, drips with dialect. Here is the first line, from Aunt Eller: "Oh, I see you, Mr. Curly McClain! Don't need to be a-hidin' 'hind that horse of your'n. Couldn't hide them feet of your'n even if yer head wasn't showin'." Throughout the text, "f'ar" is the preferred spelling of "fire," and "skeered" is used for "scared" and "sump'n" for "something." The published text even included a glossary that included such terms as "dogies," "shikepoke," "maverick," and "yellin' calf-rope."[1]

At first this slang, and the same type of talk in *Oklahoma!*, sounds like mere cornpone slapstick. But, however clumsily, Riggs was up to something else. One of his directions to actors in the text explained of the characters, *"Their speech is lazy, drawling, not Southern, not 'hick'—but rich, half-conscious of its rhythms, its picturesque imagery."*[2] This description reached for a specific tone Riggs could hear in his mind's ear. Subtitled *A Folk-Play in Six Scenes*, *Green Grow the Lilacs* was also a folk-musical, including a dozen "old and traditional" tunes, from cowboy songs to "Skip to My Lou." Riggs wrote in his preface: "It must be fairly obvious from reading or seeing the play that it might have been subtitled *An Old Song*. The intent has been solely to recapture in a kind of nostalgic glow . . . the great range of mood which characterized the old folk songs and ballads I used to hear in my Oklahoma childhood—their quaintness, their sadness, their robustness, their simplicity, their hearty or bawdy humors, their sentimentalities, their melodrama, their touching sweetness."[3]

Riggs did not mock his characters' speech and folkways, even if their dialogue sounds corny now. He haloed "my Oklahoma childhood" with an earnest, "nostalgic glow." This was the work of a native (and Native) son, gone off to the big city (he lived in both Los Angeles and New York), now honoring his home folks, attempting to forge their world into a modern work of art. Riggs was only eight years old when Oklahoma Territory became a state—the historical moment of the story—so his nostalgia was as much invented as remembered. But he tried to push that invention toward some artistic truth.

Riggs died the year before the film version of *Oklahoma!* appeared, and he was forgotten except as a footnote for his role in the musical's creation. In recent decades he has been

rediscovered as both a pioneering Native American writer—he was a citizen of the Cherokee Nation—and as a gay writer.[4] While he never publicly grappled with his gay identity, another Riggs play, *The Cherokee Night*, from 1932, featured contemporary Cherokee characters exploring their place in modern America.

Like Riggs, many artists and writers in the 1930s and '40s sought out the "folk" in its varied regional (often rural) forms. Like him they channeled local color and cadence. Some of the most widely respected American visual artists were regionalists who staged a "revolt against the city," as Grant Wood put it, to cast off the inferiority that sent all ambitious artists to mimic European traditions.[5] Other creators like Zora Neale Hurston, Josh White, Billie Holiday, William Faulkner, and James Agee and Walker Evans brought rural African American and white worlds from the American South into conversation with avant-gardism.[6] Covering both the Midwest and Far West, John Steinbeck wrote *The Grapes of Wrath* (1939) about the Joad "fambly" walking on their tired "dogs," demonstrating the "human sperit." As we will see in chapter 15, Woody Guthrie battered and fried his leftist insights as "Commonism" and "dialecticle matternilisation." Archaeologist Oliver La Farge depicted the Navajo Nation in the Pulitzer Prize–winning novel *Laughing Boy* (1930), and William Saroyan portrayed Armenian-American California in various novels. Saroyan cowrote a song in 1939, "Come On-a My House," in a kind of immigrant dialect that recalls Riggs's writing. In a jaded beholder's eye or ear, any of these examples may seem to slip into the hokey or maudlin. Yet taken together they form a broad, ambitious cultural labor to render and honor the genius of every community, every American. The provincials and the poor had something to offer the cosmopolitans and the canon. This celebration of the regional was not limited to America. Spanish poet Federico García Lorca passionately promoted *cante jondo* or Andalusian "deep song," in the 1920s and '30s, comparing it to Russian traditions: "As Ivan Turgenev saw his countrymen (Russian blood and marrow turned to sphinx), so do I see many poems of our regional folk poetry. Oh sphinx of the Andalusias!"[7]

A less optimistic way of reading these regional American works is to say they consumed or even colonized the cultures they sought to honor—mining raw material for export. Even the locals (Hurston, Saroyan, Guthrie, and Riggs) might sell out their folks in translating for outsiders. Might gathering and broadcasting local forms of genius create—paradoxically—a duller unity? Regionalist artists might mimic the speech rhythms and surface patterns of so-called folk cultures without fully engaging the worldviews or histories underlying them. This could create homogeneity, with superficial differences, akin to a folk songbook or a "world music" compilation album. It remains difficult (at least for me) to balance an

admiration for these earnest artistic and documentary endeavors with the fact that they commodified Americana for mainstream audiences, possibly diluting the power of the diverse points of view in various communities. This issue is also a concern in a museum, such as the Autry, that seeks to be encyclopedic. Still, these works of folk-inspired art and other presentations of vernacular culture can be rediscovered and reinterpreted over time, sometimes serving the communities from which they came.

Rehabilitating Riggs as a Cherokee writer remains an ambivalent enterprise. In mainstream portrayals, Indians stalk through an invented past in which they eventually vanish. Except in *The Cherokee Night*, Riggs largely erased his fellow Native citizens from Oklahoma. That *Green Grow the Lilacs* and *Oklahoma!* lacked any visible Native American presence (or African American presence) in eastern Oklahoma is astonishing but instructive. *Green Grow the Lilacs* included a few cryptic references to Indian Territory's (and the West's) violent colonization. The mournful, geographically misplaced ballad "Custer's Last Charge" interrupted an upbeat dance scene. The character Laurey mentions, symbolically, "In the Verdigree bottom the other day, a man found thirty-three arrowheads—thirty-three—whur they'd been a Indian battle."[8] But limiting Native existence to a kind of haunting leaves us little to rediscover in *Green Grow the Lilacs* as a Cherokee play. A heated exchange near the end of the play infuses a potentially rich, Indian tincture into the plot, which several critics have noted. When a group of men deputized by the federal marshal come to take Curly back to jail to eventually be tried for killing Jeeter (the play's version of the film version's villain, Jud), Aunt Eller persuades them to stand down by arguing that the United States is "jist a furrin country to me," without jurisdiction in Indian Territory. The men among the posse declare, "Now, Aunt Eller, we hain't furriners. My pappy and mammy was *both* borned in Indian Territory! Why, I'm jist plumb full of Indian blood myself. . . . Me, too! And I c'n prove it!"[9] Literary critic Craig Womack (Muscogee Creek/Cherokee) writes that "Riggs's Indian identity and gay identity are the two most relevant aspects of his life and work, but owing to the constraints of his time, he was forced to deal with these issues through coded statement." The closet, Womack argues, constrained Riggs's Cherokee identity as well as his sexual orientation. The closet inspired nostalgia for a golden moment prior to Riggs's sexual awakening, while still writing in what Womack calls a coded "Oklahomo" subtext.[10] This is certainly plausible. But Riggs's deep sympathy for settlers widely taken to be white stands at center stage in *Green Grow the Lilacs*, and in *Oklahoma!* the Indigenous subtext fades even farther into the background.

Oklahoma! included one notable and surprising character: the Persian peddler Ali Hakim. He is played as a cartoon, for laughs. In Riggs's play he is simply the Peddler,

described as "*a little wiry, swarthy Syrian, . . . very acquisitive, very cunning*" with "*beady eyes.*"[11] Riggs may have included him based on a memory of Middle Eastern immigrants in Oklahoma Territory—but the peddlers he would have remembered would almost certainly have been Lebanese Christians, whereas Ali Hakim was portrayed as Muslim. The film made a joke of him, explaining that nearly all men in Persia had numerous wives, stoking an Orientalist fascination with harems and veiling any actual Muslim history in the West. (A mosque built by Syrian homesteaders on the western North Dakota prairie in 1929 may be the first in the United States.)[12] A whiff of anti-Semitic stereotype hung around both versions of the peddler as foreign, conniving, and other. But, however caricatured and distorted, Ali Hakim added a wrinkle to the invented West, a predecessor to Rabbi Avram Belinski in *The Frisco Kid* (see chapter 4). Both characters are a nod to the demographically complex reality of the region, past and present.

Ali Hakim turned out to inspire, as a kind of drug guide, another aspect of *Oklahoma!* I want to draw out here—Laurey's dream, the long interlude choreographed by Agnes de Mille, a contributor equal to Lynn Riggs in shaping the musical's regional high-art strangeness. Hakim sells Laurey a potion for her worries, and drinking it sends her into a surreal inversion of the plot, played wordlessly in ballet. Coming just before intermission, the fifteen-minute dream-ballet interlude confounds those expecting straight Broadway, let alone barn dances. In the film version, the actors playing Laurey and Curly pass off their roles to dancer doppelgängers, who for five minutes whirl toward the country church altar in a pas de deux, amid a stylized prairie scene. Then, in the middle of the ceremony, the ogreish Jud interrupts, and the friends and family retreat, leaving dancer Laurey to flee through a series of portals. The church doors lead to a barnyard, and Jud's cabin door leads to an incarnated boudoir photograph. (Jud's French pornography reveals his perversion.) There, for another five minutes, dancer Laurey wilts and panics as boudoir ladies taunt her with sexy dances and Jud swaggers around his fantasyland, which includes raging gas lanterns and a staircase to nowhere. Finally she flees outside again, where a tornado gyrates. Dancer Curly appears and impotently fires his revolver's six bullets at Jud. A dance-fight ensues. As dancer Laurey and the dancer townsfolk look on helplessly, Jud prevails, and dancer Curly dies. All of this plays out to a nightmarish montage of the songs we've already heard, a kind of *under*ture.

This unsettling interlude, spinning across a dream prairie, jangles strangely against the folksy dialect based on Lynn Riggs's work and the neat Broadway rhymes from Oscar Hammerstein. But it grew from a single artist's distillation of the same regionalist cultural moment as Riggs's play. Agnes de Mille, the choreographer, was a westerner of a different

stripe from Riggs. Born in New York City in 1905, she inherited two intellectual and artistic legacies. Her uncle was the great filmmaker Cecil B. DeMille, and her father, William C. DeMille, was a lesser-known playwright and filmmaker. On her mother's side she was the granddaughter of the hugely influential Gilded Age economist Henry George, who wrote the best-selling critique of capitalism *Progress and Poverty* while living in San Francisco. Agnes de Mille's family helped tap the gusher of early Hollywood, and she grew up in Los Angeles and studied at UCLA. One of her first compositions upon moving to New York in the 1920s was *'49*, a Gold Rush piece she believed to be "the first use of American folk material on the concert stage."[13] She set it to music by David W. Guion, who famously rendered "Home on the Range" as sheet music.

De Mille reflected in 1951, before the film version had been made: "I had remembered how, as a little girl sitting in the Fred Harvey [railroad] car, I had seen the prairies for the first time and recognized the meaning and the love of those large lands and realized things I had never personally known but which seemed clearer than the actual calendar experiences of school and home."[14] This was Riggs's *nostalgic glow*, tempered by a self-reflection Riggs could not seem to allow himself. She was also following advice she had received from the southwestern regional writer and family friend Mary Austin: "You must let the rhythm of the American earth come through what you do."[15] In her wonderful memoir *Dance to the Piper* (1951), de Mille credits the West's role in American dance: "It is no accident that California produced our greatest dancers, [Isadora] Duncan and [Martha] Graham, and fostered the work of [Ruth] St. Denis, Doris Humphrey, [Carmelita] Maracci and [Janet] Collins. The Eastern states sit in their folded scenery, tamed and remembering, but in California the earth and sky clash, and space is dynamic."[16] De Mille, herself raised in California, rose to become a major figure in twentieth-century dance, best known for her Americana ballets, especially the cowgirl ballet *Rodeo*, which premiered at the Metropolitan Opera House in 1942. Aaron Copland composed the score, which includes the sections "The Courting at Burnt Ranch," "Corral Nocturne," and "Hoe-down." Like *Green Grow the Lilacs*, and like de Mille's early piece *'49*, *Rodeo* is built on old folk songs. The famous, memorable "Hoe-down" tune matches, almost note for note, the fiddle tune "Bonaparte's Retreat," based on a field recording of the Kentucky fiddler William H. Stepp.[17] De Mille won the *Oklahoma!* gig soon after *Rodeo*.

"Corral Nocturne." The Spanish-French mash-up title of that section of *Rodeo* might sound mannered, dissonant. (To be performed by a buckaroo artiste?) But, like *Green Grow the Lilacs*, *Rodeo* and the dream ballet in *Oklahoma!* grew from a broader movement of western-themed art dance. Following de Mille's *'49*, in 1934 the Ballets Russes de Monte-Carlo staged

Union Pacific, joining railway to *relevé* with a golden spike. The next year, modern choreographer Martha Graham staged *Frontier*, a solo of a pioneer woman's passion, setting it against a single section of wooden fence as a bar. In 1940 Graham staged the New Mexico–themed dance *El Penitente*, featuring modernist dance icon Merce Cunningham as a Christ figure. The sets of both *Frontier* and *El Penitente* were the work of Isamu Noguchi, the Los Angeles–born, globe-spanning, half-Japanese modernist who had first apprenticed with Mount Rushmore sculptor Gutzon Borglum. (Noguchi would voluntarily enter a concentration camp for Japanese Americans, the Poston War Relocation Center on the Colorado River Indian Reservation, to try to improve conditions for internees with his design skills.) Other choreographers took on western themes. Eugene Loring staged *Billy the Kid* (1938) and *Prairie* (1942). Aaron Copland composed the score for *Billy the Kid*. Sophie Maslow, a Martha Graham dancer, used Woody Guthrie's songs in the ballet *Dust Bowl Ballads* (1941) and *Folksay* (1942), introducing Guthrie to his second wife, Marjorie Mazia, in the process.[18] Here was a tradition for Agnes de Mille to join with *Rodeo* and then *Oklahoma!* The mix of down-home and avant-garde bubbled like mulligan bisque.

Oklahoma! was a runaway Broadway hit, with songs like "Oh, What a Beautiful Morning" and "The Farmer and the Cowman," but its roots in the folk and high-art hybrids of an earlier era feel submerged in the 1955 film version, shot in Arizona and on Hollywood back lots, directed by *High Noon*'s Fred Zinnemann. The work changed, and the context also changed. After World War II, just as Woody Guthrie became a national voice ("This Land Is Your Land") and Wyoming painter Jackson Pollock abandoned a regionalist style for the individualist heroics of abstract expressionism, the Western became a codified and dominant genre. At the same time it grew away from personal experience of the region that gave it its name.[19] *Oklahoma!* may not be a strict genre Western, but as a classic American musical it has offered millions of viewers an unusual amalgam of Western genre trappings and those of a less-celebrated tradition—a western folk- and high-art hybrid, exemplified by the contributions of Lynn Riggs and Agnes de Mille. The Western's laconic, stiff-walking heroes were joined in their pantheon by a cast of talkative regional characters and a dreamlike ballet.

14. WHAT A RIVER KNOWS

On August 5, 1940, two young New York professors visited with Flora Robertson, who was living in the Farm Security Administration (FSA) camp at Shafter, northwest of Bakersfield in California's San Joaquin Valley. The Shafter FSA camp was a grid of tents on wooden platforms around shared laundry and restroom facilities, with saplings planted along the dirt streets. Charles Todd and Robert Sonkin, both from the City College of New York, carried with them a Presto recorder connected to a microphone the size of a sixteen-ounce vegetable can. Robertson was about forty-one, and Todd and Sonkin were in their late twenties. Mary Sullivan, another Shafter resident, sang them one of Robertson's poems, titled "Our Mothers," as an a cappella waltz, noting that Robertson was present but "too bashful to read it—sing it."[1] Robertson seemed more comfortable speaking about her life in western Oklahoma, which she had fled amid ecological and economic calamity. She told one haunting, prophetic story that outshone the short poem it introduced, a story that cast the Dust Bowl in an unfamiliar light not seen in the iconic images of Dorothea Lange or the stories of John Steinbeck.

Robertson's story was already underway by the time the sapphire needle began carving the acetate or glass disk, moved by the power of her voice and a finicky electric battery.[2] But it becomes clear that her story is of the November 27, 1868, so-called Battle of Washita River, just north of where she and her husband would farm in Oklahoma. More than thirty years before Flora Robertson was born in Arkansas, Lt. Col. George A. Custer launched a surprise dawn attack on a Cheyenne camp along the snowy Washita River. Custer enacted a policy of total war—kill the horses, burn the tents and food, shock and awe the Cheyennes into subjection. Black Kettle, the chief at this particular camp and a survivor of the infamous Sand Creek Massacre of 1864, had one week earlier been seeking peace with the US Army at Fort Cobb, a hundred miles to the east. The Medicine Lodge Treaty of a year earlier was straining under continued attacks on railroad construction and settlers' homesteads by Dog Soldiers, young Cheyenne and Arapaho men who resisted Black Kettle's peace entreaties. Custer—and Maj. Gen. Philip Sheridan and Gen. William T. Sherman above him—believed all Cheyennes to be enemy combatants and that an attack by one justified war

on the whole Cheyenne people. "Now this must come to a violent end," Sherman wrote. Black Kettle and his wife, Medicine Woman Later, were among Custer's first victims, shot off their horse in the middle of the Washita. Perhaps three dozen other Indian men, women, and children were killed, along with twenty-one US soldiers.[3]

Black Kettle, Flora Robertson recounted at Shafter, had "dreamed that a wolf come into the camp" with "a lot of spots of blood on it. And he told his people, he says, 'Black Kettle will stay with his people, but the enemy will come, and many squaw and papoose will be killed. But Black Kettle will stay with his people.'" It was unclear where Robertson learned this story. In her telling it she flirted with the codified dialect of "Tonto talk," translating her idea of Black Kettle's Cheyenne speech into affected Western-genre-influenced English.

"See," she continued, "his nephews and part of his children identified his bones and his body by the ornaments they found with it and part of his teeth whenever he was dug up, or washed up, rather."

"When was this, when they found the bones?" the New Yorkers asked.

"Nineteen thirty-four, fourth day of April, was when the flood come."

"You think he prophesied the flood?" You can almost hear eastern eyebrows arching in disbelief.

Robertson seemed to retreat. "Well, he just meant that something terrible would happen, and he knew the white people was doing him wrong, you see? Was going to do him wrong, and he said the Great Spirit had warned him of this, and then, of course, the Indians warned us the flood was coming, and they moved out of the camp—they camp between Hammon and Cheyenne."

"And they warned the white people that the flood was coming?"

"And we wouldn't move out, we didn't pay them any attention. And the wealthiest land men and cattlemen, you see there is—they have their big ranges up and down this Washita River on Cheyenne, or by Cheyenne. And it was them that suffered the most, because the river overflowed, and it was terrible, the amount of cattle that was killed

FIGURE 14.1. Sculpture, cigar store Indian, late nineteenth century. Carved wood on pedestal. 75⅝ × 16⅝ × 19⅝ in. Autry Museum of the American West, 86.24.51.

Cigar store Indians sometimes seem to offer tobacco, an indigenous plant, to customers. This tradition may sanitize the taking of Native American life or property—or perhaps a cigar store Indian is just a cigar store Indian.

there, was drowned. And not only cattle, it was a lot of the people that was washed away and killed. One of my neighbors, Mr. Adams, lost his wife and five daughters in the flood. It washed them all away. And it just seemed, you know, I said this, but if we'd have paid attention to those Indians, why, it might have helped us out a little. They was close kin after all."[4]

Here was something new in Dust Bowl lore, a white Okie refugee, a homegrown poet, drawing a connection from the ecological destruction of her community to the history of settler colonialism in the southern Great Plains. The racial hierarchy that separated a Cheyenne camp from their non-Indian neighbors caused the latter to discount a warning—"we didn't pay them any attention"—but years after the tragedy Robertson reflected that perhaps blood spilled generations earlier had stayed in the soil and blown up into deadly storms as retribution. Perhaps too her Cheyenne neighbors were "close kin after all." Much more clearly than in Lynn Riggs's work (see chapter 13), a Native American presence entered a famous image of white Oklahoma, in this case the Okie refugees in California's San Joaquin Valley. With exceptions, the construction of Americana and "folk" cultures in the 1930s and '40s have focused on African American and southern white cultures (also described in chapter 13). But other cultures—in this case, Native peoples—are evident in folklore recordings.[5]

The poem Robertson's story introduced, "Why We Go to California," is superficially less moving than her story:

> Here comes the dust storm,
> Watch the sky turn blue.
> You'd better get out,
> Or it'll smother you.
>
> Here is the grasshopper,
> He comes a-jumpin' high.
> He jumps across the state
> And never bats an eye.
>
> Here comes the river,
> It surely knows its stuff.
> It takes home and cattle,
> And leaves the people feeling tough.

California, California,

Here I come, too.

With a coffee pot and skillet

I'm coming to you.

Nothing's left in Oklahoma

For us to eat or do.

There's apples, nuts, and oranges,

And Santy Claus is real.

Come on to California,

Eat and eat 'til you're fill.[6]

The blocky rhymes and rhythms might uncharitably be called doggerel. Yet real pathos pervades it. Verse couldn't capture a dust storm any better than a funnel and a jar. Precisely because of this, two of the most striking lines to my ear are "Nothing's left in Oklahoma / For us to eat or do." Robertson boiled the necessities of life down to two monosyllabic, common verbs, "eat" and "do."[7] Her story about Black Kettle and other details from her recorded interview added jaw-dropping footnotes that explode her poem into greater resonance. She described having ridden on a crate in a covered wagon as a child from Arkansas to central Oklahoma with her parents, and she described her parents' first log cabin, built near a tree where vigilantes hanged horse thieves and burned Indians at the stake when she was a child in the last years before statehood in 1907. Among the few possessions Robertson brought with her to California ("coffee pot and skillet"), she brought two pages about her maternal grandfather fighting in the Texas Revolution against Mexico in 1835 and 1836. She described her neighbors dying of "dust pneumonia" and butchering a sixty-dollar cow that died in a dust storm only to find the inside of its lungs "looked just like a mud pack" ("it'll smother you"), and she recalled dust storms that were red or black depending on which way the wind blew.[8] Probably most striking is the line asserting that a river "surely knows its stuff," which perhaps meant that Black Kettle was shot midstream in that river in 1868 and that his remains washed up in a flood, foretelling the disaster that would befall white farmers and ranchers three generations later.

Was there any truth to Robertson's folk history? A little. On April 4, 1934, the Washita River overflowed its banks near Cheyenne, Oklahoma, just north of where the Robertson family farmed. It was national news. "A murky monster Wednesday rolled over the usually placid sand bed of the Washita River, seizing sleeping homes and hiding the fate of dozens

of men, women and children, white and Indian alike," one national story began.[9] Another journalist wrote of "red waters, in su!len retreat" that "bared the toll of Wednesday's fury." A Mr. A. M. Adams lost his wife and five daughters in the flood, and seventeen people died in all, but Chief White Shield of the Red Moon agency of the Cheyenne-Arapaho tribes told the reporter that no Indians were among these despite there having been two Indian camps in the path of the flood. Robertson's story and poem connect the flood with Black Kettle's attempt to retreat into Indian Territory ahead of Custer's total war, right down to an image of blood turning the water red.[10]

And the human remains? In the late 1920s or early 1930s an elderly Cheyenne named Magpie told historian Charles J. Brill that he had been at the attack on the Washita. Magpie said he had found Black Kettle's body in the river the day after that but left the scene before others decided where to bury it. On July 13, 1934, construction workers digging alongside the Washita to build a bridge (perhaps to replace one washed out during the flood three months earlier) disinterred a skeleton with "ornaments"—Brill used the same word Robertson did—reportedly similar to some of Black Kettle's.[11] Gruesomely but not unusually, this skeleton was displayed first at a newspaper office in the town of Cheyenne, and then at the local museum. Maybe Flora Robertson saw this before she left Oklahoma. Maybe she heard about it. Much later, in 1968, Cheyennes would persuade the museum to rebury the remains beside the flagpole there, and it is reported that at some point a physical anthropologist examined the skeleton and determined that it belonged not to an elderly man but to a twenty-year-old woman.[12]

While evidence suggests that Black Kettle's remains did not wash up in the flood, what many believed to be his remains appeared shortly afterward during the bridge construction. Robertson may have synthesized this series of events in her story, which was an ominous indictment of colonialism and racism. Perhaps others came to the same understanding. The presence of an even broader history imbued the Okies' tent city in Shafter, California. In an untitled poem, Robertson referred to her family living in a tent there "like Abram of old," reaching back to biblical days. The Shafter camp newsletter, *Covered Wagon News*, likewise looked back, if not so far. At least two issues depicted parallel front-page cartoons of a horse- or ox-drawn prairie schooner labeled "1850" or "1859" and a motor vehicle caravan labeled "1940." These were evidently an attempt to dignify the Dust Bowl migration by conflating it with Manifest Destiny, but their effect today is to darken the romance of both overland trails.[13] Robertson's poetry and oral history likewise add complexity and lend a sobering effect to the oft-told story of the Dust Bowl migration.

15. A CALIFORNIA COMMONIST

During the 2016 US presidential election campaign, Woody Guthrie went viral. It seems that around 1951 he wrote some verses decrying the way "Old Man Trump," rich father of a leading candidate, stirred "Racial Hate . . . in the bloodpot of human hearts" by drawing a "color line" as landlord of a huge, publicly funded apartment complex in Brooklyn named Beach Haven.[1] The story confirmed what many Woody fans already knew about their beloved hardscrabble babbler, that he brought a populist Okie voice, racial egalitarianism, and Whitmanesque wordsmithery to New York City and its folk scene. But it also showed that his politics were preternaturally relevant to our own time and parallel to those of, say, his fellow Oklahoma expat Elizabeth Warren, US senator from Massachusetts. Guthrie was an adaptive, adaptable genius, and, like Walt Whitman, he contained multitudes.

A few years back, I decamped from Brooklyn and soon landed in Los Angeles. As a native South Dakotan I always should have known better, but after nearly a decade living in New York City I had to relearn that the island metropolis is not the undisputed center of the earth. At about the same time, this truth was reinforced by a new collection of essays published as *Woody Guthrie L.A.: 1937 to 1941* and edited by Darryl Holter and William Deverell. As one contributor, historian Peter La Chapelle, put it, "Los Angeles, not New York, served as the locus of Woody's political transformation, and . . . it was in Southern California that he really began to blend the folk and commercial music-making traditions of his home region [Oklahoma and Texas] with the kind of politics that he would eventually be associated with."[2]

Here is a slightly different present-day adaptation of Woody, a rediscovered prophet for a time when TV shows are as literary as the stuff New York publishers print, when Pope Francis has Lazarused the social gospel, when debt peonage and drought are surging; and when "refugee" is a trending search term. Indeed, Woody became what we know as Woody amid his sojourns in Los Angeles between 1937 and 1941, when he was in his mid- to late twenties. The lack of emphasis on these years by early Guthrie biographers reflects the fact that relatively little of his writing and music survives from this time, though persistent digging by enthusiasts and scholars has recently yielded more. Woody's politicization and

FIGURE 15.1. Album cover art, *Cowboy Songs Sung by Woody Guthrie and Cisco Houston*, Stinson Records SLP 32, released 1963. Jacket, 10½ × 10½ in. Gift of Fred Hoeptner. Autry Museum of the American West, 2010.63.450.

New York–based record shop owner Herbert Harris founded Stinson Records, which initially distributed Soviet and other international recordings. In the 1950s Stinson moved to Los Angeles and released music by folk, blues, and jazz artists. Known for its red vinyl records, the label remains in the family, owned by Harris's granddaughter Karen Williams.

ultimate artistic vision depended on unique features of Depression L.A., and *Woody Guthrie L.A.* casts light on this.

Woody Guthrie's California change was stark. He arrived at his aunt's house in Glendale as a redneck class clown, a talented yarn-spinner with loose southern Democrat politics and evangelical faith. He left expressing such sentiments as "To own everything in common. That's what the Bible says. Common means all of us. This is old 'Commonism.'"[3] Fully considering this time in Guthrie's life means grappling with his inherited white supremacist beliefs. Beyond noting Woody's father Charley's probable involvement in a 1911 lynching, *Woody Guthrie L.A.* reproduces some appalling poetry Woody himself wrote after an encounter with some African American beachgoers in Santa Monica, probably in 1937, which imagined the black folks with "jungle blood" and "doing a cannibal dance."[4] The racist notions he had learned in Okemah, Oklahoma, or Pampa, Texas, had not been sloughed off before he landed in California. Los Angeles was part of the US-Mexico borderlands and the Pacific Rim, as well as being home to the more familiar black and white immigrants from the South. In October 1937, a black college student, Howell Terence, wrote Guthrie to say that

he "deeply resented" Woody's performance of "Nigger Blues" over the air on KFVD's *Woody and Lefty Lou* show. ("Lefty" was fellow singer Maxine "Lefty Lou" Crissman.) Terence informed Guthrie that "no person, or person of any intelligence, uses that word over the air today." A news announcer had been fired from another station a year earlier, he warned, and the letter taught Woody that public mores were different in California than Oklahoma or Texas. Woody apologized on air and apparently began to assimilate racial equality into the leftist political ideas he was beginning to discover in Depression Los Angeles.[5]

As Guthrie began to shed his racist views, he alternately dragged around and then abandoned those closest to him, his first wife and two children. This raises the question of what exactly we celebrate when we celebrate Woody, and about his possible romanticization as a "lone wolf" (his radio moniker was Lone Wolf) and genius artist.[6] He coined great nicknames and wrote silly-billy songs for his children until he decided to carouse on Skid Row for a few days or tour for a few months. The damage this did to his family, and the paradox of his generosity and selfishness, remains unreckoned in most celebrations of this bard.

Some of the most surprising and fruitful parts of *Woody Guthrie L.A.* are those that stretch beyond Woody's artistic and political evolution to consider the city more broadly. One aspect of Guthrie's biography the book brings to light is his connection to the New Thought movement, which embraced "harmonial" positive thinking, faith healing, and even financial success through scientist, interfaith beliefs. Woody, it seems, operated a "Faith Healing, Mind Reading" enterprise in Texas in 1935.[7] In Los Angeles the New Thought ideas earlier popularized by Franz Mesmer and Mary Baker Eddy, among others—forerunners of *National Treasure*, Dianetics, and *The Da Vinci Code*—intermingled with tent-revival Protestantism. This influenced Woody's characterization of Jesus Christ (set to the tune of "Jesse James") as a socialist followed by working people "singing and shouting gay," but more significantly it influenced the radio evangelicalism that would become a stronger cultural force in the United States than Commonism.

In Los Angeles "New Thought" collided with socialism and bohemianism. A network of artists, intellectuals, and activists there combined unionism, proto-LGBT advocacy, and the arts to link longshoremen with Hollywood actors. Woody became close friends with actor Will Geer and an acquaintance of Geer's former lover Harry Hay. Hay would go on to help found the "homophile" movement in the fifties and the Radical Faeries in the seventies, and he preserved Guthrie's earliest known recordings, which were discovered by Peter La Chapelle in 1999. It is easy to trace the influence of socialist and communist thought on Woody's songs, cartoons, and newspaper columns after 1939. Also remarkable is Woody's fragrant

FIGURE 15.2. Will Rogers's branding iron, Dog Iron brand, Oklahoma, 1865–1912. Iron, 4⅞ × 28⅛ × 3⅗ in. Autry Museum of the American West, 89.136.187.

eroticism at times: "If there is a prettier sight on earth than those patched hairs between your legs, I've never seen or heard about it. If there's a prettier sight than this long and viney root that stands up here between my legs, I've certainly never seen that."[8] His immersion in a western bohemia, as a complement to the Okie refugees he first entertained on *Woody and Lefty Lou*, changed him markedly.

Woody's slapdash cookery, mixing these far-flung cultural and political ingredients with such good humor and unpretentious style, was ultimately magic. One precedent he looked to was the Okie comedian Will Rogers. Guthrie said that the two men he most admired were Rogers and Jesus Christ. Rogers, who died in a 1935 plane crash before Guthrie followed in his Oklahoma-to-California footsteps, is not celebrated often enough as a political poet like Woody. In addition to boosting New Deal populism, he reminded mainstream Americans about American Indian cultural politics in an era when Native people had little political power, as detailed by Amy M. Ware in her recent history *The Cherokee Kid*. Rogers needled

WASP dominance, quipping, "My ancestors didn't come over on the Mayflower. They met the boat."[9] Inspired by Rogers, Guthrie always punctured his political and intellectual airs with aw-shucks language. Writing in the *People's Daily World* in 1939 about his Marxian study sessions, he said that he was "buried about 6 foot deep in some dialecticle matternilisation, an it was speakin a bout what was real, an what was just pure old imaginin."[10]

In some cases, using Los Angeles as a lens on Guthrie helps us see the missed opportunities in Guthrie's transformation. In a *Woody Guthrie L.A.* essay titled "Woody at the Border," Josh Kun takes Guthrie's Commonism seriously and asks us to listen beyond Woody to parts of the Angeleno cultural landscape that Guthrie mostly seems to have missed. Kun highlights the recording "El Deportado" (1930), a ballad by the Los Angeles duo Los Hermanos Bañuelos that documented the way Mexican-American "women, children, and elders," many of them US citizens, were "being driven to the border" in the huge wave of deportations that accompanied the Depression. Woody spent three weeks in 1937 performing on the border-blaster Radio XELO in Tijuana and later sympathetically wrote "Deportees" (inspired by the 1948 plane crash of *braceros* at Los Gatos), but his awareness of the Southwest as a historical and cultural part of Latin America remained limited.[11]

Ultimately, I finished reading *Woody Guthrie L.A.* with the unsettling sense that the city had failed Guthrie. He couldn't make a living here, not for long. More broadly, I wondered (and I wonder now) how viable his recipe for Commonist cornpone is. In their essay "The Ghost of Tom Joad," Bryant Simon and William Deverell trace the legacy of John Steinbeck's protagonist, trying to rescue the earnest Okie progressive from nostalgia and political amnesia.[12] The exiled "Arkies, an th Oakies, th Kansies, an th Texies, an-all of the farmers an workers," as Woody classified them in one of his *People's Daily World* columns, took a variety of paths after weathering the Depression.[13] But where Simon and Deverell trace Joad through Woody's ballad to Bruce Springsteen's mid-Atlantic progressivism, I can't help but imagine a different, California-based sequel, in which Tom Joad follows the large share of his fellow Okies to the right, walking away from the New Deal once his own people have been safely settled in the suburbs.

Even in Woody Guthrie's work, unease regarding any trace of a welfare state occasionally crops up. An early song, "Them Big City Ways," recounts a country boy's fall from virtue after moving to the city. After squandering his money, Brother John "got him a job on the WPA / Woke up to eat about twice a day." The Works Progress Administration, Guthrie suspected, bred not work but idleness. He proudly noted in a 1939 column that he had never applied for relief himself, despite his poverty.[14] It is easy to trace the values of hard work and

self-sufficiency as they evolved into reactionary politics once New Deal policies, war-industry jobs, the GI Bill, and so on had pulled many Okies into the middle class. And it is also clear enough that racist feelings did not die so easily in every white Okie-Arkie-Texie heart as in Woody's. A lot of real-life Joads torched the social ladder behind them and lifted California political figures like Richard Nixon and Ronald Reagan to national power.

This is not to say that Woody is purely a figment of a progressive coastal imagination, a dreamed-up prophet like Joad. There is a chord in Okie populism that rings out for economic justice, which we might follow through Will Rogers and Woody Guthrie to Elizabeth Warren. (I recall my own Okie grandpa teaching me what a "scab" was during a Safeway grocery strike when I was fourteen.) Yet a lot of Tom Joad's children and grandchildren have lost those notes or drowned them out with their pride in self-sufficiency or the competing heritage of racial resentment. Many of them rallied to a new "Old Man Trump" as he called for an impregnable wall to stop Latin American migrants, in a clear echo of what Woody called California's "foreign legion" stopping westward migrants at the Arizona-California border. One of Guthrie's 1939 records discovered sixty years later was an early version of the tune "Do Re Mi," in which Woody, a new Californian, punctured the migrant's dream that "California is a garden of Eden, a paradise to live in or see." Guthrie warned, "Believe it or not, you won't find it so hot / If you ain't got the do re mi."[15] Amid today's housing crisis and strife, in which we need increasingly obscene amounts of "do re mi" to avoid sleeping in a jalopy RV on a diminishing number of streets with unrestricted nighttime parking, it is clear that Los Angeles has been both paradise and parched garden for a long time.

HOMESTEADS

16. CALIFORNIA *ÜBER ALLES*
On Joan Didion

First, an epilogue: Roman Polanski, Joan Didion's fugitive co-godparent, still resides in Europe after Poland refused to extradite him back to California for a long-ago statutory rape of a thirteen-year-old. The Charles Manson family's Squeaky Fromme is elderly and out of prison. Manson himself died late in 2017. Jerry Brown has just served two more terms as governor at the end of his career. Huey Newton is nearly thirty years dead; Eldridge Cleaver, twenty. Didion herself is eighty-four, just a month younger than Manson would have been. Her book *The White Album* (1979) is a certified classic, and the era it describes—the '60s and '70s—is now open for study as history.

I was born in 1980, and now I'm old enough to reflect on *The White Album*, Didion's second collection of essays. (Her first was *Slouching towards Bethlehem*, published in 1968). As I enter middle age uneasily, the essays in *The White Album* offer a creation story for the era I have lived through and for today's uncertainty. The title essay and a few others plumb the breakdown of narrative and meaning that attended the '60s and '70s. The stories we tell ourselves in order to live, to scramble Didion's memorable first line, dissolved into "flash pictures in variable sequence"—an anti-structure she invented for the essay and for those bewildering years. Nothing made sense anymore. The crumbling of narrative traumatized Didion, but she was witheringly critical of those who slouched toward comforting mirages. Hollywood liberals' naïve vanity and "dictatorship of good intentions"; the Jaycees' "astonishing notion" that campus social groups would solve student unrest; Colombians' "hallucination" that they descended from Spain's highest aristocracy—these were "stories a child might invent."[1]

The White Album is also a book about the American West, staking a claim in the rubble of the region's defunct heroic stories. (John Wayne, to whom Didion had written a "love song" essay more than a decade earlier, died in 1979.)[2] As a westerner, Didion was deeply attracted to hydraulic engineering—"the only natural force over which we have any control

FIGURE 16.1. M12 Studio, with Onix Architects, *Last Chance Module Array* (Modules No. 4 and 5), 2015–2016, Last Chance, Colorado. Image courtesy of M12.

This sculpture's alignment with the winter and summer solstice suggests a cyclical rather than epic western story.

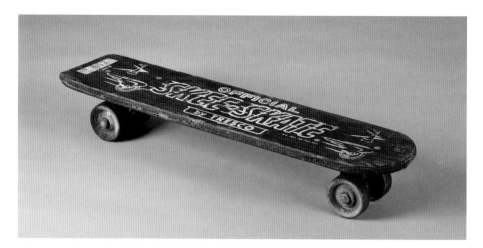

FIGURE 16.2. Skee-Skate skateboard, made by Tresco, Culver City, California, early 1960s. Wood, paint, and steel wheels, 3 × 5 × 19 in. Museum purchase, Autry Museum of the American West, 2016.8.1.

out here is water"—and deeply distrustful of social engineering. She was coolly furious, for instance, at the bureaucratic arrogance behind an early carpool-lane project in Los Angeles. She was fascinated by the institution of the shopping mall and enchanted by the "hardness" of Georgia O'Keeffe, an "angelic rattlesnake."[3]

I grew up in the inland West in the nonsensical era that followed. By the 1980s Didion's California seemed to be the generative laboratory for the rest of the United States. Malls replaced downtowns, carpool lanes multiplied. While California governor from 1967 to 1975, Ronald Reagan had commissioned the steroidal ranch house of a governor's mansion that Didion toured in her reporting for *The White Album*. (She describes its ersatz adobe walls and vinyl-topped wet bar "insistently and malevolently 'democratic.'")[4] Reagan's aggressively pacific successor, Jerry Brown, had then refused to live in such splendor, a decision that was also somehow insistently democratic. Soon Reagan was president, bringing *Star Wars* to life, and my parents, one of them a Californian, were refusing to buy me G.I. Joe dolls. First Brown and then Reagan appeared as contrapuntal icons in two versions of one of my favorite punk rock songs from back then, the Dead Kennedys' "California über Alles," which in 1979 had satirically imagined Brown as a "Zen fascist" U.S. president. In 1981, for obvious reasons, the band released a sequel, "We've Got a Bigger Problem Now." Then Mötley Crüe and crew brought Jim Morrison's black vinyl pants, along with the sex-and-cocaine Sunset Strip, to ranch houses across the country. Didion describes Californians having to drain

their swimming pools in a drought. This state of affairs sparked rapid innovation in the only sport that really drew me in as an '80s kid: skateboarding. California *über alles*.

How have we coped growing up with only "flash pictures in variable sequence" as a story line? It seems telling that in 2009 *The Simpsons* surpassed *Gunsmoke* as the longest-running prime-time TV show. "I think now that we were the last generation to identify with adults," Didion writes. As *The White Album* nears its fortieth year, it seems almost a book of Genesis for the period of American history I've happened to live through. Didion can seem both a frazzled and eloquent Eve, seeing the new world as the harrowed skeptic from a more straightforward time and place. "I am not the society in microcosm," Didion writes at one point, yet reading her I get the sense that everything is a symbol, the world in a grain of sand.[5] *The White Album* remains a memoir of a strange era by one atypical bellwether of a woman.

Reading *The White Album* today, it is difficult to avoid thinking of the author not as the expressionless, beautiful young woman smoking in a Stingray in an iconic 1970s photo by Julian Wasser but as the frail octogenarian whose biggest book sales and recognition have come from *The Year of Magical Thinking* and *Blue Nights*, the 2005 and 2011 memoirs about her husband's and daughter's deaths. When I read the author of *The White Album* describing her constant desire to find the daily *New York Times*, I flash forward to her horror as her agent calls the *Times* obituary editor on the night of John Gregory Dunne's heart attack: "'Obituary,' unlike 'autopsy,' which was between me and John and the hospital, meant it had happened."[6] She wanted to *not* tell the story, the obituary, in order that John might live—magical thinking, something a child might invent, but vastly sympathetic. When I read about the young Didion going on book tour with "six Judy Blume books and my eleven-year-old daughter," I think of that daughter's death less than thirty years later, on the heels of Dunne's.[7] When she details the paranoid insanity of *White Album* L.A., I can't help but think of the shades of Charles Manson and Roman Polanski.

The rest of us children of divorced words and meanings still oscillate between quixotic sixties idealism and helpless cynicism in a country that becomes ever more plutocratic. I long to connect the flash pictures in a collage of references (Reagan . . . skateboarding . . . Crüe . . . ranch houses), but it remains disorienting to live according to a collage narrative, a *Simpsons* episode, or *The White Album*'s opening essay. I sympathize with the lure of a clean *Gunsmoke* narrative, but that sort of satisfying story now looks antique.

17. ALL OUR VALUES ARE SHAKEN

The Western genre, like many epic traditions, is a man's world. Exceptions abound, but cowboy stories serve primarily to explore, map, and fight out notions of manhood. In one subset of western American mythology, though, women step forward. A pioneer myth primarily set in the northern Great Plains holds a sunbonneted Euro-American heroine to rival the cowboy in prominence. This myth includes powerful fictional characters like Alexandra Bergson in Willa Cather's *O Pioneers!* (1913) and the autobiographical protagonist of Laura Ingalls Wilder's *Little House* series, and it radiates in the beauty of women in paintings like Harvey Dunn's *The Prairie Is My Garden* (1941), W. H. D. Koerner's *Madonna of the Prairie* (1921), and the elevated white woman at the center of the Autry Museum's mural. While not as numerous as Western cowboys, these women have captured the imagination of many.

On a more modest scale, the Kansas poet May Williams Ward embodied an extension of this type. Born in 1882, Ward was northern, middle-class, progressive, and civic-minded. One of her great works was a small literary magazine she edited, *The Harp*, which deserves wider recognition. Ward grew up in Osawatomie, Kansas, which had been John Brown's home base during the regional violence there just before the Civil War. After graduating from the University of Kansas, she married Merle Ward, whom she had met at the university, in a ceremony held at a Congregational church in Osawatomie built by Brown and his brother-in-law. Brown's grandniece played the organ.[1] For Ward and her cultural community—which included *The Harp*, the Prairie Print Makers society, and the Middle American progressive boosterism of Emporia newspaper editor William Allen White—poetry and art were to be promoted as part of the civic and cultural development of Kansas and the West. In some way this carried forward the spirit of pioneer women of both reality and fiction.

The Harp was founded in 1925 by Israel Newman, who had moved temporarily from Boston, Massachusetts, to the Arkansas River town of Larned, Kansas, population 3,500. The next year, Newman left the state and passed his editorial duties over to Ward, who lived sixteen miles south in Belpre, while the magazine was still published and managed in Larned.[2] It was a plain little magazine, not illustrated at first, five and a half by eight and a half inches and fewer than twenty pages long, printed by the publishers of the Larned

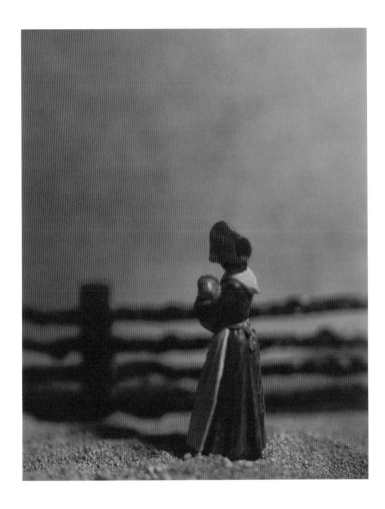

FIGURE 17.1. David Levinthal, untitled photograph of die-cut figure, *Wild West Series*, 1987–1989. Polaroid Polacolor ER print, 29½ × 25 in. Museum purchase, Autry Museum of the American West, 93.187.3.

newspaper, the *Tiller and Toiler*. Ward was then in her mid-forties and an up-and-coming poet, having had her first poem published in *Life* in 1921. Other poems of hers would be published in *Good Housekeeping*, *Ladies Home Journal*, and the *Kansas City Star*. In 1925 she was invited to the MacDowell Colony in New Hampshire, where she went for a month-long residency.[3] In the first *Harp* issue she edited, September/October 1926, she wrote, "The magazine is in no sense a commercial enterprise and the editor and publisher anticipate no remuneration except those rich rewards which are always coincident with the pursuit of an ideal. The ideal in the publication of THE HARP will be to keep its poetic standards high." She noted that poets published in the magazine would, however, be paid nominally, thanks to donations from its patrons.[4]

First among the patrons was William Allen White, quoted inside the cover: "I think the Harp is altogether the loveliest adventure in Kansas." An important endorsement, to be sure. White owned and edited the *Emporia Gazette* in the Flint Hills region of eastern Kansas and championed exactly the sort of benign progressivism as Ward and *The Harp*. The "Sage of Emporia," White had won fame in 1896 for an anti–Populist Party editorial, "What's the Matter with Kansas?" In it, he had vituperated against Kansans who would "put the lazy, greasy fizzle, who can't pay his debts, on the altar" instead of the "white shirts and brains" with "business judgment."[5] In 1930 White wrote, "[Ward's] verse is beautiful, poignant, understanding. She excels because she is of the prairie. She takes her music out of her environment, winds, birds, the rhythm of the windmill, the Kansas scene."[6]

White helped lead the intellectual project of inventing the small, Middle American town as a progressive trope and leveraged the notion that Emporia was "too good a town" to fall for wild-eyed populism, the Ku Klux Klan, Al Smith's candidacy for president in 1928, and later Nazi sympathizing and isolationism.[7] In a 1927 review of a collection of poetry called *The Poetry Cure*, Ward evinced an aesthetic counterpart to White's vision: "In this age when much of the current poetry is morbid, introspective, even bitter, when realism and disillusion infect almost all literature, this powerful 'Medicine' with no trace of any depressants is a joy."[8] This poetic medicine seems akin to the earnestness of the Jaycees mocked by Joan Didion (see preceding chapter) and the "magic of myths, fables, and tales of heroes" that Lynne Cheney would reference in the 1980s to counter skeptical new histories.[9] Like Cheney and the Jaycees, Laura Ingalls Wilder aligned her own nostalgic tales of growing up in the Upper Midwest, in the *Little House* series, with a conservative politics that contrasted with Ward's progressivism.[10]

In its May/June 1927 issue, *The Harp* included illustrations for the first time, and a new logo branded the cover: a block print of a bare, gnarled cottonwood, its six branches together bent into the rough shape of a harp. The design was by Birger Sandzen, a Swedish-born printmaker and professor at Bethany College in Lindsborg, Kansas. Inside the issue were two other prints, a woodcut of a shock of wheat by Herschel C. Logan and a lithograph of a creek in winter by C. A. Seward.[11] In 1930, these three men would become charter members of the Prairie Print Makers, a society founded "to further the interest of both artists and laymen in printmaking and collecting."[12] Subscribers paid five dollars annually to receive a special edition print by a member artist. This was a can-do response to the hardships of the Depression: prints were affordable, and the artist's fee was shared among a hundred or two hundred collectors. The Prairie Print Makers stuck to representational work, uncontroversial

and easy on the eye. At the same time the society had the aim of cultural uplift, fostering "the development of our national appreciation of fine prints," in the words of the *Wichita Eagle*.[13] One of the members later recalled it as "'missionary' work."[14]

The Prairie Print Makers were nearly all men, and they were Rotarians, Boy Scout troop leaders, Masons, or members of the local Friends of Art or the Wichita Artists' Guild.[15] In *The Harp*, by contrast, women dominated. In a selection of twenty-one issues published between 1926 and 1932, women make up 70 percent of the poets.[16] Many of these women wrote short reflections stolen from a life of domestic work; whereas a fraternity developed in printmaking, with its machines and workshop craft. Ward was a printmaker herself, but her husband printed her pieces—in an old wringer washer.

Writers in *The Harp* ranged from Genevieve Taggard, a professor at Mount Holyoke College in Massachusetts and a poetry editor of the Marxist journal *The Masses*, to the famous poet Theodore Roethke and to Billy McCarroll, an eleven-year-old from Hutchinson, Kansas, whose poem observed that the "withered dryness" of Kansas's sand hills somehow was "not hostile."[17] The magazine clearly kept in contact with the national poetry scene, publishing eastern writers such as Taggard and New England poet Amy Lowell (the latter in the first issue that Ward edited).[18]

Despite her enchantment upon entering poetry's elite, Ward remained grounded in the Plains and Midwest. "I came back [from the MacDowell Colony] with a new respect for the quality of literary work being done by westerners," she wrote a friend, "with a new appreciation for our superior pep, which is not exaggerated (it took ten days to get a coat cleaned in New Hampshire) and seeing the beauty of our plains with new eyes after the contrasts of the East."[19] *The Harp* made a statement by publishing metropolitan, degreed and pedigreed poets alongside locals and even children, evincing a flattening—a Spirit of the West?—that I admit a certain fondness for even today. Several Kansas poets appear again and again, and in a 1928 issue, Ward highlights the home-state bias: "Prophets are honored in their own country in Kansas. The editor is proud to present in the honored positions this time, some of THE HARP's nearest."[20] In her second year as editor, Ward published two "whimseys" by Thelma Chiles, "daughter of Nick Chiles who edits the leading western journal of negro opinion"—Topeka's *Plaindealer*, which he founded in 1899 and would run until 1958. Born in 1900, Thelma had graduated from the University of Michigan in 1925 and returned to manage the family newspaper.[21] Her inclusion in *The Harp* marked a quiet stand for integration on Ward's part. Thelma Chiles wrote some of the most modern pieces in the magazine, with her soul flying "up the sky tree" and dancing with a lover amid "white moon poppies."[22]

Ward's own work rarely referred to history, but one exception is notable. In "John Brown and the Cabin in Osawatomie" she likened Brown to one of the logs of the cabin he built, logs that "taught him strength / And rectitude, and calm, and certainty / That he at length must sacrifice himself as utterly / At freedom's call / As trees accepted death with dignity / To make this wall."[23] Here the bloody past of vicious sectional feuds is stilled, and the murderous Brown tamed into a placid arbor-Christ.

Her poem accompanying Sandzen's harp design for the magazine reminded readers of the deep reservoir of water drawn by the leafless tree. In the tree's voice, she wrote, "Wind, play my harp. Do you think I keep / Hating you, who in mad wild weather / Wrecked me? . . . Let us make music together."[24] Rather forthrightly she declared that art draws on an eternal well and will ameliorate and forgive life's storms. What happened, then, when the worst "mad wild weather" struck *The Harp* and its environs? In 1932, with farms going bust all around western Kansas, Ward's husband sold the grain business in Belpre. Ward left her post at the magazine, and they moved to Wellington, Kansas, where they ran her in-laws' hotel. One more issue was published from Augusta, Kansas, in January/February 1932, with the publisher's daughter as editor, but the magazine ceased publication after that.[25]

Ward continued to find success on her own. In 1937 she won the annual award from the Poetry Society of America for a sequence of poems, "Dust Bowl." The first, titled "Reversal," described the dust flung up into the realm of air, and air pressed downward: "All our values are shaken. What is earth? / Is there anything solid and sure? And what is air?" Ecological calamity shocked the Plains, and economic calamity crushed *The Harp*; these terrors shook all the values of progress for the West. One pictures the pioneer heroine of fantasy staring disillusioned across a ravaged land. Just when she thinks things are humming along toward perfection, destruction and degradation arrive. Yet in the end, in another of Ward's Dust Bowl poems, dust particles and life settled into a new rhythm, like the plants in another of Ward's poems that grow in the dirt that blew in from "who knows where?": "How red the fruit, how tall the grain / since alien dust enriched the plain!"[26] This faith in cycles and the power of narrative may have been naïve, but Ward's spirit produced a fine magazine in a time and place otherwise without one. A sunbonnet Madonna may be a magical myth worth saving.

18. A HOMESTEAD FOR CONTEMPORARY ART
On M12

On a warm May afternoon in 2012, I walked the perimeter of the Experimental Site, the forty-acre grassland plot outside Last Chance, Colorado, where the art collective M12 had begun to stage place-rooted art and social projects. Looking down at one point, I noticed that a funnel weaver spider had built a lovely trap that looked like a tiny tornado leading into an old gopher or snake hole. I touched the web with a piece of grass, and the spider emerged to see if it had scored a bug. The High Plains is tough country: exposed, windy, dry, alternately hot and cold. The town of Last Chance is nearly abandoned, with the husks of a motel and the burned ruins of a gas station facing each other across US Route 36. Plenty of people and other life forms have sojourned there and moved on. But canny organisms like that spider have continually built subtle and functional objects of beauty amid the apparent barrenness.

M12 had relocated its Office for Connective Aesthetics—that's what the spider calls its funnel too—to Byers, Colorado, about thirty miles west of Last Chance, just before my visit that spring. Byers was not a ruins by any means, but it still held its share of empty sign frames and vacant storefronts. The Byers America Feed and Supply store had moved from its Front Street location near the Union Pacific rail line (once the orienting axis of town) to the north side of Interstate 70 (today's axis). This left a disused space in which M12 wove its own homestead, truly inhabiting the rural High Plains region from which much of its work was grown. The collective had sponsored a dirt-track race car, the Black Hornet, for a fourth-generation, adolescent racer to drive elsewhere in eastern Colorado. For many years it organized an annual Big Feed potluck and Chautauqua-like event with art and community presentations. It created a redesign of a migrant shepherd's seasonal home, known as a *campito*. It coordinated an exchange between Dutch farm kids and Colorado Future Farmers of America. And it created sculptures inspired by barn architecture and other rural vernacular forms.[1]

This commitment to a specific site and community was a profound step. The High Plains region has a venerable history of short-lived visits for trade and commerce, but only a proud few have called places like Byers home: Southern Cheyenne societies in the mid-nineteenth century, then mixed-race (Native and white) or newcomer families operating rough-hewn

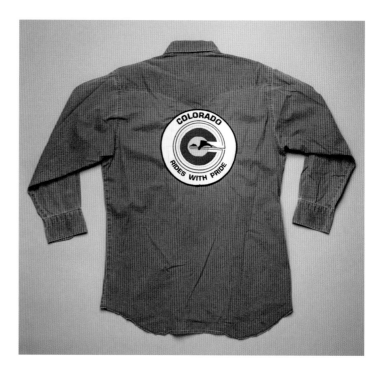

FIGURE 18.1. Shirt, Colorado Rides with Pride, Colorado Gay Rodeo Association, circa 1990s. International Gay Rodeo Association Institutional Archives, 1982–2009, Autry Museum of the American West, MSA.26.

"road ranches" that catered to gold-rushers headed to the Rocky Mountains in the 1860s; then Euro-American farmers and ranchers in the twentieth century.[2] To join this lineage and settle down is to resist the powerful vectors that jet money, workers, commodities, and art all over the world—forces that pull us away from rooted locations.

The portion of the old Byers feed store that M12 rented soon acquired a washroom and a coat of gallery-white paint, but the building still bore the marks of its long history. Built by Bob Burton in 1910, the impressive block of a building held Burton's general store as well as the post office, telephone office, a millinery business, a dance hall, and apartments. Near the floor on the east wall of M12's front gallery space, a long, charred stripe of wood could be seen sandwiched by old adobe bricks that Burton manufactured three blocks away. Although most of the building burned to the ground in 1930 (a local history reports that pinto beans stored in the basement "smoldered for many days after the fire"), that one wall endured.[3] After it was rebuilt, the site held a couple of grocery stores—one named Solitaire Grocery— and a beauty shop. After another disaster, a flood in 1965, the building was repurposed as a Packard mechanic's shop. Sand still nestles between the floorboards from when paint was stripped from steel auto bodies there. And in 1995, the mechanic sold the building to Roberta

and Eddie Roth, owners of the feed store, who eventually became local friends of M12. On my second visit to Byers, in October 2012, Eddie tended roast bison and cowboy beans in the rain at the Big Feed north of Byers, and then the couple lit up a Quonset hut dance floor that evening. They showed art students how to sculpt abnormally grown cow hooves with a power sander, how to nurse a buffalo calf on a bottle, and how to weld custom barbecue equipment.

M12 inherited all the site's layers of history and became another homely homesteader hoping to prove up on its claim. Under the rules of the 1862 Homestead Act, a settler who made improvements and stayed on his or her plot for five years would "prove up" and receive title free and clear. It is intriguing to think what "improvements" might mean in the realm of contemporary art and M12's body of work in particular: lasting connections with friends like the Roths, a shot of novelty for the broader community, a new perception of what was always there. Over the next couple of years, I became a member of the group rather than just a visitor and traveled to Byers several times, working on a couple of books and seven-inch records in our Center Pivot series.

Ultimately, knowing the history of transience in the American West in general, especially on the plains, staking a claim is always a gamble. A homestead is an impossible effort to stop the flow of time. There is always that huge Great Plains sky and maybe even the faint scent of smoldering pintos to remind you how insignificant you are. If you make it, you've proved up. If not, you're in good company in leaving this hard place, and the effort was no less beautiful for being ephemeral. After almost exactly five years, M12 had to leave the rented feed store, and it entered a new phase. Exurban Denver was starting to pull Byers into its orbit, making it the outermost burg in its solar system. Shopping for the final Byers barbeque, I noticed gluten-free products and chia seeds in a grocery store that had previously stocked only things I could have found in the markets of my South Dakota childhood, like iceberg lettuce and ranch dressing. The practice of this collective—loosely led by Richard Saxton, who embraces an antiheroic model of art and so won't mind that I've gotten this far into the essay before mentioning him by name—evolved to include elements like books (as mentioned) and installations at both traditional art spaces and the likes of a livestock barn at the Iowa State Fair in 2016. In the fall of 2017, M12's headquarters moved to an old adobe ranch outside Lobatos, in the San Luis Valley of Colorado, to begin a new chapter of its existence.

While M12 has moved on from Last Chance, the Experimental Site there grew in a profound way with a single sculpture that speaks to the history of transience in the High Plains region. Titled *Last Chance Module Array* and finished in 2015—I played no part in designing or installing it, so I see it from a visitor's perspective—this sculpture is both a humble and spectacular achievement (see fig. 16.1). It comprises eight sixteen-foot cedar frames fire-treated

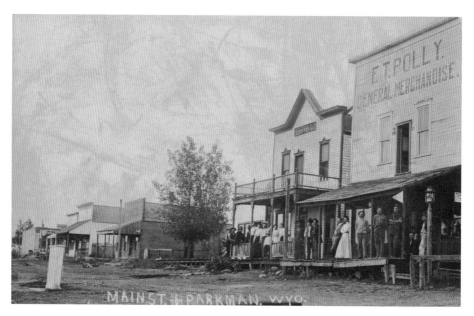

FIGURE 18.2. Postcard, *Main St., Parkman, Wyo.,* early 1900s. Gelatin silver print, 3½ × 5½ in. Rosenstock Collection, Autry Museum of the American West, 90.253.1742.3.

This Wyoming street scene evokes the false-front architecture of many High Plains and western towns, including Byers, Colorado.

with the Japanese *shou sugi ban* technique, arrayed in a henge that signals the solstices twice a year at that latitude. The long-haul truckers who roar by it may or may not notice this framework, which looks monumental to a funnel weaver spider that nests below or to a pedestrian who has climbed through the barbed wire and walked through it. Is it the last vestige of a barn, a weathered, failed homestead from long ago? Is it the start of a homestead to come? Some government engineering project? A spiritual retreat? In fact, it is a loose version of all these things. M12 cooperated with the Washington County commissioners to install *Last Chance Module Array,* and the whole Prairie Module series of sculptures of which it is a part makes clear reference to barn architecture and the social practice of barn-raising as well as to the spiritual power of the awesome landscape. Whatever a curious visitor or pilgrim might make of it, to me the sculpture suggests absence, weathering, and old dreams. It also adapts post–World War II land art practices in the West with humbler materials and less monumental ambitions. As the wind, heat, and cold begin to tear it apart in coming years, M12 —like the spider—will have to decide when to patch and repair it and when to leave the wooden wisps to fall apart and drift across the High Plains.

part six

FATAL ENVIRONMENTS

ŠŤASTNÝ LUKE

Francouzská kreslená parodie na filmové westerny – Režie: Morris

Vydala Ústřední půjčovna filmů,

19. I'M A LONER, A REBEL

A contemporary museum, with its many exhibitions, programs, and initiatives, offers a smorgasbord of odd juxtapositions. Sure: X screening reinforces Y exhibition, and A ties to the sixtieth anniversary of B. But sometimes I wonder if our intentional pairings are mostly irrelevant to visitors. In fact, I'll admit that a part of me hopes this—that museumgoers find what Lucy Lippard calls "inadvertent surprises" where no museum professional intended them. As museum staff, we probably miss some magical un-curated patterns in the rush of calendaring. Without imposing too much logic on the following pairing with intellectual sleight-of-hand, Pee-wee Herman and Edward Abbey were simply scheduled around the same time.

To screen *Pee-wee's Big Adventure* (1985) as a Western was a provocation. In the context of a museum displaying (at least over its first thirty years) a chorus line of mannequin-heroes from Buffalo Bill Cody to Clint Eastwood, Pee-wee Herman's twitchy wobble mocks, witheringly, their swagger. His Coca-Cola-red bike un-muscles their steeds. In the film, his journey from Los Angeles back east to the Alamo queers Manifest Destiny.

Meanwhile, Abbey's memoir *Desert Solitaire: A Season in the Wilderness* (1968) emerged as the museum's second selection for its One Book, One Autry series, an exploration of a single book over a few discussions and programs. The first book in the series had been, predictably, the reputed first cowboy Western, Owen Wister's *The Virginian* (1902). Abbey represented a stretch into new territory despite this alt-*Walden*'s half-century-old vintage. The Autry Museum still has not decided how to contend with the twentieth-century West in its core galleries beyond twentieth-century reinventions of the nineteenth in the Western genre, so Abbey's memoir and manifesto based in southern Utah's majestic landscape helped set precedent. Abbey followed Wister logically in several ways. Both were native Pennsylvanians who found in the open West an antidote to eastern over-civilization. Both demonstrated male chauvinism and debatable views of non-Anglos. And both created broadly resonant fictions and iconic American knights—the noble, nameless southern-bred Wyoming cowboy of *The Virginian* and Abbey's Green Beret turned eco-saboteur George Washington Hayduke in *The Monkey Wrench Gang* (1975).

FIGURE 19.1. Vratislav Hlavatý, Czech poster for the animated film *Lucky Luke* (*Šťastný Luke*), 1973, 15¾ × 11⅛ in. Autry Museum of the American West, 98.183.3.

Linking Wister to Abbey does not strain intuition, even if the two writers have attracted some different fans. Adding Pee-wee Herman to their lineage is more challenging and more fun. Like *Desert Solitaire*, *Pee-wee's Big Adventure* explores an eccentric white man's encounters with the West and his quest after a feminized object. For Abbey the quest involves nature, and for Herman it centers on a beautiful red bicycle. Neither work is a Western, but both depend on the Western as cultural foundation. Pee-wee and Abbey both find a place in a region where they are not the archetypal heroes, and they use the genre to get there.

In *Pee-wee's Big Adventure*, Herman lives in a lollipop-red homestead in some part of suburban L.A. Maybe it's Burbank, where the movie studios are; maybe Santa Monica, near his bike shop; maybe Pasadena, where the actual house still stands. His yard brims with Sunbelt kitsch: two Santa Clauses, a camp of Plains Indians, a deer, a horse, a rocket ship. His room, like the yard, embodies the way the Western had transformed, after its 1950s and 1960s hegemony, into one genre among many by the 1980s. Pee-wee sleeps in a wagon-wheel bed that features his name written in rope, under some sort of hornless ungulate's skull, surrounded by cowboy-and-Indian wallpaper, a Howdy Doody puppet, and a toy guitar. But all of that is embedded amid robots, cars, trains, Disney, dinosaurs, and other playthings.

Abbey's backyard as a seasonal ranger in Arches National Monument (now Arches National Park) was ostensibly the opposite: raw, spare, fiercely real. He slept outside as much as possible, built himself a ramada from wood posts and juniper boughs to eat and drink under, and attended to rough, scaly, feathered, venomous fauna and the arid landscape of southeastern Utah. Abbey was a prophetic exile from Howdy Doody's America, working in Arches beginning in the late 1950s, a decade before *Desert Solitaire* was published. In the book he decries asphalt, engineering, formal education, and cultivation of all sorts. ("Bricks to all greenhouses! Black thumb and cutworm to the potted plant!" he writes at one point.)[1] Yet he too finds recourse in the Western genre, including in a chapter called "The Moon-Eyed Horse"—a tale of an elusive, larger-than-life runaway steed that seems written by someone who read Will James's *Smoky the Cowhorse* (1927) as a boy and grew up to be a misanthrope. In chapters straightforwardly titled "Cowboys and Indians" and "Cowboys and Indians: Part II," Abbey finds nobility in his perceptions of both the "actual working cowboy" and the "genuine nonworking Indian," both of whom he regards as endangered species. Rather than *Virginian*-style knights, he romanticizes cowboys as stoic workingmen. Indians are the cowboys' foils, men of leisure. Of the Ancestral Puebloan artists who created the petroglyphs and pictographs that form the basis for artist Peter Parnall's illustrations in the first edition, Abbey writes that they were "primitive savages," "unburdened by the necessity of devoting

FIGURE 19.2. Still from *Go West* (1925), directed by and starring Buster Keaton.

most of their lives to the production, distribution, sale and servicing of labor-saving machinery"—truly free, laughably "unburdened" beings in the wilderness.[2] The Native people of the present Abbey finds piteous, part of the global underclass created by industrial capitalism, and he obsessively focuses on high birth rates as the key cause of Indigenous peoples' woes.

Abbey despises the "make-believe cowboys . . . crowding the streets in their big white hats, tight pants, flowered shirts, and high-heeled fruity boots."[3] (Notably, Hollywood cowboys were by the 1960s turning away from this sort of costume too, donning the dusty and drab instead.) The implication of his description—that urban cowboys in Roy Rogers getups were unmanly, even queer—was exactly what Pee-wee Herman embraced two decades later. Pee-wee was in fact profoundly queer in his refusal to grow up and be a man. A gender bender, in the film he rides a bull at a Texas rodeo, playing on the paradoxically hypermasculine yet childish or feminine tradition of cowboy fashion, the "tight pants" and "fruity boots." Pee-wee dons a colossal, pristinely white Tom Mix hat, a crisp red bib shirt with big white stars on it, and an oversize polka-dot bandanna. These jokes of proportion recall a slapstick Western tradition going back to Buster Keaton. In *Go West* (1925), Keaton's character happens upon a woman's lost purse and pockets an effeminate little derringer for his train trip to the frontier. When he steps into cowboy land, he appropriates a discarded pair of chaps and a large gun belt. His dropping the derringer deep into the holster is a sight gag to parallel his diminutive pork pie hat—an inverse of Pee-wee's oversize getup but a mockery of cowboy manhood all the same. At the rodeo in *Big Adventure*, Pee-wee

wins fans with a surprisingly tenacious ride on the bull, just as he later charms the Satan's Helpers biker gang with his "Tequila" dance.

Ed Abbey himself is queer. An odd bird, paranoid and cranky, and a rebuff to mainstream manhood. In *Desert Solitaire* his embrace of the wilderness pushes beyond the usual squinting gaze, the pretty picture, as he makes clear right away: "I want to know it all, possess it all, embrace the entire scene intimately, deeply, totally, as a man desires a beautiful woman."[4] But his disdain for women's company, except for occasional sex, crops up again and again throughout the book. He soon adopts a gopher snake, which he assumes to be male, and wears it inside his shirt, resting atop his belt. After Abbey releases his "companion," the reptile (or a doppelgänger) returns with what Ed presumes to be a female lover and performs a sort of open-air copulation or at least a pas de deux. Abbey writes, "I crawl to within six feet of them and stop, flat on my belly, watching from the snake's-eye level."[5] When he embarks in a rubber raft on the Colorado River, he finds "a pleasure almost equivalent to that first entrance—from the outside—into the neck of the womb."[6] Abbey's erotic communion with western soil and water echoes one of the queerer scenes in *The Virginian*, in which the cowboy hero and his bride spy on a small wild animal as it swims in a mountain pool and "roll[s] upon its back in the warm dry sand." The Virginian admits, "I have often done the same," and he reflects on his desire "to become the ground, become the water, become the trees, mix with the whole thing." But Abbey hardly seems poised to "give his wife all and more than she asked or desired" through staking a coal-rich claim, and to provide for many children, as does the Virginian in his story's romantic final pages.[7] Ed Abbey, patriarch? No, sir.

Of course, a form of Abbey's lonesome queerness abounds in the Western genre. The hero who can't enjoy the civilization he secures is one of its central dramas. Witness Ethan Edwards in *The Searchers*, and Shane in *Shane*, and all the others who ride off sad and solo in their knighthood. But Abbey actively *hated* the spreading civilization. He pulled up its survey stakes and wanted to dynamite its dams. He was not just a mournful silhouette clip-clopping off into history; he foresaw a tribe of men like himself holing up in the wilderness and defending American freedom like libertarian Viet Cong. He was forefather to both the Earth Liberation Front torching Hummers and spiking old-growth trees and to the Cliven Bundy clan firing on conservation officials to defend their personal ownership of federal lands.

Pee-wee Herman rides in this procession too as he turns down a sweet invitation to the drive-in: "You don't want to get mixed up with a guy like me. I'm a loner, Dottie, a rebel."

That's a line straight out of a too-obvious Western (or a tough-guy action movie, as his big adventure finally becomes, starring a suave P. W. Herman with a sleek eighties motorcycle in place of his Norman Rockwell bike). We laugh at the declaration, coming from a rosy-cheeked man-child in a bow tie. But whether uttered by a cowboy or a suburb boy, such a declaration of a western man's apartness and wildness seems both laughable and poignant. The 1968 *New York Times* review of *Desert Solitaire* included an uncannily Hermanian description of Abbey: "The author is a rebel, an eloquent loner."[8] Abbey himself quoted Charles M. Russell, the cowboy artist, as a kindred spirit: "I have been called a pioneer. In my book a pioneer is a man who comes to virgin country, traps off all the fur, kills off all the wild meat, cuts down all the trees, grazes off all the grass, plows the roots up and strings ten million miles of wire. A pioneer destroys things and calls it civilization."[9] Russell said, in so many angry words: I'm *not* a pioneer. I'm a loner, a rebel. A cowboy. Russell's and Abbey's fury at what they called civilization feels raw and real and important in mourning what is lost as the western landscape changes. It also rings a bit silly coming from men fully dependent on that hated "civilization" and treated quite well by it. Their art too nests well in civilization. A first edition of *Desert Solitaire* or a Russell sculpture of a bighorn sheep (see fig. 19.3) might equally serve as set dressing in a seven-bedroom mountain "cabin," and Abbey paperbacks and Russell keychains are perfect for the visitor center gift shop. Whatever its technical merits, Russell's nature art is functionally indistinguishable from the plastic deer in Pee-wee's yard. It pulls wildness into a safe, inert kitsch. The contradiction and queerness that both Abbey and Herman inject into the lonesome man in the West give that man a new silhouette. Reshaping this icon helps us look at the classics—and the region—in new and stranger light.

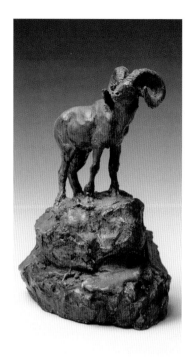

FIGURE 19.3. Charles M. Russell, *Bighorn Sheep*, circa 1900–20. Plaster, wax, 8¾ × 7 × 4½ in. Gift of Mr. and Mrs. Gene Autry. Autry Museum of the American West, 91.221.35.

This small shelf sculpture brings the western wilderness safely into the domestic sphere.

20. SEUSS IN BOOTS

It is true that *The Lorax*, Dr. Seuss's 1971 seemingly Earth Day–inspired, anapestic tetrameter call to eco-consciousness, does not mention the American West at any point. Its story of a faddish factory owner clear-cutting Truffula trees and glumping ponds full of Humming-Fish could easily be transposed onto New Jersey (the book mentions Weehawken) or Michigan. Yet there is something western in its account of a rapid fall from a nearly psychedelic Eden. The Once-ler, the story's antihero, recounts his arrival in an unpeopled but fabulously biodiverse landscape via covered wagon, where he sets to monomaniacally exploiting the place's Truffula trees for their silky tufts. The Truffula might be gold, bison, beavers, redwoods, uranium, spring water, or even simply space, like the exquisite vessels of Hetch Hetchy and Glen Canyon. Whatever the resource, it is liquidated. ("The West has been raided more often than settled, and raiders move on when they have got what they came for," noted the western writer Wallace Stegner.)[1] The Once-ler summons his extended family, who make short work of extirpating the Truffulas, smogging up the sky, and glumping the ponds with by-products. Then, after the last tree falls, they all pack up and leave.

All but the Once-ler. He becomes a hermit lurking in the mess he made, ever more haunted by the destruction. His blooming conscience may have few individual predecessors historically, but he stands in for a wider society that regrets its (or its ancestors') heedless exploitation of the land. *The Lorax* rhymed with new environmental legislation from its historical moment: the Clean Water Act (1972), the Endangered Species Act (1973), the founding of the Environmental Protection Agency (1970), and so on. In this the Once-ler diverges from most of the raiders in other eco-Westerns. An exception is the wise old miner, Howard, played by Walter Huston in *The Treasure of the Sierra Madre* (1948), who feels that his trio of placer miners should remediate their dig after taking out the gold: "We've wounded this mountain. It's our duty to close her wounds." Whether Howard has a Loraxian streak or just developed a taste for restoration in a long career of mining, his ethic is a rare one among raiders then or now. In twenty-first-century films, the water thief Tortoise John in *Rango* (2011) and the sociopathic oilman Daniel Plainview from *There Will Be Blood* (2007) indicate artists' dim hopes for environmental reform in the West springing from the raiders themselves.

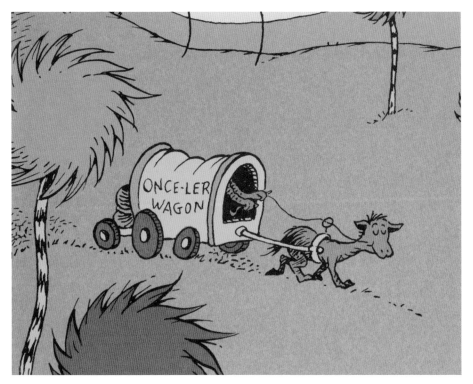

The Once-ler arrives in a paradise via covered wagon, only to exploit its resources to disastrous effect.

And the Lorax? He too crystallizes some western regional archetypes. The Lorax is a mustachioed prophet who "speak[s] for the trees, for the trees have no tongues." He is John Muir, Ed Abbey, David Brower, and the make-believe Indian Iron Eyes Cody, whose anti-pollution commercial launched in 1971, the same year *The Lorax* was published. A spirit of the West who is initially angry and gruff but then makes, in Seuss's words, a "sad backward glance" in the wake of destruction of an American paradise, the Lorax pops up again and again to harangue the Once-ler but finally launches heavenward when he can no longer save the old-growth trees. Abbey's rhapsodies and lectures in *Desert Solitaire*— followed by a farewell raft trip down damned-to-be-dammed Glen Canyon—follow the same story arc. In *There Will Be Blood*, the young evangelical missionary Paul Sunday varies the Lorax theme. His concern is less for unspoiled lands than unsoiled souls. Sunday is more complicated than a children's book character or an anti-pollution-commercial icon, but his attention to values untallied in ledger books places him in the Lorax tradition.

FIGURE 20.2. Charles F. Lummis, portrait of John Muir, 1901. Photographic print, 10 × 8 in. Braun Research Library Collection, Autry Museum of the American West, P.33188D.

Sierra Club founder John Muir, perhaps casting a sad backward glance.

Theodor Seuss Geisel was born, reared, and educated "back east," but, like so many, he transplanted himself in Southern California after World War II, and there in La Jolla produced most of his best-known work (cats, hats, eggs, ham, Horton, Grinch). So he became a western artist but not exactly a regionalist. If *The Lorax* stands out as western, it is only because its preservationist, Sierra Club mode of environmentalism grew up in the West. As storytellers, environmentalists recounted the negative beside what the Autry Museum once termed the "spirit of opportunity"—what one might call a spirit of decline and despoliation. A ransacking of the sublime wilderness of the old romantic paintings, John Gast's *American Progress* as American tragedy.

Yet Dr. Seuss chose not to leave children hopeless. In the book's final stanzas, the Once-ler tosses down the last Truffula seed on earth to a child who is a stand-in for the reader. (It seems a little incautious to fling something so precious to the first kid who has thought to ask about the Lorax. Oh, well.) The Once-ler suggests that maybe the titular arboreal flack will come back, along with all the other biodiversity, if the boy cultivates a new crop of Truffulas. In real life, environmental restoration has become an increasing feature of western landscapes and history, but it has not found its literary form. The removal of dams like the Elwha in Washington State, the return of the bison to the Great Plains and the accompanying metaphor of the Buffalo Commons, the piecemeal reintroduction of Indigenous practices such as traditional burning—bring on the pioneer epics of *these* dramas![2] This would innovate on the eco-spiritual tradition, the crying shame of John Muir, Ed Abbey, Iron Eyes Cody, and even *There Will Be Blood*. If we have lost our compass in the decline of Western and western heroic allegories, a *Lorax* fan-fiction sequel may be in order: a century-long romance of rewilding this glorious ecology. We need not only the child to plant that seed but also the poet to sing of that planting.

21. AMERICAN REMAINS

In February 2011 Jeff Hanneman was drinking beer in a Southern California hot tub when he noticed a small spider bite on his arm. One of two shredding, macabre guitarists in Slayer, he was a not-unthinkable victim when the bite roared into a necrotizing fasciitis. The flesh with which he had for thirty years thrashed turned feast for willful bacteria. When he died a little over two years later at forty-nine, it was unclear whether necrosis or cirrhosis or something else had doomed him.

A decade earlier, the altogether softer party-metal outfit Great White had attempted to re-create their 1980s explosive grandeur in the diminished reserve of a small nightclub, the Station, in West Warwick, Rhode Island. They opened their set with "Desert Moon," whose chorus was crooned, "Time to dance in the magic light of the desert moon." Within seconds, their pyrotechnic effects ignited the club's foam sound insulation, and soon flames engulfed the club. Exactly one hundred people died in the fire, including guitarist Ty Longley. Less than two years after that horror, the fierce but fleet Pantera guitarist Dimebag Darrell began a set in Columbus, Ohio, with a new band, Damageplan. Again during the first song, disaster struck. A deranged fan leapt onstage and shot Dimebag, killing him (and three others) with a 9mm semiautomatic handgun. The killer believed that Dimebag had stolen lyrics from him and sought to steal his identity.

By poison, hubris, and murderous insanity—three core motifs in heavy metal—these men, always men, were snuffed out.[1] In the din of their sensational outros, I keen for all of the nameless metalheads who succumb every day now to shocking or mundane demise: car crash, cancer, overdose, suicide, and old age. Old age! And behind these bodies lurk the walking dead, left behind after flickering glories onstage or in the pit. Inevitably, almost half a century after Black Sabbath's *Paranoid* and thirty-seven years after *Bad Brains*, the first brooders and thrashers are sinking into decrepitude. Metal is a hoary genre, and it is tempting now to classify its old guys as dinosaurs.

They are not dinosaurs. They are not extinct—just haggard, feral, and often unwanted by the next generation of music fans. Think of Ozzy Osbourne doddering in suburbia, flaccid-finned like an old orca in a back-lot SeaWorld antiquarium-aquarium—an embarrassing

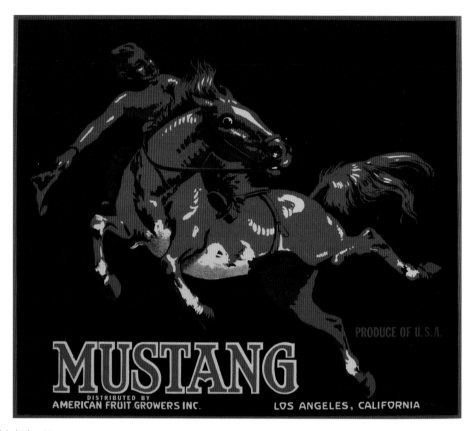

FIGURE 21.1. Crate label advertising Mustang brand oranges, American Fruit Growers, Inc., Los Angeles, California, 1930s. Lithograph, 9¾ × 11⅛ in. Gift in memory of Ted Warmbold from his wife, Carolyn Nizzi Warmbold. Autry Museum of the American West, 91.170.276.

parody of Moby-Dick, which you might think to be the true spirit animal of metal's patriarch. But rather than being sedated and tanked, most rusting iron men, I suspect, have strayed like smaller whales in remote reaches of the sea, or like wolf-dogs peeled off from their packs to die, or like old broomtail mustangs wandering out on the rangeland.

They have limped into abjection or invisibility for ten thousand reasons. Wild horses gnaw down scabby, chapped Western land that belongs officially to American taxpayers but really to ranchers. Like cowboys of old, these unbroken equines look ahead to no safe retirement pasture. Dayton O. Hyde, one of the best-known foster fathers to wild horses, says that Social Security and World War II industries "robbed the ranches of their old cowboys" and their stories, and in the end these weak souls "frittered away their days in querulous company in some nursing home."[2] Hyde would deny the cowboys what he's given the horses. But what, oh what, has become of the headbanger in winter?

Metal is a son of country and western, an electrification of blues and ballads that screams its modernity even as it gazes at progress with dread—a morbid angel of history. In Pantera's case, Jerry Bob Abbott, the father of the band's Dimebag and Vinnie Paul Abbott, was a country guitarist and recording engineer who toured Texas honky-tonks as a young man. The honky-tonk sound perseveres in the blues-scale riffs and lyrical themes of, say, Pantera's "Cowboys from Hell." Both generations combine a chins-up workingman's pride with flashy guitar licks, set to a head-nodding or -banging beat. But, speaking historically, the flourishing of the metal son in the 1980s accompanied the aging of the father.

I have been listening a lot lately to the Highwaymen (Johnny Cash, Waylon Jennings, Willie Nelson, and Kris Kristofferson), a hobbling *adiós* from former rebels in the 1980s and 1990s era of Nashville computers and sleek Stratocaster solos. This super-group's repertoire plumbs old age and history. It is clear that cowboying and Westerns had grown too cartoonish to sing about except slantwise. Their namesake song, "Highwayman," takes a kind of Buddhist approach to its hero, reincarnating him "again and again and again" as a sailor, dam builder, and finally starship pilot. The Trekkie subject matter and synthetic production hangs awkwardly around these warm, human voices. I associate these men with Luckenbach and Folsom and wipers slappin' time to pedal steel and Willie's warm guitar, Trigger. (Of course, there are cycles. The "outlaw country" sound had actually moved back to the land from the almost vaudevillian tunes of the singers' own boyhood heroes like Roy Rogers and Gene Autry, whom they salute with a cover of the classic "Back in the Saddle Again.") But such confusion doesn't repel me; the Highwaymen's strangeness is intoxicating.

The industry tends to meathook old stars after drugging them and running them ragged for a decade or so. The Highwaymen were escapees from a secret abattoir in Nashville. In the music video for "Silver Stallion," an ostensibly simple fantasy song about freedom, the men sing their verses in a dark room, glancing back at a small film screen behind them. A sepia-toned silent Western depicts a blond hero, a 1990-vintage hunk à la the movie *Young Guns* (1988), who steals a horse and then kills a man in a game of poker (as a love interest—a lacy saloon girl, of course—looks on). Then the "Saloon" sign changes to "Souvenir Shop" and the film to color, at which point the stars (now in late-'80s fashion) hop on a gleaming Harley-Davidson and pursue the old stallion as it gallops down a desert highway. The young actor in the video looks like a Great White fan, and no doubt he would have earned more money had his exploits been set to "Lady Red Light." But again, this late run by four aging country-western steeds has a grace of its own. Multiple levels of pathos inflect the "Silver

Stallion" video and the song, and it has depth that Great White only achieves in light of their tragic conflagration decades later. When they recorded that song and sang of the silver stallion with "not a mark upon his silky hide," the Highwaymen knew that they were scarred nags.

The word "mustang" derives from *mesteño*, Spanish for "stray." But the stray or stolen silver stallion becomes almost a breed of its own when it joins the society of mustangs. Wildness has its own codes: roughen the silky hide, shed the hay fat, nick the ear in a territorial scrap. When boys stray into metal they similarly learn about drop-C# tuning, blast beats, and breakdowns—and they acquire skin ink, long manes, and black uniforms. The 1971 Wild and Free-Roaming Horses and Burros Act ended the legal slaughter, or even harassment, of mustangs on federal land, and it protected them as "living symbols of the historic and pioneer spirit of the West." It marked almost a high tide of what we might think of as decency legislation in the aftermath of World War II's carnage. In 1972 the US Supreme Court even effectively banned human execution for a few years.

Soon, though, the rightist Metal Age kicked in. One of the new era's masterpieces, released as executions picked up again, was Metallica's 1984 album *Ride the Lightning*, whose title copped slang for a visit to the electric chair. But horse protection survived as the equines shape-shifted from innocent creatures needing protection to fierce beasts snorting "don't mess with me."

Horse advocates like Nevada-based Wild Horse Annie (Velma Bronn Johnston) recoiled from the hunting of horses from trucks and airplanes, the brutal yank of the rope, the claustrophobic corrals and freight cars, the bolt-gun strike to the skull, the rolling eyeballs, the flaying inside echoing cement walls, the grinding and canning of muscle to be fed to cats and dogs. I think of the arcane lyrics of the English death metal band Carcass, reveling in the horror of "making hash of the spumous crubescent." The Carcass song "Pedigree Butchery" actually imagined turning human infants into pet food, several taboo steps beyond horse-eating—although in case the dark humor isn't obvious, it is worth noting that the band members were vegetarians. Carcass formed the nihilistic inverse of a slaughterhouse reformer like Temple Grandin, who also began in the Metal Age to write of the abattoir. From a 1996 Grandin address to the American Association of Bovine Practitioners: "1.25 amps must be passed through a pig's brain to reliably induce insensibility"; "head restraint devices . . . hold a bovine's head for captive bolt stunning"; "animals became visibly frightened by sudden air hissing noises or extremely high pitched noises"; "fully conscious cattle shackling and hoisting by one back leg."[3]

A few songs after "Silver Stallion" on *Highwayman 2*, is the historical ballad "American Remains." In it each of the four Zen nags takes on a character for a verse: Cash as a shotgun rider on the San Jacinto stagecoach line, Jennings as a riverboat gambler on the Mississippi, Nelson as an indebted midwestern farmer; and Kristofferson as a Cherokee Indian. The men, always men, all face existential threats, always from other men. In sequence, the characters are held up by bandits, thrown overboard upon being caught cheating, in danger of the "bank man" repossessing worldly goods, and oppressed by polluting industry. But only Cash's character mortally dies in the song (it may be that he is reincarnated in the other three characters), and the refrain declares in unison, "We'll ride again." The song meditates on the ways we as individuals, subcultures, or whole nations like the Cherokees can sustain ourselves even as we are superseded by more powerful individuals, subcultures, or nations. We may be shot down, thrown out of fashion, or colonized, but we'll ride again. The Highwaymen stood in a unique position to hear how a Martin D-28 could still ring with a power even as a Warlock axe blasted through three Marshall stacks to drown it out for a time.[4]

Despite the valedictory tone of the Highwaymen, only Waylon Jennings faded quietly, and he died in 2002. Johnny Cash and Willie Nelson each staged a revival in the 1990s and 2000s, releasing some great and commercially successful records. In 1994, the first album of Cash's "American" series included a haunting song, "Thirteen," written by the gothic metal man Glenn Danzig, and in 2002 Cash made a smash hit of a country rendition of the Nine Inch Nails song "Hurt." Nelson's 1998 album *Teatro*, while not metallic, is as fine as anything he ever released in his supposed prime, if you ask me. Kris Kristofferson, that stud, continued a steady Hollywood career.

One can imagine that a metal song titled "American Remains" would read and sound quite different from the Highwaymen's version. The title of Carcass's debut album, *Reek of Putrefaction*, offers an idea of how it might spew and rot, and the band's English sense of humor would surely savor the putrid remains of a succeeding empire. Heavy metal uniquely embraces terrible truths that won't resolve—ever more so as the subgenres (grindcore, doom, and black metal) become darker and heavier. Where else is a death grunt a perfectible vocal technique? In pure metal there is no redemption, no society or Christ to save anyone. "We'll ride again" becomes Metallica's "Trapped under Ice." A country song about the metalhead might gleam with a silver lining, with a weathered and lonely longhair offering wisdom to a young buck or perhaps finding a triumphant last lap in his aged legs. But a grindcore rendering of the mustang's American remains would be a bludgeon. The range

cracks and blows into miserable black clouds; a rancher hamstrings some mangy horses and lets them fall to wolves or cougars; "kill buyers" reduce a herd of pioneer spirit into industrial glue or cat food. Of course, "American Remains" is itself a bleak redemption, which is sometimes the only one we get. Before the optimistic end of each chorus, "We'll ride again," the Highwaymen song half admits that the resurrection of the American remains could be—I want to add "merely"—a metaphorical one: "Our memories live on in mortals' minds and poets' pens."

AFTERWORD
Once upon a Place

In 2021, the Autry Museum is slated to reopen our Ted and Marian Craver Imagination Gallery, originally the Spirit of Imagination Gallery. This is the museum's core gallery related to popular culture and the mythic West. The title of the gallery's exhibition, we think, will be *Imagined Wests*. This book you are reading reflects some of my thinking during the planning process for the new gallery, more than thirty years into the Autry's history and a century into the life of the Southwest Museum. As curator I am one member of a broad collective of designers, advisers, educators, and visitors who will bring together a vast array of material into a single room.

If you have read this book, you have a sense of some of the countless stories, objects, and ways of thinking about the West and the Western genre. How can one gallery represent this all? The new exhibition must do justice to the mainstream Western in a way I have skirted in this book, but it must also consider the Western "slantwise," as I have put it, in a "post-Western" age. Museum docents report that younger visitors have little knowledge of many classic stars and films, and today's most prominent Westerns deconstruct the genre or remix cowboys with robots. Joan Didion long ago sensed the shattering of narrative, so what is a Western today? "Once upon a time," stories often begin, but for half a century artists have complicated the phrase's historical conjuring, from Sergio Leone's *Once upon a Time in the West* to Quentin Tarantino's work-in-progress (as of this writing) *Once upon a Time in Hollywood*. Poet Juan Felipe Herrera uses "once upon a time" to tie Los Angeles to Tenochtitlan (see chapter 12). Many Indigenous voices insist on a "once upon a place"—for example, in the writings of Leslie Marmon Silko or in *Cahuilla*, the Lewis deSoto sculpture (see fig. 8.4) that is slated to occupy a large plot of the new gallery. From across the room, *Cahuilla* may appear to visitors as just a vintage truck, as in a 1980s urban-cowboy car commercial, but its details say otherwise. It will reclaim Native space in a room shared with artifacts related to Gary Cooper and John Wayne. The reality of the borderlands too—*la frontera*—is a crucial consideration for gallery planners, and it is a slippery one. While post-Western experience should be playful, and gallery visitors should have fun, I share with others concerns about the

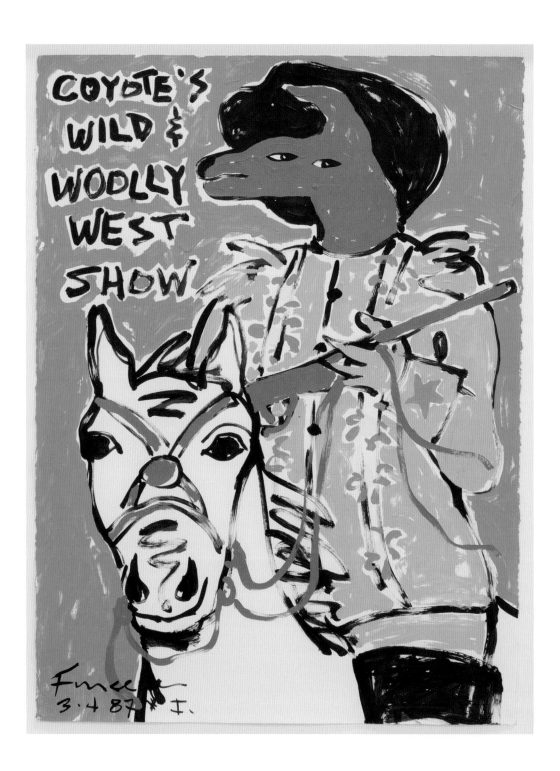

decline of shared fables and fantasies, which were once embodied in the Western genre and the myth of the historical West (see chapter 5).

Recent cultural works about Westerns and the West engage with the difficulties of "once upon a place," using one of two main approaches—or measures of both. One might be called "Weird West," and the other "Boots on the Ground." Users of the first approach seem to feel that the West is best illuminated under black lights, casting it as otherworldly and engaging other genres, like science fiction or horror. The robots of HBO's series *Westworld*, the Neanderthal villains of *Bone Tomahawk* (2015), and Quentin Tarantino's plates of spaghetti and great balls of fire exemplify the Weird West. Writer Claire Vaye Watkins published the "cli-fi" book *Gold Fame Citrus* (2016), which speculates regarding climate disaster in California, and the *Twilight* series and a reboot of *Twin Peaks* spiraled out from the Pacific Northwest's haunted vortices. The ambitious art project *Pueblo Revolt 1680/2180* by Virgil Ortiz indigenizes this approach (see fig. 7.1). Recent comics and graphic novels use the approach too, as in the somewhat embarrassing remix of ethnic tropes in *Bouncer: The One-Armed Gunslinger* (2011), by Alejandro Jodorowsky and Fraçcois Boucq; the more subtle combination of werewolves and hoodoo magic in a nineteenth-century Texas town of free African Americans in *High Moon: Bullet Holes and Bite Marks* (2017) by David Gallaher and Steve Ellis; and the more surprising tale of a Chinese American gunslinger, Kingsway Law, in an 1860s California warped by "red gold" in *Kingsway West* (2017), created and written by Greg Pak with art by Mirko Colak. This "Weird West" tradition goes back to pre–World War II stories like *The Crimson Skull* (see chapter 3) and Gene Autry's sci-fi serial *The Phantom Empire* (1935) or even Edward S. Ellis's nineteenth-century dime novel *The Steam Man of the Prairies*.

"Boots on the Ground" is a different approach, far less playful but more humane. With this approach storytellers seem largely unconcerned with the burdens and opportunities of the Western genre in telling unexpected and highly empathetic tales. The filmmaker Kelly Reichardt has told several such stories, from contemporary Oregon and Montana stories of friendship, poverty, gender, and politics to an account of the historic Oregon Trail. These slowly paced movies force viewers to live within excruciatingly human events. The novel *There There* (2018) by Tommy Orange (Cheyenne-Arapaho) follows urban Native characters in Oakland without the constant toggling between stereotypes and unexpected reality of some earlier Native novelists. One of the most powerful Western films of recent years is Chloé Zhao's *The Rider* (2018). This film stars a young Lakota rodeo star, Brady Jandreau, and

FIGURE 22.1. Harry Fonseca (Nisenan Maidu, Hawaiian, and Portuguese), *Coyote's Wild and Woolly West Show*, 1987. Acrylic on canvas, 48 × 36 in. Autry Museum of the American West, 2016.10.7.

The trickster Coyote was a recurring character in the work of Harry Fonseca.

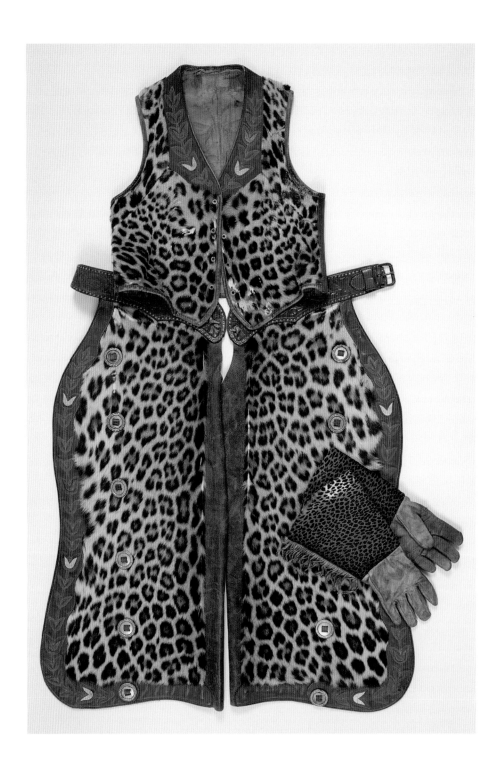

his family and community playing fictionalized versions of themselves. Zhao captures these nonprofessional actors in powerful, believable performances, and she illuminates a part of the West that rarely if ever appears onscreen: a world of Lakota horsemen living at the edge of the Badlands on the Pine Ridge Indian Reservation. The film is breathtaking and makes no reference to the genre Western beyond the unavoidable connection conveyed by prairies, horses, and cowboy hats. During a question-and-answer session after a screening in April 2018, Zhao—who grew up in Beijing—guessed that she had seen four Westerns in her life, perhaps a salutary fact for the quality of the film. For viewers looking for evidence of the complicated and traumatic histories Native people have experienced or looking for an American allegory, the film may offer evidence, but it presents its characters first as people.

Both "Weird West" and "Boots on the Ground" can be true to the West in the region's layering of real experience and invention. The resemblance of Virgil Ortiz's work (see fig. 7.1) and Zoë Urness's (see fig. 9.1), though one is speculative and the other documentary, is one example of this. I expect that the Autry Museum's new *Imagined Wests* exhibition will use both approaches: reveling in the weird bling of Nudie's Rodeo Tailors or in ersatz Indian motifs, while letting western voices speak of the harm some stories have caused, of earnest love for silver-screen heroes, or of surviving thanks to the International Gay Rodeo Association. I hope this book has made a start in uniting these tendencies with empathy. And I hope the public square of the museum gallery goes even further, letting other people and objects speak louder than the restless, musing voice of the curator.

FIGURE 22.2. Chaps and vest designed and manufactured by Charles P. Shipley, with gauntlets, 1910–15. Leather, metal, 37½ × 35¾ in. Autry Museum of the American West, 95.21.5.

Jaguar-print clothing may exemplify the "Weird West" approach to popular culture.

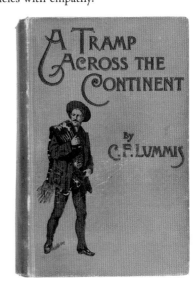

FIGURE 22.3. Charles F. Lummis, *A Tramp across the Continent* (Charles Scribner's Sons, 1892). Print on paper, cloth binding, 7⅝ × 5⅜ × 1⅛ in. Rosenstock Collection, Autry Library, Autry Museum of the American West, 90.253.236.

Southwest Museum founder Charles Lummis gained his fame with a literal "Boots on the Ground" approach, walking from Cincinnati to Los Angeles in 1884.

NOTES

Foreword

1. Samuel Bowles, *Our New West: Records of Travel between the Mississippi River and the Pacific Ocean* (Hartford, Conn.: Hartford Publishing, 1869), 87.
2. John Kenneth Galbraith, *The Affluent Society* (1958; repr., Boston: Houghton Mifflin, 1998), 8–10.
3. Ibid., 16.

Introduction

1. Many have noted the influence of the fantasy West on the real region. Historian Elliot West writes: "Each part of the West, then, is what it is, in part because of the tales people have told about it; and because the land west of the Missouri has been the special playground of the mass imagination, the stories that have been spun off in the process, the ones we call Westerns, have walked through the country with a John Wayne swagger, changing it profoundly." Elliott West, "Stories," in *The Essential West: Collected Essays* (Norman: University of Oklahoma Press, 2012), 291. Geographer Dydia DeLyser has characterized the "historic West and the mythic West" as inseparable and "mutually constitutive." Quoted in Gary J. Hausladen, ed., *Western Places, American Myths: How We Think about the West* (Reno: University of Nevada Press, 2003), 5. Literary scholar Stephen Tatum critiques new western history as drawing too sharp a line between myth and reality (perhaps cherry-picking its most polemical quotes) and promising deliverance from a haze of fiction. See Tatum, "The Problem of the 'Popular' in the New Western History," in Forrest G. Robinson, ed., *The New Western History: The Territory Ahead* (Tucson: University of Arizona Press, 1997).
2. For a theoretical rethinking of regionalism, see Neil Campbell, *The Rhizomatic West: Representing the American West in a Transnational, Global, Media Age* (Lincoln: University of Nebraska Press, 2008), especially chapter 1, "Toward an Expanded Critical Regionalism: Contact and Interchange," 41–74. See also David Wrobel and Michael Steiner, eds. *Many Wests: Place, Culture and Regional Identity* (Lawrence: University Press of Kansas, 1997).
3. In her excellent study of Native Americans in film, Michelle H. Raheja adopts the queer readings of Hollywood cinema by Patricia White to show how a retrospective lens is somewhere between "decoding" and "textual revision," finding subtlety and speculative Native resistance in very mainstream movies. Raheja, *Reservation Reelism: Redfacing, Visual Sovereignty, and Representations of Native Americans in Film* (Lincoln: University of Nebraska Press, 2010), 10–11.
4. My approach throughout this book is often consonant with Campbell, *Rhizomatic West*. Campbell writes, "To examine the West in the twenty-first century is to think of it as always already transnational, a more routed and complex rendition, a traveling concept whose meanings move between cultures, crossing, bridging, and intruding simultaneously" (4). Campbell's references

and rhetorical strategies are distinct from mine, drawing extensively on poststructuralist theory and high literature and art. I also believe there is something of an actual, physical space to the West, sometimes in tension with the "traveling concept" of what Campbell calls "westness." For another take along these lines, see Carlton Smith, *Coyote Kills John Wayne: Postmodernism and Contemporary Fictions of the Transcultural Frontier* (Hanover, NH: University Press of New England, 2000). Tex Ritter's break in *Green Grow the Lilacs* is covered in Richard Aquila, *The Sagebrush Trail: Western Movies and Twentieth-Century America* (Tucson: University of Arizona Press, 2015), 111.

5. Immense shelves of smart books plumb the mainstream, dominant, mythic or imagined West, often moving past fandom to true erudition. A few major examples: Richard Slotkin, *Gunfighter Nation: The Myth of the Frontier in Twentieth-Century America* (New York: Athenaeum, 1992), as well as Slotkin's other work on earlier iterations of the frontier mythology; Jane Tompkins, *West of Everything: The Inner Life of Westerns* (New York: Oxford University Press, 1992); Michael Coyne, *The Crowded Prairie: American National Identity in the Hollywood Western* (London: I. B. Tauris, 1997); Aquila, *The Sagebrush Trail*; and Andrew Patrick Nelson, *Still in the Saddle: The Hollywood Western, 1969–1980* (Norman: University of Oklahoma Press, 2015). More interdisciplinary works on the mythic West include Robert G. Athearn, *The Mythic West in Twentieth-Century America* (Lawrence: University Press of Kansas, 1986); Richard W. Etulain, *Re-Imagining the Modern American West: A Century of Fiction, History, and Art* (Tucson: University of Arizona Press, 1996); William H. Truettner, ed., *The West as America: Reinterpreting Images of the Frontier, 1820–1920* (Washington: Smithsonian Institution Press, 1991); Hausladen, *Western Places, American Myths*; William H. Goetzmann and William N. Goetzmann, *The West of the Imagination*, 2nd ed. (Norman: University of Oklahoma Press, 2009); and Marian Wardle and Sarah E. Boehme, eds. *Branding the American West: Paintings and Films, 1900–1950* (Norman: University of Oklahoma Press, 2016).

6. On the theoretical and academic side, there is a rich "discourse" around Westerns. Campbell, *Rhizomatic West*, is fun to read if you're into that kind of theory—bringing Gilles Deleuze and Félix Guattari to the Western back lot. Who knew Deleuze had once declared, "I am a poor lonesome cowboy," quoting the French cartoon cowboy Lucky Luke? *Rhizomatic West*, 32. Other key works include Krista Comer, *Landscapes of the New West: Gender and Geography in Contemporary Women's Writing* (Chapel Hill: University of North Carolina Press, 1999); and Susan Kollin, ed., *Postwestern Cultures: Literature, Theory, Space* (Lincoln: University of Nebraska Press, 2007).

7. For more on the mural's history, see Stephen Aron, "From Romance to Convergence," in Amy Scott, ed., *Art of the West: Selected Works from the Autry Museum* (Norman: University of Oklahoma Press, 2018), vii–xii.

8. See Scott, ed., *Art of the West*. This catalog and ongoing evolution in the galleries reflect the period since 2013.

9. Lucy R. Lippard, *On the Beaten Track: Tourism, Art, and Place* (New York: New Press, 1999), 108.

10. The white dominance of Westerns is widely noted in scholarship on the genre, with key examples being Slotkin, *Gunfighter Nation*, and Coyne, *The Crowded Prairie*. Coyne argues that the genre reinforced "white *centrality*" rather than white supremacy (4), though the fierce reactions against revisions of this centrality (see, e.g., chapter 11 below for the reactions of Goetzmann and

Goetzmann to the visions of Aztlán) suggest that a power relation rather than simply a point of view is at stake. Note that in the Autry Museum mural, the white, northern European couple is not only central but also elevated above the rest of the multiethnic cast and backed by a virtual halo.

11. For more on the mural, see Aron, "Romance to Convergence," vii–xii.

12. The historian colleague is Flannery Burke; she has also engaged this topic in more scholarly and extensive detail in twentieth-century New Mexico and Arizona. See, for example, Burke, *A Land Apart: The Southwest and the Nation in the Twentieth Century* (Tucson: University of Arizona Press, 2017), especially chapter 5, "The Searchers: Race and Tourism in the Southwest," 159–193. The second colleague is the artist Nick Kramer, no longer at the Autry.

13. The song is on Johnny Cash, *I Would Like to See You Again* (Columbia Records, 1978).

14. On the historical continuity between the American Empire in the West and its offshore and "virtual" empires, see Walter Nugent, *Habits of Empire: A History of American Expansion* (New York: Knopf, 2008).

15. Richard Aquila makes more detailed historical and political parallels throughout *The Sagebrush Trail*. Michael Coyne makes the connection between the post–World War II golden age of Westerns and the "deep faith in America's possibilities" noted by another historian, William L. O'Neill. See Coyne, *Crowded Prairie*, 5. On literary regionalism putting in place a mythical time amid ethnic resentment, see Roberto Maria Dainotto, "'All the Regions Do Smilingly Revolt': The Literature of Place and Region," *Critical Inquiry* 22, no. 3 (Spring 1996): 486–505.

16. Coyne, *Crowded Prairie*, 165. My sense of this era is influenced by Studs Terkel, *The Great Divide: Second Thoughts on the American Dream* (New York: Pantheon, 1988); and Daniel T. Rodgers, *The Age of Fracture* (Cambridge, Mass.: Harvard University Press, 2011).

17. Aquila, *Sagebrush Trail*, 299, 331. Again, other books treat these historical changes with greater depth than I can here.

18. Neil Campbell, *Post-Westerns: Cinema, Region, West* (Lincoln: University of Nebraska Press, 2013), 2, 19–55.

19. Gloria Anzaldúa, *Borderlands/La Frontera: The New Mestiza*, 25th anniversary ed. (San Francisco: Aunt Lute Books, 1987, 2012), 19; Louis Owens, *Mixedblood Messages: Literature, Film, Family, Place* (Norman: University of Oklahoma Press, 1998), 26; Campbell, *Rhizomatic West*, 4. Another inspiring work along these lines is Eduardo Galeano, *Memory of Fire Trilogy: Genesis, Faces and Masks, and Century of the Wind* (New York: Open Road Media, 2014), which integrates pan-American histories of colonialism.

2. *The West's World*

1. Ch. Didier Gondola, *Tropical Cowboys: Westerns, Violence, and Masculinity in Kinshasa* (Bloomington: Indiana University Press, 2016), 65.

2. Ibid., 72.

3. See Louis Chude-Sokei, "'But I Did Not Shoot the Deputy': Dubbing the Yankee Frontier," in Rob Wilson and Christopher Leigh Connery, eds., *The Worlding Project: Doing Cultural Studies in the Era of Globalization* (Berkeley: North Atlantic Books, 2007), 133–70; and Susan Kollin, *Captivating Westerns: The Middle East in the American West* (Lincoln: University of Nebraska Press, 2015), esp. 181–210.

4. Scott Ezell, *A Far Corner: Life and Art with the Open Circle Tribe* (Lincoln: University of Nebraska Press, 2015), 6–11.

5. Some scholars have paid attention to the Western internationally. In addition to Gondola, *Tropical Cowboys*, Chude-Shokei, "But I Did Not Shoot the Deputy," and Kollin, *Captivating Westerns*, the literature includes the Autry-affiliated Kevin Mulroy, ed., *Western Amerykanski: Polish Poster Art and the Western* (Los Angeles: Autry Museum of Western Heritage; Seattle: University of Washington Press, 1999), which includes an excellent introductory overview of the world Western; and Christopher Frayling, *Once upon a Time in Italy: The Westerns of Sergio Leone* (New York: Harry N. Abrams, 2005). See also James K. Folsom, ed., *The Western: A Collection of Critical Essays* (Englewood Cliffs, N.J.: Prentice Hall, 1979), including two essays on "The Foreigner's Western," 111–36; Neil Campbell, *The Rhizomatic West: Representing the American West in a Transnational, Global, Media Age* (Lincoln: University of Nebraska Press, 2008); and Bernd Desinger and Matthias Knop, eds., *Treasure of Silver Lake: The Myth of the American West in Germany* (Düsseldorf: Filmmuseum, 2011).

6. This quote appears on a plaque in the Autry Museum's main plaza.

7. Pierre Bayard, *How to Talk about Places You've Never Been: On the Importance of Armchair Travel* (New York: Bloomsbury, 2016), 143.

8. Transcribed from *Winnetou: The Last Shot* (1965), online streaming.

9. Franz Kafka, *Amerika* (New York: Schocken Books, 1946), 297–98.

10. See, for example, William R. Handley and Nathaniel Lewis, eds., *True West: Authenticity and the American West* (Lincoln: University of Nebraska Press, 2004); and Paul Andrew Hutton, "A Fool's Errand: Does Such a Thing as a Historically Accurate Western exist?" *True West*, February 2018, 32–34.

11. For a more extensive conversation on *Tampopo* and Westerns, see John Bruns, "Itami and the Postmodern Japanese Film," in Cristina Degli-Esposti, ed., *Postmodernism in the Cinema* (New York: Berghahn Books, 1998), 96–100.

3. *A Posse of Soul Westerns*

1. Transcribed from Walt Disney Imagineering, Gene Autry Western Heritage Museum, Finale, final edited master, October 15, 1988, Autry Museum archives.

2. Maine-based scholar Michael K. Johnson, in a broad account of African American literature and film from and about the West from the 1890s to the 2010s, finds a mix of optimism and pessimism, silver lining and clouds. Some stories depict "an exceptional West where the limitations of race can be transcended," while others tell of "hopes for a new life crushed by the existence of unexceptional western prejudice." Michael K. Johnson, *Hoo-Doo Cowboys and Bronze Buckaroos: Conceptions of the African American West* (Jackson: University Press of Mississippi, 2014), 10.

3. One classic work appeared over a decade before the museum's opening: Nell Irvin Painter, *Exodusters: Black Migration to Kansas after Reconstruction* (New York: W. W. Norton, 1976).

4. Video of this debate, between James Baldwin and William F. Buckley Jr., is available online. A text source is the documentary film companion reader: James Baldwin, *I Am Not Your Negro* (New York: Vintage, 2017), 23. The "great shock" suffered by these children reiterated W. E. B. Du Bois's idea of "double consciousness," the "veil" dropped around African Americans by the color line in

the United States. See W. E. B. Du Bois, *The Souls of Black Folk: Essays and Sketches* (Chicago: A. C. McClurg, 1903), 3. Kyle T. Mays critiques Baldwin's shorthand as using Indigenous genocide as "a prophetic tool, a prop," which ignores Native resistance and erases contemporary Indigenous people. While I agree that this is an element of Baldwin's quote, I also see it as more simply linking African American and Native fates (along with those of other people of color around the world) as simple others on which to build white supremacy and white identity. See Kyle T. Mays, "Indigenous Genocide and Black Liberation: A Short Critique of *I Am Not Your Negro*—with Love," *Indian Country Today*, February 24, 2017.

5. On revisionist Westerns, see, for example, Michael Coyne, *The Crowded Prairie: American National Identity in the Hollywood Western* (London: I. B. Tauris, 1997), 120–65; Richard Aquila, *The Sagebrush Trail: Western Movies and Twentieth Century America* (Tucson: University of Arizona Press, 2015), 195–257; John Saunders, *The Western Genre: From Lordsburg to Big Whiskey* (London: Wallflower Press, 2001), 81–113; and R. Philip Loy, *Westerns in a Changing America, 1955–2000* (Jefferson, N.C.: McFarland, 2004).

6. Baldwin, *I Am Not Your Negro*, 23, 47, 49, 79, 99.

7. Ibid., 47–48.

8. The films are available in the five-disc DVD set *Pioneers of African-American Cinema* (New York: Kino Classics, 2016).

9. For a more in-depth consideration of Micheaux and race, see Johnson, *Hoo-Doo Cowboys*, 51–74.

10. The full script of *The Crimson Skull*, held by the Autry Museum, is published as an appendix to Barbara Tepa Lupack, *Richard E. Norman and Race Filmmaking* (Bloomington: Indiana University Press, 2014), 276.

11. Ibid., 280. The Norman Studios Silent Film Museum supports the legacy of this company, and the Autry Museum holds significant archives of Norman Studios material.

12. See Painter, *Exodusters*; and Steven Hahn, *A Nation under Our Feet: Black Political Struggles in the Rural South from Slavery to the Great Migration* (Cambridge, Mass.: Harvard University Press, 2005).

13. Vincent Canby, "Poitier Directs 'Buck and the Preacher,'" *New York Times*, April 29, 1972.

14. "John Wayne: Playboy Interview," *Playboy*, May 1971.

15. Several more scholarly books approach these subjects more extensively than I can here. See Johnson, *Hoo-Doo Cowboys*; Blake Allmendinger, *Inventing the African American West* (Lincoln: University of Nebraska Press, 2005); and Emily Lutenski, *West of Harlem: African American Writers and the Borderlands* (Lawrence: University Press of Kansas, 2015).

4. On The Frisco Kid

1. "Jorge Luis Borges," interview by Ronald Christ, in *Writers at Work: The Paris Review Interviews*, fourth series, ed. George Plimpton (New York: Viking, 1976), 116.

2. *Frisco Kid* director Robert Aldrich was better known for his work in other genres (thrillers, war movies, and sci-fi), but he also directed a number of other Westerns: *Apache* and *Vera Cruz* (both from 1954); *The Last Sunset* (1961); and *Ulzana's Raid* (1972). He even directed another Western comedy, *4 for Texas* (1963), starring Frank Sinatra and Dean Martin.

3. See, for example, Ava Kahn, ed. *Jewish Life in the American West* (Berkeley: Heyday, 2004).

4. Richard White, *The Middle Ground: Indians, Empires, and Republics in the Great Lakes Region, 1650–1815* (Cambridge, UK: Cambridge University Press, 1991). Regarding fast-and-loose application of White's concept, such as I am deploying here, see Philip J. Deloria, "What Is the Middle Ground, Anyway?," *William and Mary Quarterly* 63, no. 1 (January 2006): 15–22.

5. *History as Genre Literature*

1. Frederick Jackson Turner, "The Significance of the Frontier in American History," delivered to the American Historical Association, 1893. Published in Frederick Jackson Turner, *The Frontier in American History* (New York: Henry Holt, 1921), 1–38.

2. Patricia Nelson Limerick, "The Unleashing of the Western Public Intellectual," in Patricia Nelson Limerick, Clyde A. Milner II, and Charles E. Rankin, eds. *Trails: Toward a New Western History* (Lawrence: University Press of Kansas, 1991), 63.

3. Ray Allen Billington, *The Far Western Frontier: 1830–1860* (New York: Harper & Brothers, 1956), xviii.

4. Billington (ibid.) uses the word "corrosive" to describe the effect of all of the West on early "Mountain Men," to characterize the effect of Utah on the Mormons, and to explain the genocidal rages of white gold miners against Indians, Mexicans, and Chinese (44, 53, 212, 238); he also describes nineteenth-century Overland Trail migrants devising not a constitution but a "simpler body of laws suited to their primitive social group" (100), Mexican-American War soldiers in Mexico City "leaping from pillar to pillar like so many Indians" (190), and so on.

5. Patricia Nelson Limerick, "Persistent Traits and the Persistent Historian: The American Frontier and Ray Allen Billington," in Richard W. Etulain, ed., *Writing Western History: Essays on Major Western Historians* (Reno: University of Nevada Press, 1991), 285.

6. Anthony F. C. Wallace, *The Long, Bitter Trail: Andrew Jackson and the Indians* (New York: Hill and Wang, 1993), 11.

7. Billington, *Far Western Frontier*, 10–13.

8. Ibid., 120.

9. Ibid., 47. Thanks to Patricia Nelson Limerick for noting this passage to me; see Limerick, "Persistent Traits and the Persistent Historian," 290.

10. Billington, *Far Western Frontiers*, 1, 91, 168.

11. The American studies pioneer Henry Nash Smith had already traced the power of—and in a sense, deconstructed—the frontier "myth" in the nineteenth century as a cultural trope culminating in Turner's thesis, in *Virgin Land: The American West as Symbol and Myth* (Cambridge, Mass.: Harvard University Press, 1950). See also Ann Fabian, "Back to *Virgin Land*," *Reviews in American History* 24, no. 3 (September 1996): 542–53

12. Ibid., 77.

13. Wilbur R. Jacobs, *On Turner's Trail: 100 Years of Writing Western History* (Lawrence: University Press of Kansas, 1994), 195–96.

14. Will Henry, *I, Tom Horn* (1975; repr., New York: Bantam Books, 1980), xii.

15. Ibid., 333.

16. Ibid., 201.

17. Quoted in John Mack Faragher, "The Significance of the Frontier in American Historiography: A Guide to Further Reading," afterword to *Rereading Frederick Jackson Turner: "The*

Significance of the Frontier in American History" and Other Essays (New York: Henry Holt, 1994), 226.

18. See, for example, William Cronon, George Miles, and Jay Gitlin, "Becoming West: Toward a New Meaning for Western History," in Cronon, Miles, and Gitlin, *Under an Open Sky: Rethinking America's Western Past* (New York: Norton, 1992); and Jeremy Adelman and Stephen Aron, "From Borderlands to Borders: Empires, Nation-States, and the Peoples in between in North American History," *American Historical Review* 104, no. 3 (June 1999): 814–41.

19. Faragher, "Significance of the Frontier in American Historiography," 230.

20. Turner, *Frontier in American History*, 15.

21. Quoted in *On Campus* 7, no. 3 (November 1987): 2, cited in George Lipsitz, *Time Passages: Collective Memory and American Popular Culture* (Minneapolis: University of Minnesota Press, 1990), 24–25.

22. Larry McMurtry, "How the West Was Won or Lost," *New Republic*, October 22, 1990, 38.

23. John Mack Faragher, "'And the Lonely Voice of Youth Cries "What Is Truth?"': Western History and the National Narrative," *Western Historical Quarterly* 48, no. 1 (Spring 2017): 1–22. For good discussions of the new western history as narrative, see Forrest G. Robinson, *The New Western History: The Territory Ahead* (Tucson: University of Arizona Press, 1997); and Michael L. Johnson, *New Westers: The West in Contemporary American Culture* (Lawrence: University Press of Kansas, 1996), 55–101.

24. Tiya Miles, *Ties That Bind: The Story of an Afro-Cherokee Family in Slavery and Freedom* (Berkeley: University of California Press, 2005); Richard White, *Railroaded: The Transcontinentals and the Making of Modern America* (New York: Norton, 2011); Andrew Needham, *Power Lines: Phoenix and the Making of the Modern Southwest* (Princeton, N.J.: Princeton University Press, 2014).

25. A character-driven survey to rival *The Far Western Frontier* might be Anne F. Hyde, *Empires, Nations, and Families: A History of the North American West, 1800–1860* (Lincoln: University of Nebraska Press, 2011).

6. *Historical Angels*

1. Barry O'Connell, ed., *On Our Own Ground: The Complete Writings of William Apess, a Pequot* (Amherst: University of Massachusetts Press, 1992); Phillip H. Round, *Removable Type: Histories of the Book in Indian Country, 1663–1880* (Chapel Hill: University of North Carolina Press, 2010); Philip J. Deloria, *Indians in Unexpected Places* (Lawrence: University Press of Kansas, 2004); Christopher Scales, *Recording Culture: Powwow Music and the Aboriginal Recording Industry on the Northern Plains* (Durham, N.C.: Duke University Press, 2012); Michelle H. Raheja, *Reservation Reelism: Redfacing, Visual Sovereignty, and Representations of Native Americans in Film* (Lincoln: University of Nebraska Press, 2010).

2. "Sending Cinematic Smoke Signals: An Interview with Sherman Alexie," by Dennis West and Joan M. West, *Cineaste* (January 1998), quoted in Robin L. Murray and Joseph K. Heumann, *Gunfight at the Eco-Corral: Western Cinema and the Environment* (Norman: University of Oklahoma Press, 2012), 182.

3. Thanks to the expert film fans at the Autry Museum's "What Is a Western?" series who identified *Santa Fe Trail*.

4. "John Wayne: Playboy Interview," *Playboy*, May 1971.

5. For an inspiring essay about the difference between romance and epic as models for Western history, see Pekka Hämäläinen and Samuel Truett, "On Borderlands," *Journal of American History* 98, no. 2 (September 2011): 338–61.

6. See, for example, Frederick E. Hoxie, *This Indian Country: American Indian Activists and the Place They Made* (New York: Penguin Books, 2012), 393–401.

7. Walter Benjamin, *Illuminations: Essays and Reflections* (New York: Schocken Books, 1968), 257–58.

8. Vine Deloria Jr., *God Is Red: A Native View of Religion*, 30th anniversary ed. (Golden, Colo.: Fulcrum, 2003), especially chapters 4, 6, and 7; and Peter Nabokov, *A Forest of Time: American Indian Ways of History* (Cambridge, UK: Cambridge University Press, 2002).

9. West and West, "Sending Cinematic Smoke Signals," quoted in Murray and Heumann, *Gunfight at the Eco-Corral*, 188.

7. *The Wonders of Leslie Marmon Silko*

1. Leslie Marmon Silko, *The Turquoise Ledge* (New York: Viking, 2010), 7.

2. Ibid., 129.

3. Walter Benjamin, *Illuminations: Essays and Reflections* (New York: Schocken Books, 1968), 261, 257.

4. Leslie Marmon Silko, *Ceremony* (New York: Penguin, 1977), 192.

5. Silko, *Turquoise Ledge*, 1.

6. Ibid., 46.

7. Vine Deloria Jr., *Red Earth, White Lies: Native Americans and the Myth of Scientific Fact* (New York: Scribner, 1995).

8. Vine Deloria Jr., *God Is Red: A Native View of Religion*, 30th anniversary ed. (Golden, Colo.: Fulcrum, 2003), vii.

9. Ibid., 65, 89.

10. Deloria, *Red Earth, White Lies*, 68.

11. See, for example, Fikret Berkes, *Sacred Ecology: Traditional Ecological Knowledge and Resource Management* (New York: Routledge, 1999); M. Kat Anderson, *Tending the Wild: Native American Knowledge and Management of California's Natural Resources* (Berkeley: University of California Press, 2013).

12. Silko, *Turquoise Ledge*, 46.

13. Ibid., 47.

14. Ibid., 26, 281.

15. Deloria, *God Is Red*, 85.

8. *Horse Power*

1. I have taken all of these production dates from *Wikipedia*, which is poor academic form, although I suspect this is one of the realms in which crowdsourced history is reliably accurate.

2. Philip Deloria, *Indians in Unexpected Places* (Lawrence: University Press of Kansas, 2004), 152.

3. Ibid., 136–82.

4. James H. Nottage, *Saddlemaker to the Stars: The Leather and Silver Art of Edward H. Bohlin* (Los Angeles: Autry Museum of Western Heritage, 1996), 190–201.

5. Tommy Orange, *There There* (New York: Alfred A. Knopf, 2018), 7.

6. Among others: Brian Dippie, *The Vanishing American: White Attitudes and U.S. Indian Policy* (Lawrence: University Press of Kansas, 1984, 1991); Philip J. Deloria, *Playing Indian* (New Haven, Conn.: Yale University Press, 1998); Mick Gidley, *Edward S. Curtis and the North American Indian, Incorporated* (Cambridge: Cambridge University Press, 2000); Shari M. Huhndorf, *Going Native: Indians in the American Cultural Imagination* (Ithaca, N.Y.: Cornell University Press, 2001); Alan Trachtenberg, *Shades of Hiawatha: Staging Indians, Making Americans, 1880–1930* (New York: Hill and Wang, 2005); Elizabeth Hutchinson, *The Indian Craze: Primitivism, Modernism, and Transculturation in American Art, 1890–1915* (Durham, N.C.: Duke University Press, 2009); Sherry L. Smith, *Hippies, Indians, and the Fight for Red Power* (New York: Oxford University Press, 2012).

7. Untitled article, *Indian News* 7, no. 1 (November 1940), 1–2.

8. DeSoto's sculpture is featured in *News from Native California* 28, no. 2 (Winter 2014), 6–7. See also Ralph A. Rossum, *The Supreme Court and Tribal Gaming: California v. Cabazon Band of Mission Indians* (Lawrence: University Press of Kansas, 2011); Alexandra Harmon, *Rich Indians: Native People and the Problem of Wealth in American History* (Chapel Hill: University of North Carolina Press, 2010).

9. *Standing Rock and the Museum*

1. American Alliance of Museums, "Statement from AAM President & CEO Laura Lott on the Demolition of the Standing Rock Sioux Tribe's Ancestral Burial Ground," September 9, 2016, https://www.aam-us.org/.

2. Quotes from Native artists were collected by the author and formed part of the gallery text of *Standing Rock: Art and Solidarity* at the Autry Museum, on display May 2017–February 2018.

3. See Smith, *Hippies, Indians, and the Fight for Red Power*. Smith shows how a similar series of sometimes awkward and problematic alliances in the 1960s and '70s nonetheless accomplished real progress for Native self-determination.

4. Elliott West, *The Last Indian War: The Nez Perce Story* (New York: Oxford University Press, 2009), 79.

5. See, for example, Blaire Briody, *The New Wild West: Black Gold, Fracking, and Life in a North Dakota Boomtown* (New York: St. Martin's Press, 2017).

6. See, for example, Sierra Crane-Murdoch, "The Other Bakken Boom: America's Biggest Oil Rush Brings Tribal Conflict," *High Country News*, April 23, 2012, http://hcn.org; Valerie Volcovici, "In Montana's Indian Country, Tribes Take Opposite Sides on Coal," Reuters, August 20, 2017, https://www.reuters.com/; David Grann, *Killers of the Flower Moon: The Osage Murders and the Birth of the FBI* (New York: Doubleday, 2017).

7. Margaret M. Bruchac, *Savage Kin: Indigenous Informants and American Anthropology* (Tucson: University of Arizona Press, 2018), 48–113; Michelle H. Raheja, *Reservation Reelism: Redfacing, Visual Sovereignty, and Representations of Native Americans in Film* (Lincoln: University of Nebraska Press, 2010), 102–44.

8. Melanie Benson Taylor, "The Convenient Indian: How Activists Get Native Americans Wrong," *Los Angeles Review of Books*, April 9, 2017, https://lareviewofbooks.org/.

10. *Calexico*

1. Patricia Nelson Limerick, "The Adventures of the Frontier in the Twentieth Century," in James Grossman, ed., *The Frontier in American Culture* (Berkeley: University of California Press, 1994), 90, 95.

2. On the creation of artistic visions of a borderland space, see, for example, Ramón Saldívar, *The Borderlands of Culture: Américo Paredes and the Transnational Imaginary* (Durham: Duke University Press, 2006); and José David Saldívar, *Border Matters: Remapping American Cultural Studies* (Berkeley: University of California Press, 1997). Saldívar's account includes musical visionaries of the border including Los Tigres del Norte and El Vez.

3. Joshua Garrett-Davis, "Composing the New Western," *High Country News*, September 13, 2004.

4. Josh Kun, *Audiotopia: Music, Race, and America* (Berkeley: University of California Press, 2005).

5. Jorge Luis Borges, "Kafka and His Precursors," in *Labyrinths: Selected Stories and Other Writings*, edited by Donald A. Yates and James E. Irby (New York: New Directions, 1964), 201.

6. Gloria Anzaldúa, *Borderlands/La Frontera: The New Mestiza*, 25th anniversary ed. (San Francisco: Aunt Lute Books, 2012), 88.

11. *Aztlán Cowboys*

1. Gloria Anzaldúa, *Borderlands/La Frontera: The New Mestiza*, 25th anniversary ed. (San Francisco: Aunt Lute Books, 2012), 82.

2. The 2009 revised edition of *The West of the Imagination*, by William H. Goetzmann and William N. Goetzmann, has no place for this vision except in a single chapter, "Montezuma's Return," on late-twentieth-century Latino art. Goetzmann and Goetzmann, *The West of the Imagination*, 2nd ed. (Norman: University of Oklahoma Press, 2009), 473–84. Richard W. Etulain includes writers and artists like Rudolfo Anaya and Judith Baca in *Re-Imagining the Modern American West: A Century of Fiction, History, and Art* (Tucson: University of Arizona Press, 1996) and explicitly addresses the treatment of the region in late-twentieth-century literature by nonwhite authors. He writes that "few critics would cite these writings as primarily works about the Southwest, the Far West, or the northern West." They are, for Etulain, overwhelmingly about "*ethnic* rather than *regional*" experience (151, his italics). He does not address the hegemony of white experience, which makes it invisible as an ethnicity or artistic point of view and allows white authors to frame their individual experience as regional in a way nonwhite artists have not been free to do.

3. Some of these Autry Museum exhibitions had publications associated with them: Gene Autry Western Heritage Museum, *The Mask of Zorro: Mexican Americans in Popular Culture* (Los Angeles: Gene Autry Western Heritage Museum, 1994); Chon A. Noriega, Terezita Romo, and Pilar Tompkins Rivas, eds. *L.A. Xicano* (Los Angeles: UCLA Chicano Studies Research Center, 2011); and Colin Gunckel, ed., *La Raza* (forthcoming). In engaging with the terms "West" and "frontier," I am drawing on Emily Lutenski, *West of Harlem: African American Writers and the Borderlands* (Lawrence: University Press of Kansas, 2015), especially pages 21–22, where she discusses joining "borderlands" to "West" conceptually. Lutenski quotes Krista Comer, "West," in *Keywords for American Cultural Studies*, ed. Bruce Burgett and Glenn Hendler (New York: New York University Press, 2007), 238–42.

4. For an examination of the subregions of the physical West that reflects some of the subregions of the imagined West, see David Wrobel and Michael Steiner, eds., *Many Wests: Place, Culture and Regional Identity* (Lawrence: University Press of Kansas, 1997). There are many histories

of the conception of wilderness, including Roderick Nash, *Wilderness and the American Mind* (New Haven, Conn.: Yale University Press, 1967), and many more recent books. My conception of "Indian Country" is taken from the Indian Country Today media group and Phillip H. Round, *Removable Type: Histories of the Book in Indian Country, 1663–1880* (Chapel Hill: University of North Carolina Press, 2010). On the Sunbelt and suburbs, see Kenneth T. Jackson, *Crabgrass Frontier: The Suburbanization of the United States* (New York: Oxford University Press, 1985); Geraldo L. Cadava, *Standing on Common Ground: The Making of a Sunbelt Borderland* (Cambridge, Mass.: Harvard University Press, 2013).

5. Anzaldúa, *Borderlands/La Frontera*, 33.

6. Ibid.

7. Goetzmann and Goetzmann, *West of the Imagination*, 483.

8. Anzaldúa, *Borderlands/La Frontera*, 81.

9. Herbert E. Bolton, *The Spanish Borderlands: A Chronicle of Old Florida and the Southwest* (New Haven: Yale University Press, 1921), vii.

10. Quoted in Albert L. Hurtado, *Herbert Eugene Bolton: Historian of the American Borderlands* (Berkeley: University of California Press, 2012), 123–24.

11. Bolton, *Spanish Borderlands*, vii–x.

12. Ibid., ix.

13. I'm grateful to Anthony Macías for selecting and introducing *The Ride Back* and *Man from Del Rio* (1956) for the Autry's "What Is a Western?" series. On Latino/a history in Hollywood, see the documentary *The Bronze Screen: 100 Years of the Latino Image in Hollywood* (Chicago: Questar, 2002).

12. *A Triple Landscape*

1. Rodolfo F. Acuña, *Anything but Mexican: Chicanos in Contemporary Los Angeles* (New York: Verso, 1996), 33–34. Acuña first raised his criticisms within a year of the Autry's opening, in an op-ed titled "No Way to Celebrate Cinco de Mayo," *Los Angeles Herald Examiner*, May 5, 1989. The museum responded publicly, in part by asking, "Tell us, Señor Acuña, what are you doing to preserve Hispanic history?" although Acuña was and is a leading Chicano historian. See William Estrada, "Museum's Criticism Sparks a Showdown," *Los Angeles Herald Examiner*, June 11, 1989.

2. Walt Whitman, "Song of Myself," in *Leaves of Grass* (New York: Penguin Classics, 1959), 33.

3. See Kevin Mulroy, preface to Lawrence B. de Graaf, Kevin Mulroy, and Quintard Taylor, *Seeking El Dorado: African Americans in California* (Los Angeles: Autry Museum of Western Heritage, 2001), ix–xiii; Stephen Aron, "From Romance to Convergence," foreword to Amy Scott, ed., *Art of the West: Selected Works from the Autry Museum* (Norman: University of Oklahoma Press, 2018), vii–xii.

4. Juan Felipe Herrera, "Rodney King, the Black Christ of Los Angeles and All Our White Sins," in *187 Reasons Mexicanos Can't Cross the Border: Undocuments 1971–2007* (San Francisco: City Lights Books, 2007), 223, 221, 226.

5. Ibid., 227.

6. Excerpt, "One Year Before the Zapatista Rebellion," in ibid., 181, from Herrera, *Mayan Drifter: Chicano Poet in the Lowlands of America* (Philadelphia: Temple University Press, 1997).

7. Michelle H. Raheja, *Reservation Reelism: Redfacing, Visual Sovereignty, and Representations of Native Americans in Film* (Lincoln: University of Nebraska Press, 2010), 20–34.

13. *An Old Song*

1. Lynn Riggs, *Green Grow the Lilacs*, in *The Cherokee Night and Other Plays* (Norman: University of Oklahoma Press, 2003), 3, 8, 105.

2. Ibid., 8.

3. Ibid., 4.

4. Jace Weaver, foreword to Riggs, *Cherokee Night*, ix. Weaver doesn't take up Riggs's sexuality, which is featured in a chapter excellently titled "Lynn Riggs as Code Talker: Toward a Queer Oklahomo Theory and the Radicalization of Native American Studies," in Craig Womack, *Red on Red: Native American Literary Separatism* (Minneapolis: University of Minnesota Press, 1999).

5. Grant Wood, *Revolt against the City* (Iowa City: Clio Press, 1935). For a dimmer view of regionalism, see Roberto Maria Dainotto, "'All the Regions Do Smilingly Revolt': The Literature of Place and Region," *Critical Inquiry* 22, no. 3 (Spring 1996): 486–505.

6. On Holiday—a northerner herself—as a "fusion of jazz and political cabaret, of Louis Armstrong and Bertolt Brecht," and White as an overlooked innovator, see Michael Denning, *The Cultural Front: The Laboring of American Culture in the Twentieth Century* (New York: Verso, 1997), 323, 360.

7. Federico García Lorca, "Deep Song," in *In Search of Duende* (New York: New Directions, 2010), 14.

8. Riggs, *Green Grow the Lilacs*, 25, 63–65.

9. Ibid., 103.

10. Womack, *Red on Red*, 273.

11. Riggs, *Green Grow the Lilacs*, 34.

12. For a more extensive, academic treatment of Ali Hakim and the surprisingly long history of the Western genre and tropes of the Middle East, beginning with Wild West shows and continuing into the "war on terror," see Susan Kollin, *Captivating Westerns: The Middle East in the American West* (Lincoln: University of Nebraska Press, 2015), 113–44. On the general history of Lebanese and Syrian immigrants in part of the region, see Jay M. Price and Sue Abdinnour, "Family, Ethnic Entrepreneurship, and the Lebanese of Kansas," *Great Plains Quarterly* 33, no. 3 (Summer 2013): 160–86. On North Dakota, see Cary Beckwith, "Of Mosques and Men: How a North Dakota Prairie Became the Home of America's First Mosque," *New Republic*, January 31, 2016, https://newrepublic.com/; and Samuel G. Freedman, "A Mosque Rises above the Plains as a Symbol of Muslims' Long Ties," *New York Times*, May 28, 2016.

13. Agnes de Mille, *Dance to the Piper* (1951; repr., New York: New York Review Books, 2015), 108.

14. Ibid., 109.

15. Ibid., 116.

16. Ibid., 21.

17. See Stephen Wade, *The Beautiful Music All around Us: Field Recordings and the American Experience* (Urbana: University of Illinois Press, 2012), 25–46.

18. On these pieces, see, for example, Julia L. Foulkes, *Modern Bodies: Dance and American Modernism from Martha Graham to Alvin Ailey* (Chapel Hill: University of North Carolina Press, 2003), 152–54.

19. On Pollock's relationship to regionalism, see Henry Adams, *Tom and Jack: The Intertwined Lives of Thomas Hart Benton and Jackson Pollock* (New York: Bloomsbury, 2009).

14. *What a River Knows*

1. The recordings of Flora Robertson and Mary Sullivan come from the collection "Voices from the Dust Bowl: The Charles L. Todd and Robert Sonkin Migrant Worker Collection," 1940–1941, housed at the American Folklife Center at the Library of Congress (hereafter Todd-Sonkin Collection), available at memory.loc.gov/ammem/afctshtml/tshome.html. Transcriptions are mine. Sullivan quote: "Our Mothers" (call number AFS 4119a2). Information on Todd and Sonkin is available on the same website, as are photographs of them working in the field with their equipment. See especially "[Will Neal playing fiddle being recorded by Todd and Sonkin]," from the Arvin FSA Camp in 1940 (call number AFC 1985/001:P8-p1), and "[Mr. and Mrs. Frank Pipkin being recorded by C. Todd with 7 men and a little boy in the background]," from the Shafter FSA Camp in 1941 (call number AFC 1985/001:P9-p1), both photographs by Robert Hemmig, Ventura, California. The brand of the recording machine comes from Charles Shindo, *Dust Bowl Migrants in the American Imagination* (Lawrence: University of Kansas Press, 1997), 198.

2. Expense list for "Todd-Sonkin Trip to Alabama and California," undated, and letter from Robert Sonkin to Jerry [no last name given], July 31, 1941, Todd-Sonkin Collection, correspondence from 1940–1941, pp. 18–19.

3. The quote comes from Elliot West, *The Contested Plains: Indians, Goldseekers, and the Rush to Colorado* (Lawrence: University Press of Kansas, 1998), 312. See also Thom Hatch, *Black Kettle: The Cheyenne Chief Who Sought Peace but Found War* (Hoboken, N.J.: John Wiley & Sons, 2004), 233–54; and Robert M. Utley, *George Armstrong Custer and the Western Military Frontier*, rev. ed. (Norman: University of Oklahoma Press, 2001), 64–71.

4. Flora Robertson, "Why We Come to California," Todd-Sonkin Collection.

5. I have written more extensively about the narrow range of celebrated "folk" culture in Josh Garrett-Davis, "The South Stole Americana," *Los Angeles Review of Books*, January 5, 2016.

6. Robertson, "Why We Come to California." The Library of Congress typed copy of this poem, which uses "Come" in the title instead of "Go," as said in the recording, ends after the line "I'm a-comin' to you." My guess is that Todd or Sonkin typed this from Robertson's manuscript and forgot to copy the back of the page (I think I can hear her turn the sheet over at the same point in the recording). Where words are slightly different, I'm using my transcription rather than theirs. (I wonder, for instance, if she spelled the state's name "Californy" as the typed copy does or whether it was an attempt at dialect.) "Why We Come to Californy," text document (call number AFC 1985/001), Todd-Sonkin Collection.

7. Historian James Gregory also considers this poem, among other songs recorded by Todd and Sonkin, in his book *American Exodus: The Dust Bowl Migration and Okie Culture in California* (New York: Oxford University Press, 1989), 20–21. He finds the lines about what he calls the "cornucopia" of rich foods and Santa Claus to be the most resonant, saying that Robertson's invocation of Santa hints that perhaps California "will prove to be a fantasy, a false and empty illusion." Where I hear "There's apples, nuts, and oranges," he transcribes the line as "And if apples, nuts, and oranges," adding substantially to her ambivalence. I also hear a glee and a suspension of disbelief in her performance of those last four lines. So I doubt how ironic she is about California's horn of plenty.

8. The "mud pack" quote is from Robertson, "Interview about the dust storms," Todd-Sonkin Collection; other details come from Robertson, "Interview about Oklahoma," Todd-Sonkin Collection.

9. "16 Drown in Oklahoma Flood; 7 Miles of Homes Obliterated," *Dallas Morning News*, April 5, 1934.

10. "Four Die in Southwest Texas Floods as Oklahoma Freshet Toll Reaches 17," *Dallas Morning News*, April 6, 1934.

11. Charles J. Brill, *Conquest of the Southern Plains: Uncensored Narrative of the Battle of Washita and Custer's Southern Campaign* (Oklahoma City: Golden Saga, 1938), 25–26.

12. Hatch, *Black Kettle*, 253–54.

13. *Covered Wagon News* (Shafter Farm Workers Community) 3, nos. 29 and 47, Todd-Sonkin Collection.

15. *A California Commonist*

1. See Will Kaufman, "Woody Guthrie, 'Old Man Trump,' and a Real Estate Empire's Racist Foundations," *Conversation*, January 21, 2016, https://theconversation.com/woody-guthrie-old-man-trump-and-a-real-estate-empires-racist-foundations-53026. The lyrics are at Woody's daughter Nora's website: http://woodyguthrie.org/Lyrics/Old_Man_Trump.htm.

2. Peter La Chapelle, "The Guthrie Prestos: What Woody's Recordings Tell Us about Art and Politics," in Darryl Holter and William Deverell, eds., *Woody Guthrie L.A.: 1937 to 1941* (Santa Monica, Calif.: Angel City Press, 2015), 74.

3. Quoted in Ronald Briley, "Woody Sez: The *People's Daily World* and Indigenous Radicalism," in Holter and Deverell, *Woody Guthrie L.A.*, 135.

4. Quoted in Dan Cady and Douglas Flamming, "Ramblin' in Black and White," in Holter and Deverell, *Woody Guthrie L.A.*, 58.

5. Ibid., 59.

6. On Woody as a "lone wolf," see Darryl Holter, "Woody Guthrie in Los Angeles, 1937–1941," in Holter and Deverell, *Woody Guthrie L.A.*, 32–41.

7. Philip Goff, "In the Shadow of the Steeple I Saw My People," in Holter and Deverell, *Woody Guthrie L.A.*, 100.

8. From Guthrie's book *Born to Win* (1967), quoted in Ed Robbin, "Woody and Will," in Holter and Deverell, *Woody Guthrie L.A.*, 125. Ed Robbin was a Los Angeles newscaster who introduced Guthrie to this part of the political left, as recounted in this reprint of an excerpt from Ed Robbin, *Woody and Me: An Intimate Reminiscence* (Berkeley, Calif.: Lancaster-Miller, 1979).

9. Rogers quoted in Lary May, *The Big Tomorrow: Hollywood and the Politics of the American Way* (Chicago: University of Chicago Press, 2000), 13. See also Amy M. Ware, *The Cherokee Kid: Will Rogers, Tribal Identity, and the Making of an American Icon* (Lawrence: University Press of Kansas, 2015). On Will Rogers and Jesus Christ as Guthrie's heroes, see Goff, "In the Shadow of the Steeple," in Holter and Deverell, *Woody Guthrie L.A.*, 109.

10. Briley, "Woody Sez," 142.

11. Josh Kun, "Woody at the Border," in Holter and Deverell, *Woody Guthrie L.A.*, 170.

12. Bryant Simon and William Deverell, "The Ghost of Tom Joad," in Holter and Deverell, *Woody Guthrie L.A.*, 153–65.

13. Briley, "Woody Sez," 139.

14. Holter, "Woody Guthrie in Los Angeles," 23; and Briley, "Woody Sez," 136.

15. La Chapelle, "Guthrie Prestos," 81; and Holter, "Woody Guthrie in Los Angeles," 21.

16. *California über Alles*

1. Joan Didion, *The White Album* (New York: Farrar, Straus & Giroux, 1979), 13, 86–87, 95, 189.

2. "John Wayne: A Love Song" appears in Joan Didion, *Slouching towards Bethlehem* (New York: Farrar, Straus, and Giroux, 1968).

3. Didion, *White Album*, 64, 127–28.

4. Ibid., 69.

5. Ibid., 207, 135.

6. Joan Didion, *The Year of Magical Thinking* (New York: Knopf, 2005), 31.

7. Didion, *White Album*, 175.

17. *All Our Values Are Shaken*

1. Bruce Cutler, foreword to May Williams Ward, *In That Day: Poems* (Lawrence: University Press of Kansas, 1969), x.

2. Kansas Writers' Project, *The Larned City Guide*, compiled by the Workers of the Federal Writers' Project of the Works Progress Administration of the State of Kansas (Larned, Kans.: Chamber of Commerce, 1938), 28.

3. Cutler, foreword to *In That Day*, xi.

4. May Williams Ward and Leslie Wallace, "From the New Editor and Publisher," *Harp* 2, no. 3 (September/October 1926): 18.

5. William Allen White, "What's the Matter with Kansas?," *Emporia Gazette*, August 15, 1896.

6. Quoted in Lana Wirt Myers, *Prairie Rhythms: The Life and Poetry of May Williams Ward* (Lawrence, Kans.: Mammoth Publications, 2010), 72.

7. Edward Gale Agran, *"Too Good a Town": William Allen White, Community, and the Emerging Rhetoric of Middle America* (Fayetteville: University of Arkansas Press, 1998), 97, 42.

8. May Williams Ward, "About Books," *Harp* 3, no. 1 (May/June 1927): 18.

9. Quoted in George Lipsitz, *Time Passages: Collective Memory and American Popular Culture* (Minneapolis: University of Minnesota Press, 1990), 24–25.

10. See Caroline Fraser, *Prairie Fires: The American Dreams of Laura Ingalls Wilder* (New York: Picador, 2017).

11. *Harp* 3, no. 1 (May/June 1927): 8–10.

12. Barbara Thompson O'Neill and George C. Foreman, in cooperation with Howard W. Ellington, *The Prairie Print Makers* (Topeka: Kansas Arts Commission, 1981), 3.

13. *Wichita Eagle*, January 25, 1931, quoted in ibid., 4.

14. O'Neill and Foreman, *Prairie Print Makers*, 10.

15. Ibid., 42, 27, 39, 47. White's Rotary Club involvement is mentioned in David Hinshaw, *A Man from Kansas: The Story of William Allen White* (New York: Putnam, 1945), 198.

16. I checked the tables of contents in twenty-one issues held by the Beinecke Library at Yale University and found that of 644 names of poets, 451 seemed to be those of women. (I did not count

a poet twice if he or she had two poems in the same issue, but I counted the same poet multiple times if he or she appeared in multiple issues.) There were two other issues that were "Editors' Numbers," in which all the poets were editors at other magazines. I did not include these in the total because they were the only issues in which male poets were nearly equal in number to females (there seemed to be thirty-two male names and twenty-seven names of contributors to these two issues). This appears to be a function of other gender dynamics in the publishing world at that time. Even including these issues in the total, women seem to have made up 478 of 703 poets, or 68 percent.

17. Billy McCarroll, "Kansas Sand Hills," *Harp* 3, no. 1 (May/June 1927): 14.
18. Myers, *Prairie Rhythms*, 59–60.
19. Ibid., 63.
20. "In This Number of the Harp," *Harp* 4, no. 4 (November/December 1928): inside cover.
21. "In This Number of the Harp," *Harp* 3, no. 3 (September/October 1927): inside cover. "Snow Whimsey" and "Moon Whimsey" appear on page 13 of the same issue. Thelma Chiles's biographical information comes from *Who's Who in Colored America* (New York, 1942), 502.
22. Thelma Chiles, "Moon Whimsey," *Harp* 3, no. 3 (September/October 1927): 13.
23. May Williams Ward, "John Brown and the Cabin at Osawatomie," in *Wheatlands: Poems and Block-Prints* (Wellington, Kans.: May Williams Ward, 1954), 20.
24. May Williams Ward, "Great Tree, Giver and Forgiver," *Harp* 3, no. 1 (May/June 1927): 10.
25. Cutler, foreword to *In That Day*, xi; Kansas Writers' Project, *Larned City Guide*.
26. May Williams Ward, "Alien," in *Wheatlands*, 24.

18. A Homestead for Contemporary Art

1. For some of these projects, see Margo Handwerker and Richard Saxton, eds., *A Decade of Country Hits: Art on the Rural Frontier* (Heijningen, Netherlands: Jap Sam Books, 2014). This chapter is adapted and expanded from one in that book.
2. For a good history of the region through the Colorado gold rush, see Elliott West, *The Contested Plains: Indians, Goldseekers, and the Rush to Colorado* (Lawrence: University Press of Kansas, 1998), especially pp. 68–93 (on Cheyenne history) and 208–15 (on road ranches).
3. Susan Eldringhoff, ed., *Colorado Prairie Towns: A Pictorial History of Agate, Deer Trail, Byers, and Strasburg* (Virginia Beach, Va.: Donning, 2011), 135.

19. I'm a Loner, a Rebel

1. Edward Abbey, *Desert Solitaire: A Season in the Wilderness* (New York: Simon and Schuster, 1968), 24.
2. Ibid., 102.
3. Ibid., 110.
4. Ibid., 5.
5. Ibid., 20.
6. Ibid., 154.
7. Owen Wister, *The Virginian* (1902; repr., New York: Signet Classic, 2002), 363, 370–71.

8. Edwin Way Teale, "Making the Wild Scene," *New York Times*, January 28, 1968.

9. Russell quote, originally from John Hutchens, *One Man's Montana: An Informal Portrait of a State* (New York: J. B. Lippincott, 1964): Abbey, *Desert Solitaire*, 167–68.

20. Seuss in Boots

1. Wallace Stegner, "The Sense of Place," in *Where the Bluebird Sings to the Lemonade Springs: Living and Writing in the West* (New York: Random House, 1992), 202.

2. I tried to celebrate the poetry of rewilding in Josh Garrett-Davis, *Ghost Dances: Proving Up on the Great Plains* (New York: Little, Brown, 2012). On the Buffalo Commons, see also Anne Matthews, *Where the Buffalo Roam: The Storm over the Revolutionary Plan to Restore America's Great Plains* (New York: Grove Press, 1992). On reclaiming Native traditional knowledge, see, for example, M. Kat Anderson, *Tending the Wild: Native American Knowledge and the Management of California's Natural Resources* (Berkeley: University of California Press, 2005).

21. American Remains

1. It may be too much of a leap to quote it in the main text, but this essay owes much to the tragic-historic perspective of the German-British author W. G. Sebald. Particularly relevant is a passage from *The Rings of Saturn* (1995; repr., New York: New Directions, 1998), 124–25, in which Sebald visits the site of the Battle of Waterloo and realizes that the historical perspective essentially amounts to "standing on a mountain of death." Very metal.

2. Dayton O. Hyde, *The Pastures of Beyond: An Old Cowboy Looks Back at the Old West* (New York: Arcade, 2011), 3.

3. Temple Grandin, "Animal Welfare in Slaughter Plants," presented at the 29th Annual Conference of the American Association of Bovine Practitioners, 1996, http://www.grandin.com/welfare/general.session.html.

4. In light of Kristofferson's verse, I can't help but add a note on American Indians in relation to all of this. Contrary to the history many of us have been taught and the one somewhat implied by "American Remains," Indigenous American history has not been one long decline since the arrival of Europeans in 1492. Finnish historian Pekka Hämäläinen—perhaps the Scandinavian metalhead of the academy—describes in his book *The Comanche Empire* (New Haven, Conn.: Yale University Press, 2008) a brutal world on the southern American plains in which a nonhierarchical empire of Comanches and allied Kiowas and Apaches dominated and exploited the region during the eighteenth and early nineteenth centuries. A century and a half: a very long time. This empire was created and enabled by these tribes' adoption of European horses and guns. In the mid-nineteenth century their empire fell hard to the American one, which in turn colonized these peoples and imprisoned them on reservations. Men who had been "centaurs," in the term of Kiowa novelist N. Scott Momaday, became colonial subjects. Will they ride again? *Almanac of the Dead*, an epic metal novel by Laguna Pueblo writer Leslie Marmon Silko, imagines a near future filled with violent reconquest and redemption led by Indigenous revolutionaries centered a bit farther west around Tucson (see chapter 7). The United States has now controlled the Southwest for about as long as Comanchería did, and still the Native nations who have been

there for millennia—for all they've suffered—are not going away. It should almost go without saying that both country and metal are beloved in Indian Country. See, for example, Kristina M. Jacobsen, *The Sound of Navajo Country: Music, Language, and Diné Belonging* (Chapel Hill: University of North Carolina Press, 2017); and Julie Turkewitz, "Looking to Uplift, with Navajo 'Rez Metal,'" *New York Times*, January 25, 2015.

INDEX

Page numbers in *italic* refer to illustrations.

Copyedited and indexed by Chris Dodge

Book design and composition by Julie Rushing

Set in Adobe Jenson Pro and Scala Sans Pro

Cover design by Tony Roberts

Image prepress by University of Oklahoma Printing Services

Manufactured by Versa Press, Inc.